TRACINGS OF LIGHT

Sir John Herschel & The Camera Lucida

"Stopped & diverged a little from the road to see the Fall of Chede...it is finely situated, and being early in the morning, & the sun being in the proper situation, a fine rainbow was exhibited in it, producing an effect equally singular and beautiful...took a Camera Lucida sketch of it."

John Herschel
14 August 1821

FIGURE 1. John Herschel, *The Fall of Chede*. Pencil *camera lucida* drawing, 1821. 29.1 x 19.2 cm. No. 325, Graham Nash Collection; quote from his notebook *Tour in France*, 1821, Humanities Research Center, The University of Texas at Austin.

TRACINGS OF LIGHT
SIR JOHN HERSCHEL & THE CAMERA LUCIDA

DRAWINGS FROM THE GRAHAM NASH COLLECTION

LARRY J. SCHAAF

with introductions by Graham Nash and Graham Howe

THE FRIENDS OF PHOTOGRAPHY, SAN FRANCISCO
This publication was prepared by Curatorial Assistance, Los Angeles

TRACINGS OF LIGHT:
SIR JOHN HERSCHEL & THE CAMERA LUCIDA

DRAWINGS Copyright ©1990 by Graham Nash Collection
TEXT Copyright ©1989 by Larry J. Schaaf
INTRODUCTIONS Copyright ©1990 by Graham Nash and
Graham Howe
All rights reserved

Library of Congress Catalog Number 89-85802
ISBN 0-933286-55-4

Printed in the United States of America

Distributed by ARTBOOKS
113 East Union Street
Pasadena, California 91103 USA

THE FRIENDS OF PHOTOGRAPHY

The Friends of Photography, founded in 1967 in Carmel, California, is an international not-for-profit organization with headquarters at the Ansel Adams Center in San Francisco. The programs of The Friends in exhibitions, publications, education and awards to photographers are guided by a commitment to photography as a fine art and to the discussion of photographic ideas through critical inquiry. The Friends is supported by a membership program that offers a variety of educational activities. The publications of the Friends, which along with admission to the Ansel Adams Center are the primary benefit of membership, emphasize contemporary photography yet are also concerned with the criticism and history of the medium. They include the newsletter re:view, the periodic books in the Untitled series and major photographic monographs. Membership in The Friends is open to everyone. To receive an informational membership brochure, write to Membership Director, The Friends of Photography, Ansel Adams Center, 250 Fourth Street, San Francisco, California 94103.

It was a crisp, sunny day in August, 1974, when my friend Mac Holbert and I were out across London on our quest for photographic treasures. I was motivated by an urgency to act on my recent revelation that photographs were a very powerful and compelling graphic medium and that many of the best of them were still waiting to be discovered.

In Berkeley Square we headed for Maggs Brothers, one of London's oldest and most respected book shops. John Maggs, a descendent over several generations from the original Mr. Maggs, served us tea and spoke enthusiastically about the past. There was something ironic about this man, a bastion of good manners and British decorum, drinking tea from a 'Mickey Mouse' mug.

I had the feeling we were being "tested," but as the afternoon drew on and we had worked our way through various graphic and literary artifacts - among which were renowned British scientist Sir John Herschel's entire meteorite collection, Mr. Maggs finally brought out three large bound volumes of Herschel's pencil sketches rendered with the aid of a *camera lucida*. Instinctively I knew they were important. These exquisite, optically correct renderings seemed to me to exist between drawing and photography. Not being sure of their importance or if they were even recorded in the histories made me all the more excited. I bought them immediately and left Maggs that evening elated, curious and burning to know more about these enigmatic artifacts.

Thanks to Larry Schaaf's extraordinary research and eloquent writing and Graham Howe's scholarly analysis, much of this wish has been realized. Sir John Herschel's drawings are now accorded their own historical context greatly helping our understanding of them. For me, however, they remain no less mysterious or compelling than when I first set my eyes upon them at Maggs book shop.

GRAHAM NASH

In 1976, when I was appointed curator to the Graham Nash collection, and first discovered Herschel's drawings, I was struck by their delicate beauty. With the earliest dated 1816, some 23 years before Daguerre's announcement of the invention of photography, here was evidence on which to speculate that photography's last predecessor was optically aided drawing.

In Herschel's works we find qualities of pictorial organization which would soon become fundamental to photography. The alignment of the lens - or prism, in the case of the *camera lucida* required assessing the view from many possible aspects so as to arrive on a satisfactory arrangement of foreground, midground and distance. A discontinuous or jarring foreground might prompt Herschel to alter the composition, even to omit the offending part.

The logic of Herschel's pictorial organization is most apparent in the complex arrangements of depth in his drawings. For example, Herschel's 1816 *View from Hotel Window, Leamington, Warwick*, made on his honeymoon, (p. 22), shows an aspect from inside a room looking out through a window to a garden and the town beyond. The grid of the window is aligned so as to best enhance the scene. The vertical frame of the left center window pane has been lined up with the joining wall between two distant town houses so as not to fracture the single profile of any building while breaking only one roof line. The bisecting horizon of the window frame is raised just above the garden fence and cornerstone, where it defines the garden space and obscures only the least significant areas of some trees and buildings. Herschel's efforts to gracefully compose pictures within each window pane and yet integrate them all in a homogeneous view were to become common devices in 20th century art, particularly in modernist photography. This example of 1829 shows Herschel's artistic vision as an aesthetic precursor, almost a century ahead of its time.

I imagined that Herschel would have selected his view and drawn it all at one sitting - since moving away from the selected vantage point would have made it almost impossible to re-align his original view at a later sitting. In this sense, Herschel's drawings are again like photographs since they were made during one continuous exposure or sitting. Given the complexity of most of these drawings, it must have taken Herschel several hours to observe and render a single scene. His notation "*with extreme care & precision*" which appears on several of his drawings, indicates his intention that they be wholly accurate works - unlike the fantastic renditions of exotic and distant sites

of many of his contemporaries. Herschel's sketches are amazing documents, and in certain ways they are even more accurate than photographs. Consider, for example, Herschel's view of *Les Eaux Chaudes*, (p. 23), made on September 12, 1850, and John Stewart's photograph, (f. 23), of the same aspect. We know Herschel and Stewart traveled together on this trip and that while Herschel sketched, Stewart photographed. However, this view by Stewart, made virtually from the exact vantage point as Herschel's, appears to have been made on a subsequent trip since we can detect physical changes in the landscape and buildings. The road by the river prominent in Herschel's view appears to have been filled by a slide in Stewart's photograph. The slide itself might have been the result of leveling to make way for the construction of the additional buildings seen in Stewart's view where only a small cluster of trees appears in Herschel's view. Furthermore, the chimneys which are clearly apparent in Stewart's view are not shown in the Herschel drawing. Looking at the skyline of each image we see how Herschel's view is more detailed than Stewart's. Stewart's wet collodion image could not record the distant atmospheric mountain ridge while Herschel has faithfully rendered the skyline to indicate more of the actual topography.

With a *camera lucida* capable of such accuracy in rendering, Herschel saw no reason to give it up for photography. Unlike the earliest topographic photographers, whose large cameras were limited by a shallow depth of field and a dark, ground glass viewing image, Herschel had the pleasure of working in daylight with a bright image of infinite sharpness. He continued to use the *camera lucida* as his standard means of recording throughout his life. The *camera lucida* was demanding to use and with the invention of the photographic camera most topographers were inclined to make mechanically produced and chemically fixed images.

Herschel's indication of navigational coordinates of various marks, his written notes on geological formations as well as the occasional poem written next to the scene speak further of the accuracy, artistry, and importance of these drawings to Sir John Herschel. A leader in the "age of science," Herschel was also clearly the possessor of a high aesthetic sensibility. This catalogue, and the exhibition of these drawings will broaden the public appreciation of the extraordinary observational powers of Sir John Herschel - scientist and photographic artist.

GRAHAM HOWE

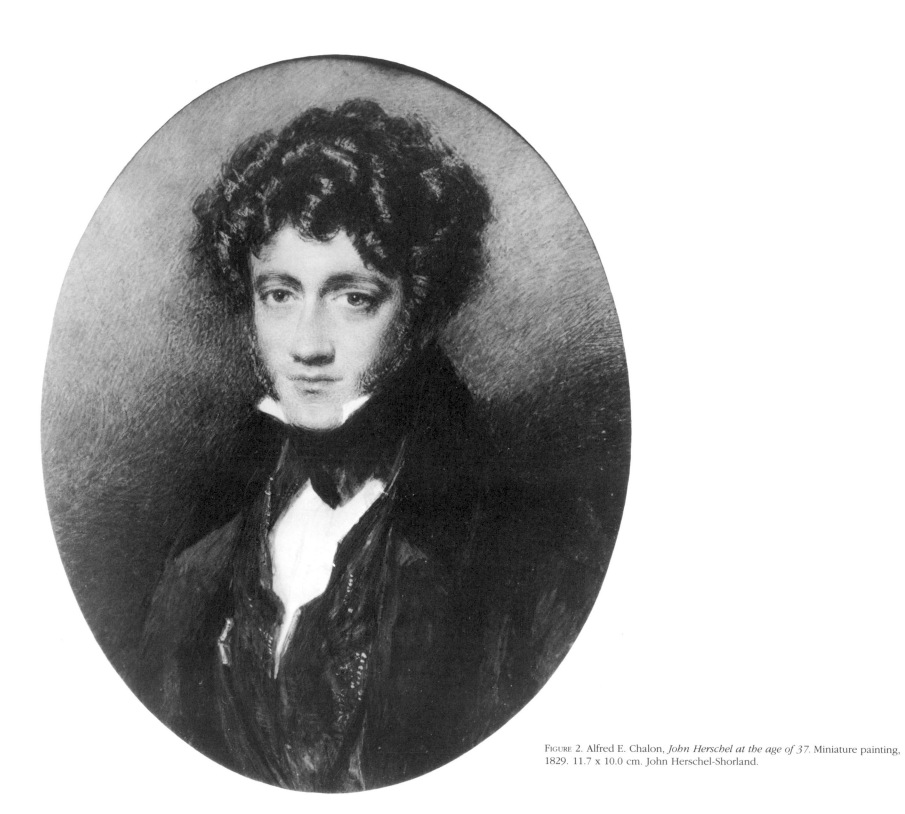

FIGURE 2. Alfred E. Chalon, *John Herschel at the age of 37.* Miniature painting, 1829. 11.7 x 10.0 cm. John Herschel-Shorland.

Telephone calls from rock stars were not part of my usual teaching day at The University of Texas in the 1970s. But then, what Graham Nash had rung about was outside mainstream history of photography as well. We discussed an artistic portfolio created by a man whose reputation (a very dry one at that) was largely as a scientist. Other interests intervened, and it wasn't until Nash's curator, Graham Howe, pressed the issue upon my return to Baltimore four years ago that I seriously examined the collection. I was stunned. Herschel's *camera lucida* drawings continue to raise many questions. They have also yielded some answers. Why wasn't Sir John the inventor of photography? This towering scientific figure, a brilliant chemist and optician, understood the underlying basis of photography so well that, once he was interested, he needed less than a week to independently invent it! We still use his hypo fixer in our darkrooms today. Once photography was a reality, why did Herschel not employ it more? The technique was child's play to him and he had a constant need for images. I now feel that the answers to these questions lie substantially in Herschel's mastery of the *camera lucida*, the last major optical tool to be offered to artists before the advent of photography. The *camera lucida* dovetailed so neatly with Herschel's spirit and activities that even the ready availability of photography after 1839 did not sway him from it. Research opportunities posed by the new art engaged him, yet philosophically he was inclined not to the rapidity of the photographic camera but instead towards the analytical aspects of drawing with the *camera lucida*.

A highly portable and beguillingly simple little device, the *camera lucida* was an ideal aid to the scientific traveller. Little more than a tiny prism elegantly perched on top of a brass stem, this eye to the world perfectly transmitted perspective and form. It conveyed these forms, but it did not translate them into visions. The device was a devilish frustration for anyone who lacked understanding of how to digest complex visual information for presentation in a two-dimensional medium; in fact, Herschel's friend and colleague, William Henry Fox Talbot, invented photography simply because he was a failure at using the *camera lucida*. In the hands of an artist, however, the *camera lucida* facilitated field work and injected a higher level of precision into visual representations. Sir John was one of the most accomplished of the elite group of artists who successfully applied the *camera lucida* to their work. His oeuvre is one of the precious few surviving groups of *camera lucida* drawings known, and is the largest of them all. Perhaps

more importantly, Herschel's *camera lucida* collection is unique in its wealth of documentation. Herschel considered his work with the instrument to be very special, and he took great pains to record the circumstances under which it was created.

The *camera lucida* has traditionally received short shrift from historians, making me feel a bit of a lost soul when starting this enquiry. Without the initial encouragement of Helen Smailes of the Scottish National Portrait Gallery, Professor Martin Kemp of the University of St. Andrews, and Chris Titterington of the Victoria & Albert Museum, this would have been a lonely quest indeed. Assessing Herschel's collection would have been more difficult, if not impossible, without the resources of The Peabody Library in Baltimore. The most substantial 19th century library still intact in America, its collections embody the thinking of that century, rather than of ours, and the clues to a long-forgotten instrument have not been circumcised by 20th century mindsets. Its stacks are bound to yield still more examples, not only of *camera lucida* use, but also of its implications. I am grateful to the Librarian, Robert Bartram, for making the collection freely available, and for providing ample study space in Baltimore's "Cathedral of Books." Professor Emerita Dr. Phoebe Stanton was a constant guide to its collections and an enthusiastic supporter.

The main repository of Herschel's papers is in the Archives of The Royal Society in London; Keith Moore, Sheila Edwards, and Sally Grover have consistently been helpful. A Herschel collection less recognized is that of the Humanities Research Center at The University of Texas at Austin. Assembled from the miscellany sold at the same auction as Nash's drawings, this complex and fascinating mass has yet to be catalogued; Cathy Henderson, Ken Craven, Pat Fox, and John Kirkpatrick have seen innumerable requests as a challenge rather than a burden. John and Esther Herschel-Shorland have freely shared the Herschel family archives, continuing a tradition and a privilege I have enjoyed from Herschel's descendants for many years. Institutions who have made their collections available include St. John's College, Cambridge; The British Library; Victoria & Albert Museum; British Museum; National Portrait Gallery, London; National Library of Scotland; Scottish National Portrait Gallery; Special Collections, University of St. Andrews; National Library of Wales; Museum of Art, Rhode Island School of Design; Kresge Physical Science Library, Dartmouth College; The Lilly Library, Indiana University; Eisenhour Library, Johns

Hopkins University; Library of Congress; and the Photography Collection and the Perry Castaneda Library at The University of Texas. John Ward of the Science Museum in London, Tony Simcock of the Museum of the History of Science in Oxford, Sinclair Hitchings of the Boston Public Library, and Hans P. Kraus, Jr. provided special assistance and advice. Professor Victor Luftig of Yale University and Professor Charles Mann of the Pennsylvania State University have tendered many valuable suggestions for this text.

Tracings of Light was first shown at the Baltimore Museum of Art from December 1988 - March 1989; Jay Fisher recognized the importance of showing these drawings during photography's sesquicentennial year, and Jan Howard contributed to the hanging of the exhibition. Fred Spira very generously shared his collection with both the exhibition and this book. Karen Bowers energetically attacked a plethora of conflicting demands to achieve the quiet simplicity that I desired for the design of this book. Graham Howe has provided the impetus for the book all along, and was largely responsible for its production.

The most enthusiastic supporter of this entire project has been its originator, Graham Nash. His early recognition that these drawings might be important led me on a course of discovery which has culminated in this book. Nash's support to all aspects of this project has made possible this contribution to our knowledge and understanding of the early confluence between drawing and photography.

Watching my wife Elizabeth use 'Lucie' at Villa Melzi on Lake Como (in the very same spot where Henry Talbot had his inspirational failure), capped a vicarious learning experience for me that started with the first time she grappled with the instrument (like Herschel, she can sketch -- like Talbot, I cannot). We had slipped away from Verona during the production of the facsimile of Talbot's *Pencil of Nature*. What more exquisitely satisfying way could there be to tie together these components of the beginnings of the art of photography?

LARRY J. SCHAAF
ROCK HOUSE
BALTIMORE, MARYLAND
10 JULY 1989

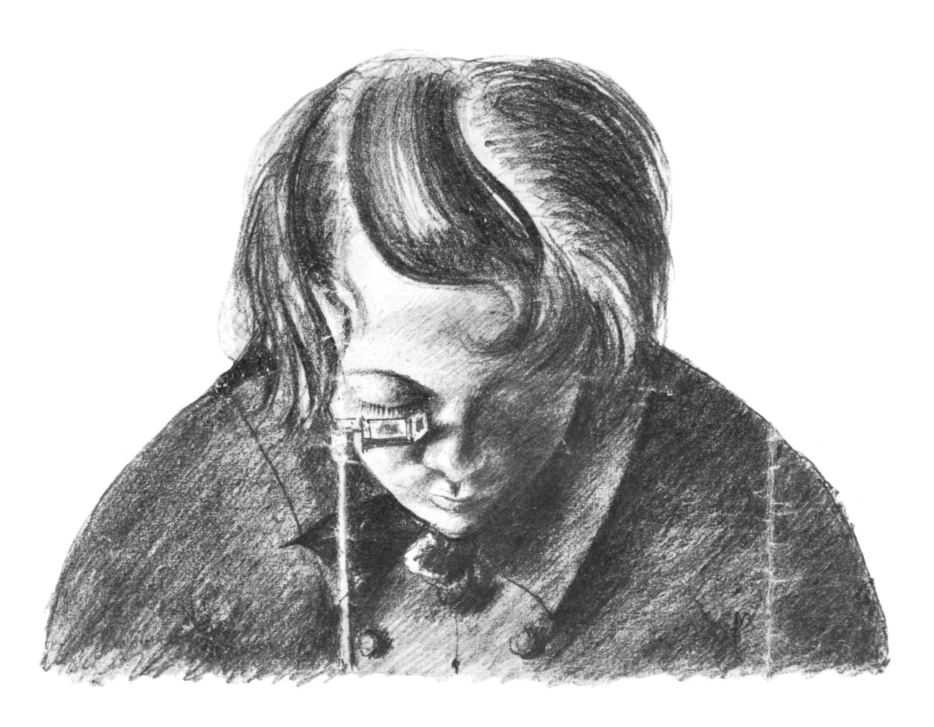

FIGURE 3. Self Portrait? *Reverend Calvert Jones? sketching with a Wollaston camera lucida.* Pencil *camera lucida* drawing, ca. 1830. 22.8 x 8.6 cm. Sketched on the back of a letter, this is most likely a self-portrait done in a mirror. The National Library of Wales.

"Such a model of the accomplished philosopher...
can rarely be found beyond the regions of fiction"
THE DUKE OF SUSSEX, ON SIR JOHN HERSCHEL IN 1833 [1]

Vulcan and Aphrodite were the muses of Herschel's *camera lucida.* A twice-broken heart set John Herschel wandering abroad (a not unusual cure then or now); the intellectual stimulus of continental travel appealed strongly to his classical education and revived his dormant interest in science, awakening him to a new challenge. With the *camera lucida,* a tool uniquely suited to his artistic gifts and philosophical concerns, Herschel would exercise his already accomplished draftmanship in the service of his growing understanding of the primeval forces still shaping the earth.

John Herschel was an extraordinary individual in an extraordinary epoch. His father, the astronomer William Herschel, fired the public imagination in a way almost impossible for us to appreciate in our scientifically-jaded present day. William's discovery of the planet Uranus overturned the long accepted Copernican universe, forever changing humankind's underlying concepts of the world. William's forty-foot telescope at Slough, within the sight and the patronage of Windsor Castle, was the pre-eminent symbol of the dawn of a new age (and too often, as well, an unwelcome billboard for a reclusive household). John, born in 1792, grew up in the shadow of this great and wonderful machine, in an intellectually rich environment that fully developed his innate abilities. And develop he did. Even before the ascension of Victoria, Sir John Herschel became the very embodiment of science -- Herschel and science were interchangeable terms, both to the man on the street and throughout the professional community.

By the time Herschel would be buried next to Sir Isaac Newton in Westminster Abbey in 1871, the comparison between the two men would already be firmly fixed in the public mind. The Royal Society lamented that "British science has sustained a loss greater than any which it has suffered since the death of Newton, and one not likely to be soon replaced."[2] While still a student, Herschel radically changed the course of mathematical study throughout Britain. At the age of 21, he was elected -- on merit, not because of his famous father -- one of the youngest ever Fellows of The Royal Society. He was to publish more than 150 scientific papers and many books in his lifetime. Frequently honored by the world's scientific groups, he was knighted in 1831 and achieved his Baronetcy in 1838. Following his father, John Herschel made significant contributions to stellar astronomy. Like Newton, he became Master of the Mint, enduring great personal sacrifice to institute important scientific reforms. His best known invention in photography, the hypo fixer, is still used to this day. This was but one of a myriad of important and less appreciated contributions in this field.[3]

Yet at the center of all this scientific glory remained a great humanist of diverse talents and interests, and a man of universally generous thoughts and behavior. In an era when ambitions and personality clashes in the scientific community were frequently and strongly expressed, disparaging comment about Sir John Herschel was virtually non-existent. He was "as truly a philosopher as any we may ever hope to see, ornamenting and instructing all who came within his influence."[4] Herschel wrote with elegance and grace in a style that brought the most complex of thoughts within the grasp of any educated person. "How few...like him, could so touch the dry bones of fact that they became clothed at once with life and beauty!," marvelled astronomer Richard Proctor.[5] In addition to his immense personal achievements in science, Herschel contributed something less tangible but even more important. He had the peculiar gift to "combine with his special studies a breadth of view and power of expression.... We have called Sir John Herschel the Homer of science because he was its highest poet. It is the poet's function to move the soul -- rousing the emotions, animating the affections, and inspiring the imagination; and all this Herschel did on almost every page of his writings...he has drawn beautiful pictures of nature's doings -- so beautiful that they have disposed two generations to find their recreation and joy in science."[6]

A great part of the mind of John Herschel remained loyal to the more lofty ambitions of the century of his birth, the 18th century, and he clung to the hope (not unreasonable in his time) that one individual might grasp the entire universe of knowledge. The quality and scope of his achievements make him an intimidating subject for a modern biographer.[7] Even within his lifetime this symbol incarnate of modern science was recognized as a uniquely paradoxical product of an era already yielding to the unrelenting forces of industrialization: "The tendency, and almost the necessity, of modern scientific study is strongly in favor of an exclusive devotion to some narrow specialty. Dissipation of energy is conditioned on

FIGURE 4. John Herschel, *Monuments in Penrith churchyard*. Diary page, pen and pencil sketch with wash, 4 August 1809. 11.5 x 18.0 cm. Herschel was 17 when he took a trip around Britain, exploring manufacturing and technological centers, as well as historic sites. Herschel Collection, the Humanities Research Center, The University of Texas at Austin.

superficiality, and the universal genius is regarded with suspicion. Nevertheless, the example of Herschel is an exhortation and an encouragement to the most liberal culture, by showing how many things can be done, and done well...."[8]

And he could do well a great many things! By the time he entered Cambridge at the age of seventeen, "he was a good Poet...a good Pianoforte player, afterwards an Excellent Flute. Drawing. I heard Hauptman Müller wishing to have but one of John's Talents, viz. that of Drawing" -- so remembered his aunt, the renowned astronomer Caroline Herschel, who had been John's closest childhood friend and his scientific mentor.[9] Most of John Herschel's education before Cambridge came from private tutors. In the days before the stars took over, his father had been the organist at Bath, and is the likely source of his son's musical interests. It is less clear who nurtured John's talents with the poet's pen and the draftsman's pencil, but his native abilities would have been constantly stimulated by the many interesting people who frequented his father's home.

Herschel became an accomplished draftsman while still a child. We can recognize that many of his sketches

and watercolors were intended to document places that he had visited and things that he had found interesting; others of his early works are impressive visual accomplishments, but we may find his intentions for them more difficult to categorize. John Herschel recognized no man-made barriers between what we call science and what we call art; the qualities of both contributed to his intellectual appreciation of man's place in the world. Ultimately, we must conclude that they both represented Truth to him, and Truth was, after all, a unique entity. The highly partitioned 20th century mind must comprehend that unity if we are to fully appreciate Herschel's work with the *camera lucida*.

"Lucidity, lucidity
We seek it with avidity.
Has a camera lucida anything to do with lucidity?"
MISS SAVAGE, 1882 [10]

Near the end of the 19th century, by the time novelist Samuel Butler was confronted with Eliza Savage's poetic question, the *camera lucida* had quietly served artists, architects, draftsmen, and scientists for 75 years. Its fate was that of a helper too rarely acknowledged; perhaps because of this, it seldom rates more than a cursory comment in the few histories of art and photography in which it is mentioned at all. Its pervasiveness and influence in 19th century illustration has been vastly underrated.

The *camera lucida* is a brilliantly simple instrument -- so simple, in fact, that its invention was inspired by an effect that William Hyde Wollaston observed in his shaving mirror one morning.[11] Wollaston was an outstanding scientist of wide-ranging interests, who greatly influenced his own generation. His wealth came from exclusive knowledge of how to manufacture platinum in a useable form; the benefits of this monopoly were later to be distributed in scientific philanthropy. Wollaston specialized in chemical analysis, mastering quantities so minute that his entire laboratory was contained within a tea tray. His lens designs would be used by the first photographers. His 'periscopic spectacles' are the basis of the majority of eyeglasses today. Yet, while he was a

brilliant optician and had many links with the artistic community, his personal artistic skills were undeveloped.

A colleague recalled that around the year 1800, Wollaston gave up his practice as a physician, and "a few months after we went together, with another friend, to the Lakes, the mountains, mines, and scenery of which furnished abundant food for thought. Geology, as a study, was at that time in its infancy, but with the forms,

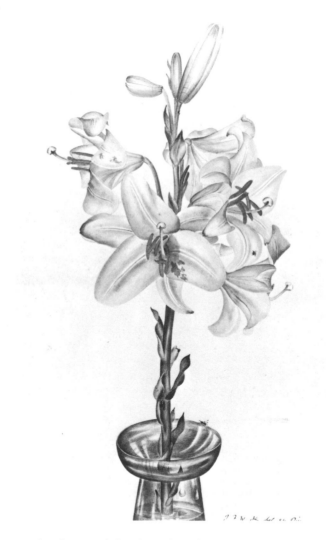

FIGURE 5. John Herschel, *White Lily*. Colored drawing, signed JFWH, del et Pinx, July 8th 1809. 31.1 x 22.4 cm. Done when he was 17 years old, this extremely precise rendition presages the floral illustrations that he would do in collaboration with his wife 25 years later in South Africa. No. 761, Graham Nash Collection.

fashions, and contents of the hills he seemed already well acquainted. We could only take the <u>outline</u> of the districts, for neither of us could draw well, and we lamented our not being able to do so." Scientific illustration was taking on increasing importance as disciplines such as geology were becoming more sophisticated, and this necessity led to another of Wollaston's inventions: "calling on him a few months afterward in town, I found him with a minute truncated and half-silvered prism fastened with sealing wax to a piece of wire. 'Look,' said he, 'here is the very thing we wanted at the Lakes;' and very soon came forth that elegant and very useful little instrument, the camera lucida." [12]

The *camera lucida* plays tricks on the eye. When we look out a window, we usually see a reflection of the room inside (often to our annoyance). One image bounces off the surface of the window while another is being transmitted through it. The sofa behind us is not placed in the garden, of course, but our eye fuses the two superimposed images, leaving it up to our brain to sort out which is which. The *camera lucida* makes a positive virtue of this effect. The artist sees the scene apparently laid out on his drawing paper. His pencil can then follow the true lines of nature, even though it is all an illusion.

The *camera obscura,* literally a dark chamber, had been a mainstay of artists for centuries (often playing the role of a silent partner). In the camera obscura, popularly known as 'the artificial eye,' an image was transmitted via a lens (or a pinhole) to a screen opposite in the darkened room. Later, this dark room was shrunken to the size of a portable box and the artist could trace what he saw projected on the ground glass. Still later, in the 19th century, the tracing paper in this box was to be replaced with a light sensitive surface, leading to the realization of photography. The *camera lucida,* by contrast, is a 'room of light' -- a provocative term far less paradoxical than it might at first sound.

When Wollaston took out a patent for his invention in 1806, the nameless device had only the ungainly title of an "Instrument whereby any Person may draw in Perspective." [13] Somewhere in the six months before announcing his invention to the public, Wollaston adopted

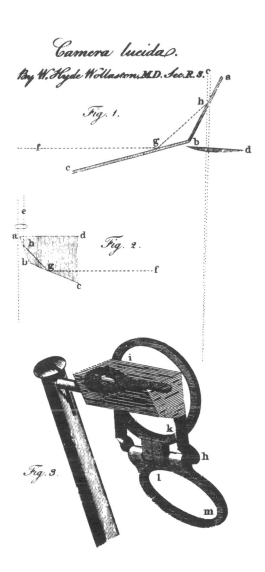

FIGURE 6. *William Hyde Wollaston's Camera Lucida.* 17.2 x 9.6 cm. Wollaston's original design (shown here) remained essentially unchanged through many years of manufacture by various opticians; the prism was usually brass-bound for protection. The aperture, which controlled the relative amount of light reaching the eye from the drawing board and the scene, is shown in a typical position on the edge of the prism. *Nicholson's Journal,* June 1807. The Peabody Library, Baltimore.

the name *camera lucida,* but never explained how he had arrived at it. The most obvious explanation of the term's origin is that Wollaston contrasted his device with the dark workings of the *camera obscura.* Or, just perhaps, since he was an astronomer, the physical shape of his invention reminded him of the Lion's Tail, which

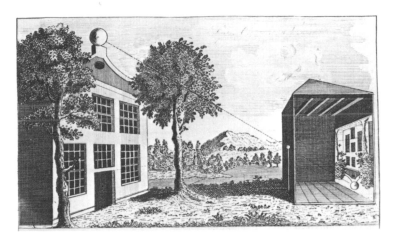

FIGURE 7. *The Camera Obscura, or Dark Chamber.* 8.7 x 14.8 cm. When the *camera obscura* was a room with a pinhole forming the image, it was most frequently a device of entertainment. With the addition of a lens, and with the chamber reduced to the size of a table-top box, the *camera obscura* became a favored artist's tool by the 17th century. Since an actual image was projected onto a screen in the *camera obscura,* it would become the basis of the photographic camera. Engraving from Frederick Barlow's *The Complete English Dictionary* (London, 1772). The Peabody Library, Baltimore.

was called 'Lucida' in ancient times. It is also possible that Wollaston referred back to an unrelated 1668 invention by Robert Hooke, which had become known in dictionaries as a *camera lucida.* Ironically, Hooke called his invention simply a 'Light Room,' only to have an 18th century lexicographer translate this into Latin! [14] Many historians have blindly followed the dictionary definitions without reference to Hooke's original publication, therefore confusing Wollaston's and Hooke's inventions, which were completely dissimilar. One author has chosen to attribute the concept to Johann Kepler in 1611, but this claim is without foundation. [15] Wollaston's idea was fresh; like his laboratory on a tea tray, his *camera lucida* elegantly represented nature in a world in miniature.

In Wollaston's 1807 *Description of the Camera Lucida,* he explained that after attempting "to sketch various interesting views without an adequate knowledge of the art of drawing, my mind was naturally employed in facilitating the means of transferring to paper the apparent relative positions of the objects before me; and I am in hopes that the instrument which I contrived for this purpose may be acceptable even to those who have

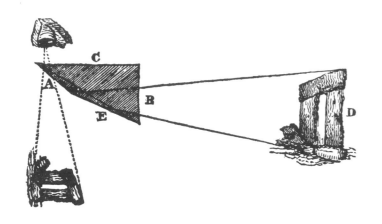

FIGURE 8. *Principle of the Wollaston camera lucida.* The image of the scene was twice reflected in the prism, making it appear correct to the eye. By shifting the pupil to look over the edge of the prism (left in this case), this person would see simultaneously the image of nature and the paper below. The mind would fuse the two images, making nature appear to be on the drawing paper. *Magazine of Science,* 25 January 1840. Photography Collection, the Humanities Research Center, The University of Texas at Austin.

attained to a greater proficiency in the art, on account of the many advantages it possesses over the common camera obscura."[16] Wollaston pointed out that his device was smaller and lighter, had no optical distortion, and took in a wider field of view.

The Wollaston form of *camera lucida* utilizes a small prism mounted at the top of an adjustable stem. One looks down on the prism from overhead, and when all is adjusted to the proper angle, the scene in front is reflected to the eye. Now, imagine withdrawing one's head a little bit (still looking downwards) so that part of the eye is looking past the edge of the prism. The paper below will come into view. The trick in using the camera is to combine these two effects. Regulating the position of the pupil over the edge of the prism will allow the reflected image in the prism to enter part of the pupil and the rest of the pupil to see the paper below. Because of the proximity of the prism, the eye will fuse these two images into one. Nature's scene will appear to be on the paper and the artist's pencil can trace the outlines and forms. As a refinement, Wollaston added a small aperture: "in order to avoid inconvenience that might arise from unintentional motion of the eye, the relative quantities of light to be received from the object and from the paper are

regulated by a small hole in a piece of brass...."[17] This pivoting paddle is not absolutely essential; some artists worked quite comfortably without it. In fact, Captain Basil Hall, the foremost advocate of *camera lucida* work, was deadset against it: "It will be found better in many respects, and far less fatiguing, always to keep both eyes wide open when this instrument is used; and I think the little black piece of metal, containing what is called the eye-hole, should be entirely discarded. This part of the apparatus is detrimental to an agreeable or proper use of the Camera, and is only useful in explaining the principle by which the position of the eye is regulated."[18]

Seeing the world in a *camera lucida* is a very private experience, for in reality there is no image projected on the paper. What the artist is seeing is known as a *virtual image.* It is not 'real,' in the sense of a projected image, and is available only to his eye. A person standing beside the artist will see nothing (as is most often the case, artists would claim, with or without a *camera lucida*!). There is a lucidity -- a lightness -- about the image the *camera lucida* presents that is best appreciated by spending a few minutes with the instrument. The scene is at once vividly bright and ethereal, yet very real. It begs to be examined closely. To a practiced eye, many *camera lucida* drawings suggest their origin. The lines, while

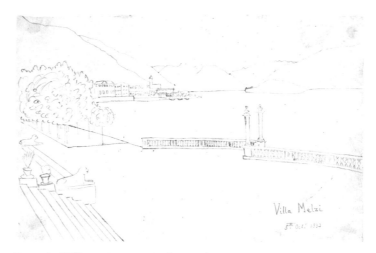

FIGURE 9. William Henry Fox Talbot, *Villa Melzi 5th October 1833.* Pencil *camera lucida* drawing. 14.2 x 21.9 cm. It was Talbot's frustration with trying to draw with a *camera lucida* on Lake Como that led him to invent photography. The Science Museum, London.

delicate and accomplished in short segments, are formed with obvious confidence and authority. There is a truthfulness about the result, a fidelity to nature, that escapes the often ponderous impressions drawn in the *camera obscura.* Wollaston's term was really quite apt. *Camera lucida* is an appropriately descriptive term -- certainly not, as one critic would have it, an "inept choice" on Wollaston's part.[19]

A simple sheet of glass will exhibit the principle of the *camera lucida.* In fact, this inexpensive form was suggested frequently in the 19th century. Sir John Robison recommended such a user-built device as being useful in delineating botanical specimens.[20] A mirror will also work, but with either a glass or a mirror the reflected image would be reversed. This was an advantage to engravers who needed a backwards image on their plate, but for most artists it would be thoroughly useless. Wollaston's choice of a solid quadrilateral glass prism was a good solution. The image bounces twice within the prism, restoring it to correct orientation. In contrast to the surface of a mirror, the internal surfaces of such a prism are perfect reflectors, losing none of the light. Unlike an image inevitably distorted by the curvilinear surfaces of a lens, that passing through the flat surfaces of a prism remains perfect. There is no distortion, and objects at any distance are equally in focus.

The *camera lucida* was rapidly taken up by people who saw in it a spectrum of possibilities ranging from enhancing existing skills to creating new ones. But those lacking in artistic prowess were inevitably disappointed. The most dramatic example of this was William Henry Fox Talbot, a scientist and a friend of Herschel's; yet Talbot's failure with the *camera lucida* had a happy consequence. He related in his *Pencil of Nature* that on "one of the first days of the month of October 1833, I was amusing myself on the lovely shores of the Lake of Como, in Italy, taking sketches with Wollaston's Camera Lucida, or rather I should say, attempting to take them: but with the smallest possible amount of success. For when the eye was removed from the prism -- in which all looked beautiful -- I found that the faithless pencil had only left traces on the paper melancholy to behold. After various fruitless attempts, I laid aside the instrument and came to

possible to cause these natural images to imprint them-selves durably, and remain fixed upon the paper!"[21]

Thus, the art of photography was born -- and perhaps Talbot's experience was not unique. Vernon Heath was "accustomed to sketch a great deal out of doors, devoting myself chiefly to water-colour landscape work, using as a help the camera lucida invented by Dr. Wollaston." He found that by using it "a practical knowledge of per-spective is acquired, not easily attained without some such assistance. This was a period long previous to the discovery of photography. How often, though, when using my camera lucida, and looking at the brilliant and distinct picture its prism had formed on the paper beneath it -- how often did I wonder whether, within the realms of chemical science, there existed means by which that picture as I saw it could be retained and made lasting! Day after day I thought and dwelt upon this, as others no doubt had done before me."[22]

Adjusting to the use of *camera lucida* was a skill of some nicety, often acquired through practice. Some never got the hang of it, and it was frequently referred to (in polite conversation, anyway) as a 'difficult little instrument.' A remark by John Ruskin illustrates the remoteness of the device: "I more and more wonder that ever anybody had any affection for *me*. I thought they might as well have got fond of a camera-lucida."[23] Broadly speaking, there were two types of failures with the *camera lucida*. Henry Talbot epitomized one. If you could not draw to start with, Wollaston's device was not going to make an artist of you. As one writer put it, "such means are like the railing of a road; they may keep the active traveller on the right course, but they cannot make the lame walk. Let not any one imagine that he can learn to draw, merely by purchasing a Camera Lucida; he might as soon learn music, by merely buying a fiddle."[24] It was up to the artist to analyse the components of the scene and figure out how to transfer them to the paper.

The other type of failure was more mechanical in nature. The 'chamber of light' had to be preserved. The prism is a near-perfect reflector, so deficient illumination of the subject was rarely a problem; but, if the scene is brightly illuminated (say, by a summer sun), while the

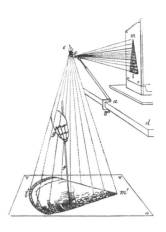

drawing board is shaded, the pencil and paper will be hard to see.[25] The real function of the viewing aperture was to balance the light levels between the subject and the paper. This is part of why Basil Hall suggested dis-pensing with it. As the artist narrowed in on a component of the scene that was darker or lighter, it was possible to shift the eye slightly to regulate what percentage of the light from the prism was admitted. Some *cameras* were fitted with chromatic filters, partially to translate the colorful display of nature into monochrome (as in a Claude Lorrain glass), and partially to cut down on glare. Users cautioned that transient shadows would suddenly cause the pencil to disappear: "you know that there is no drawing with the Camera Lucida with a bonnet on, and even when that is removed it is needful to hold up the hair away from the forehead;"[26] and "parts of the head-dress in particular are sometimes unsuspected obstruc-tions, and the brim of the hat the most formidable of all."[27] Another common problem was not having the drawing board firmly positioned. If the board were to be displaced, returning everything to the same alignment was virtually impossible, and the drawing consequently was confused. One enthusiastic user helpfully suggested a stabilizer: "in order to prevent the slight motion of the head, which is apt to take place, the olfactory organ may be delicately placed in contact with the brass adjusting screw of the prism."[28]

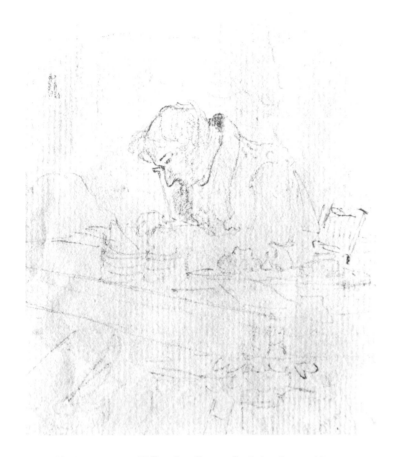

the conclusion, that its use required a previous knowl-edge of drawing, which unfortunately I did not possess." After recalling his earlier use of the *camera obscura,* Talbot was led "to reflect on the inimitable beauty of the pictures of nature's painting which the glass lens of the Camera throws upon the paper in its focus -- fairy pictures, creations of a moment, and destined as rapidly to fade away. It was during these thoughts that the idea occurred to me...how charming it would be if it were

Regardless of other circumstances, the eye had to be situated right above the prism; consequently, the image of nature in the prism was always the same size. Yet the *camera lucida* was capable of various magnifications. The stem supporting the prism was telescoping, and thus the prism could be brought closer or farther away from the drawing board (a typical distance was about ten inches). If the tube were extended, the board was forced farther away and thus appeared smaller in relation to the fixed size of nature in the prism. Nature was then relatively larger, giving a telephoto effect. If the prism were brought in very close, a much grander slice of nature was fit into the confines of the drawing paper. Wollaston claimed an angle of view of 70° to 80° was possible, but in practice incorporating this much involved constant shifting of the eye and was consequently very difficult. Some artists, Herschel included, solved this problem by mounting their drawing table on a pivot and making successive sketches to build up a panorama.[29] Many *cameras* had markings on the tube to variously indicate optimum distances for copying, portraits, and landscapes.

The prism of the *camera lucida* did not need to be focussed. But the artist's eye did. It was presented simultaneously with an image of an object (often at a great distance) and the image of the drawing board just inches away. Adjusting the eye to this disparity could lead quite rapidly to eyestrain, so most Wollaston style *cameras* were fitted with lenses to compensate for the differences in distance between nature and the paper. These lenses, of course, introduced distortions, and ultimately persuaded Herschel to switch to an improved form of *camera lucida*.

"I have skimmed the cream of my days already.... My heart dies within me"

<div align="right">John Herschel, 1816 [30]</div>

John Herschel's meteoric rise during his youth led to a premature sense of failure and disillusionment. He had achieved the highest honours in getting his BA from St. John's College, Cambridge in 1813, and was "dismissed with a flaming compliment" after the grueling examinations. Within months he was elected a Fellow of The Royal Society. Herschel had already achieved more as a student than many men would expect in a whole lifetime, but the young genius was still immature in many respects, and his youthful vision had yet to extend sufficiently far into the future. He was greatly troubled and, for a period of five years, floundered with no sense of direction. Part of the difficulty was his mundane need to earn a living. His father imagined, probably unwisely, that a man of the

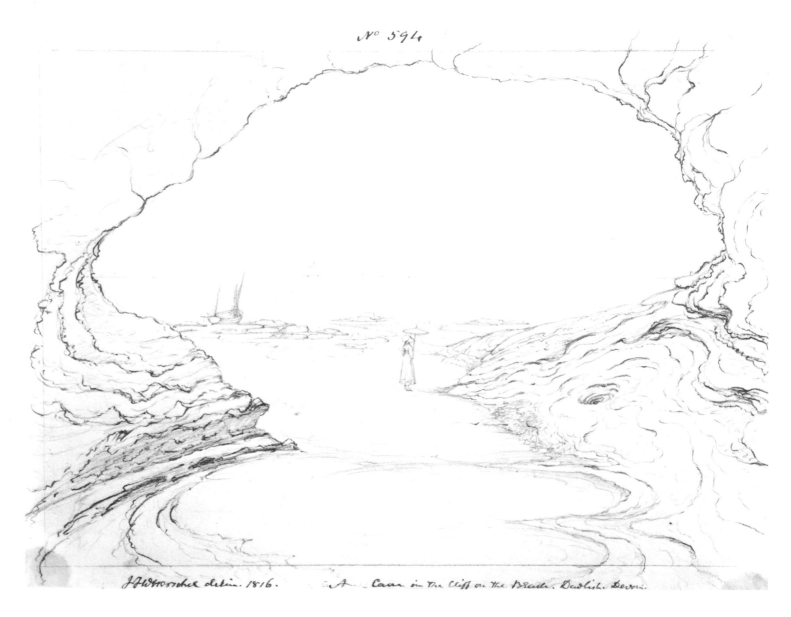

FIGURE 12. John Herschel, *A cave in the cliff on the beach, Dawlish, Devon*. Pencil *camera lucida* drawing, monogrammed on verso, August, 1816. 18.6 x 25.7 cm. The ethereal (but still realistic) nature of the strokes and the unconscious extension of the lines past the reference frame are characteristic of productions of a neophyte *camera lucida* user. It was possibly during his stay at Sir William Watson's house in Dawlish in the summer of 1816 that Herschel first took up the *camera lucida*. Other drawings made during this visit imply that he was experimenting with various optical instruments, probably with his host, who was an accomplished draftsman. In any case, this is the earliest Herschel *camera lucida* drawing known. No. 594, Graham Nash Collection.

cloth would have free time for philosophical pursuits. John elected instead to enter the profession of law, and in 1814 he enrolled as a student at Lincoln's Inn.

Though his legal studies continued for but a year, even this brief stint in London was to have a profound effect: it would prove, in fact, to be "the turning-point of his scientific career...for it was in London that he made his acquaintance with Wollaston [who] completely fascinated him by the breadth and accuracy of his scientific pursuits, and fostered, if not awakened, in him that dormant taste for Chemistry and general Physics which wanted but the magic touch of such a mind, to kindle into the intellectual passion of a life."[31] Wollaston, the inventor of the *camera lucida,* certainly contributed to changing John Herschel's direction in life, but the young man was still to face much uncertainty.

Returning to Cambridge, this time as a tutor, Herschel soon found formal teaching hopelessly unsatisfying. When he had been a student there in 1813, and was still fired with excitement about the new mathematics that he was helping to forge, he exclaimed to his fellow student and close friend, Charles Babbage, "how ardently I wish I had ten lives, or that capacity, that enviable capacity of husbanding every atom of time, which some possess, and which enables them to do ten times as much in one life."[32] In stark contrast, in the summer of 1816, he was seeking Babbage's help in finding any alternative to university life: "I hear you have been writing papers for this new journal of the Royal Institution. Who are the Editors of it? Will they pay one for writing? or do you know any body that will? I should like to get to write articles for some of these Encyclopaedias if I could which are on the tapis at present, or employed by some newspaper Editor to cry down the prince, or by some lottery office keeper or Quack Doctor to write for or lastly to indict hymns for a Methodist meeting. If you know of anything of this sort write me word. In a word I want to get money <u>and reputation at the same time</u>, and to give up cramming pupils, which is a bore & does one no credit but very much to the contrary."[33]

John Herschel's transformation, begun by Wollaston in London in 1814, gained momentum at his father's home in Slough two years later. William Herschel, now approaching his 80th year, could no longer take an active role in astronomical observation. The elder astronomer had opened up so many new worlds he could never explore himself that it was natural for him to hope his son would carry on his work. Filial affection was quite strong in the younger Herschel, and during a visit to his father's old friend, Sir William Watson, John finally consented to his father's entreaties. Astronomy had not yet become a compelling attraction for him; in resignation, he wrote to Babbage that "I am going, under my Father's directions, to take up the series of his observations where he has left them." This was a course that appeared to hold little hope for him. "I shall go to Cambridge on Monday where I mean to stay but just time enough to pack up my books and bid a long -- perhaps a last farewell to the University...which I can never look back to without a full conviction that there is nothing better in store for me and that whatever may hereafter become of me, about which I care very little, I have skimmed the cream of my days already. I always used to abuse Cambridge as you well know with very little mercy or measure, but upon my soul, now I am about to leave it, my heart dies within me."[34]

It seems likely that during the same visit to Sir William Watson's in Devonshire that decided his future, Herschel also took up the *camera lucida.* Apparently anticipating a dull stay, he had told Babbage in advance that he planned "to take my book or at least my pen ink & paper with me and write all the time."[35] During this fortnight, however, it seems that he employed the draftsman's pencil more than writer's ink. Watson (about whom too little is presently known) was an accomplished draftsman himself. Was it from him, or was it from Wollaston two years earlier, that John Herschel got his introduction to the *camera lucida?* Two of Herschel's drawings done at Dawlish during this visit reveal traces of the employment of optical aids. One drawing is ruled on the verso in a grid, indicating a likely transfer employing a *camera obscura.* The other (while not specifically labelled as such) exhibits unmistakable signs of having been made with a *camera lucida*; it is the earliest known Herschel *camera lucida* drawing, and signals the appeal of direct observation that was beginning to take hold of him.

During these soul-searching years at Slough, John Herschel underwent a radical change in philosophy. He had been a theoretician, and a brilliant one at that, in his days at Cambridge. The abstract appeal of Aristotelian logic began to give way to facts based on actually studying the world. Undoubtedly the close association with his father in astronomical observation contributed to this shift; Wollaston's chemical experiments may have as well. In fact, by the time John Herschel would publish his highly influential *Preliminary Discourse* in 1830, he had become positively disparaging of any other approach: "among the Greek philosophers...we are struck with the remarkable contrast between their powers of acute and subtle disputation, their extraordinary success in abstract reasoning, and their intimate familiarity with subjects purely intellectual, on the one hand; and, on the other, with their loose and careless consideration of external nature, their grossly illogical deductions of principles of sweeping generality from few and ill-observed facts, in some cases; and their reckless assumption of abstract principles having no foundation but in their own imaginations, in others; mere forms of words, with nothing corresponding to them in nature.... In this war of words the study of nature was neglected, and an humble and patient enquiry after facts altogether despised, as unworthy of the high *priori* ground a true philosopher ought to take. It was the radical error of the Greek philosophy to imagine that the same method which proved so eminently successful in mathematical, would be equally so in physical enquiries, and that, by setting out from a few simple and almost self-evident notions, or *axioms,* everything could be reasoned out."[36]

The young John Herschel, in common with many of his contemporaries, found a new spiritual leader in his "immortal countryman," Francis Bacon. Baconian inductive reasoning came to direct his research and his life. Herschel's research was propelled by a firm belief that to "ascertain what is the course of law of nature under any proposed general contingency, the first step is to accumulate a sufficient quantity of well ascertained facts, or recorded instances, bearing on the point in question. Common sense dictates this, as affording us the means of examining the same subject in several points of view."[37] The world of nature -- the inescapable truth of nature --

emerged as his intellectual quest. In this context, the *camera lucida*, the undistorting prism of Dr. Wollaston, became John Herschel's third eye. Excitement returned to his spirits: "I have not been very mathematical of late. Chemistry & optics have taken up my time."[38] It is not surprising that John Herschel's interest in optics grew when he came under the combined influence of his own father and Wollaston, both innovative opticians and researchers in physical optics. "By the bye what a beautiful toy [the] Kaleidoscope is.... If the sun will only shine this summer, I shall enter with all the means I can command into the field of physical optics."[39] Experimental chemistry simultaneously became a major interest. In 1819 Herschel published his observations on the properties of hyposulphurous acid; twenty years later this would emerge as the fixer 'hypo,' so crucial to the invention of photography, and still in use today.[40] Herschel's new spirits were so infectious that Babbage found that just a "visit to Slough...has contributed to revive my Chemico-mania." In fact, Babbage (who would lay the foundations for the modern computer), would never become much of a chemist, but at this point he and Herschel shared interests. "I hope in the course of a few weeks to be able to introduce you to a clean laboratory... where no provoking acids spoil mineralogical reputations by dissolving lime where theory requires it to be alumina."[41]

Geology, mineralogy, and chemistry were so closely inter-related at this time that they were almost one discipline, and it is not surprising that Herschel's interest in chemistry led him into mineralogy and finally into geology. John's mentor Wollaston was a pioneer in this field. It should be recalled that the invention of the *camera lucida* was prompted by one of Wollaston's geological jaunts. By 1820, Herschel told Babbage he was looking forward to yet another return visit to Sir William Watson's in Devonshire. "I shall eke out the time and test the temper of my new mineralogical hammer on the crags of Ilfracomb.... I am as innocent as the unbegotten babe of any tincture of Geology. Do you know of any geological work of moderate (ie. portable) magnitude by which one can study the rocks by the wayside...? When our Cornish expedition is done (if we do not break our necks by the way) I have a plan...for making a trajectory

from St. David's to Hereford & then fairly cutting across Ireland to the Lake of Killarney. If this does not satiate my wandering propensities there is no remedy but a tooth & nail attack on the Giants Causeway."[42]

This was a happy affliction of wanderlust. "I have been chemurising or perhaps I should say preparing to chemurise a good deal. Indeed I have done little else, except roam the country on horseback, which I generally do five or 6 hours per diem. This morning I visited a very strange old place...which remains in the same state almost precisely in which it was in the reign of H[y] VI. It has rather excited (or revived) a dormant taste for antiquarian knowledge in my chaos of a brain."[43]

The elements were all in place to prepare John Herschel for his first *Grand Tour*. Ironically, for an expedition that was to turn out so splendidly, the stimulus was tragic. An exceptionally sensitive soul, John Herschel suffered the first of two broken hearts when approaching the age of 30. His engagement to be married was broken off. In the throes of a remorse that would soon be parlayed into joy, he and Charles Babbage set out on their first Grand Tour.

"I should imagine it must fall to the lot of very few to traverse... under circumstances so favourable to the development of poetical & picturesque beauties"

JOHN HERSCHEL, FROM CHAMOUNI, 1821 [44]

The Grand Tour, so essential a component of a gentleman's education in the 17th and 18th centuries, had certainly descended to a less noble status by the beginning of the 19th. Tales of the young men of Britain 'breaking loose' on the continent abound; for the majority of them (at least in intellectual terms), such a trip was a waste. It would be premature to announce the death of the Grand Tour, however, or to dismiss its siren song lightly. During Herschel's day, along with the uncertain but gradual easing of warlike tensions, the type of traveller began to change. The great collectors, antiquarians, and gentlemen of culture, the Lord Elgins and Arundels, were beginning to be replaced by a new class:

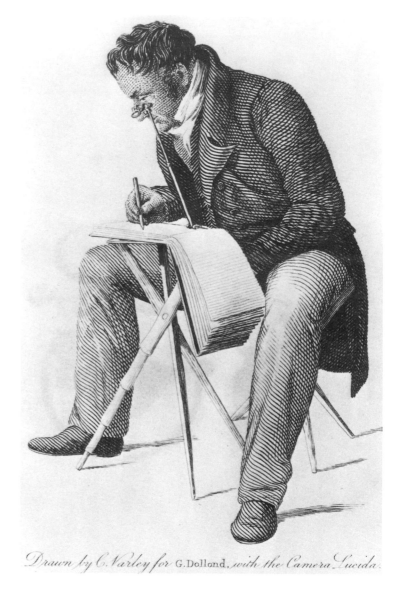

Drawn by C. Varley for G. Dolland, with the Camera Lucida.

FIGURE 13. Cornelius Varley, *Artist sketching with a Wollaston style camera lucida*. The collapsing trip table and stool were sold as useful accessories for Dolland's *camera lucida* outfits. The instrument was normally furnished with a base clamp to attach it to a drawing board. Once the sketch was started, it was important that the instrument and the paper were not moved out of alignment; otherwise, the drawing would become confused. Frontispiece for George Dolland's *Description of the Camera Lucida* (London, 1830). Photography Collection, the Humanities Research Center, The University of Texas at Austin.

writers, painters, and poets, the Shelleys, Byrons, and Goethes, who embarked on rambles of personal discovery.

Herschel set out, not only to see the world, but to size it up, measure it, and to understand it. With the clear mandate of Francis Bacon ringing in his ears, he sought to contribute as many basic facts as possible to the store of human knowledge. Arriving in France in the summer of 1821, Herschel started a detailed notebook. In it, he listed his philosophical travelling kit (which he was pleased to see pass through customs duty free):[45]

A mountain Barometer
A small chest of Chemical apparatus
A Tennant's Blowpipe with the usual appendages
A Pocket Compass
A Small Pocket Sextant
A Good Thermometer
A large & small Mineralogical hammer
A reflecting Goniometer
A Camera Lucida, Drawing board & other apparatus for drawing with various other useful apparatus

Travelling with Charles Babbage and two other friends, he determined a "most convenient & expeditious mode of travelling on the Continent. You buy a carriage at the beginning of your journey & sell it at the end (at a loss, of course)."[46] Herschel's 1821 diary is liberally sprinkled with references to his using the *camera lucida*, taking views at every turn in much the same way that a photographer might today. If 1816 had been, in fact, the first year he had worked with the instrument, he had certainly mastered it completely by the time of his 1821 journey.

Herschel the poet, Herschel the scientist, and Herschel the artist were all stimulated in the best tradition of the Grand Tour. To his uncle, James Gordon, who had preceded him, John Herschel enthused that "every waterfall was swelled to a torrent.... The summits of all the higher mountains and even the outskirts of Mont Blanc, white with new fallen snow, which has been more abundant in this than perhaps in any former season, -- and over all, a cloudless sky and a gentle breeze like the breath of paradise. Did you see the fall of Chede, or did you see it with a double rainbow. In this state it is one of the finest spectacles in nature, a thing of which till I saw it I could not have formed the most distant conception."[47]

Though John Herschel would be troubled with indifferent health through much of his life, especially in later years, he was still in the full vigor of youth and in fine condition on this journey. In detailed letters, he kept his family informed of the progress: "we proceeded the first day 35 miles on mules up the Valley of St Nicolai one of the most magnificent pieces of Alpine Scenery it is possible to conceive, by a road your nerves would have agreed very ill with." Assailing what he thought was Mount Rosa (it later turned out to be Breithorn), Herschel sought to go where no Englishman had preceded him: "after 5 hours hard walking knee deep in snow, we reached the ridge of the mountain and looked over the precipice at least 9000 feet in the valley of Zermatt whence we came. The highest crest of the mountain now only remained to climb. It was tremendous, being literally a sharp edge of snow along which a cat might have walked. Our four guides from Zermatt here refused to go a step further, only Coutet & an old man whom we had engaged at Breil would proceed."[48]

Herschel and his party coursed through France, Switzerland, and Northern Italy, mixing in scientific experiments with appreciation of the range of nature's mysteries. He broadened his personal contacts as well. In Paris, Geneva, and all other centers of activity, the Herschel family name gave him a ready reception in scientific and cultural circles, though John Herschel's agile mind and generous character insured that he was soon accepted on his own merits. So impressed were most savants on meeting him that the connections made on this and subsequent journeys were to serve Herschel throughout his professional life.

In 1822, Herschel travelled with an old friend, the lawyer James Grahame, through Belgium and Holland. Having thoroughly tested his *camera lucida* on nature in the Alps, he now turned it on architecture. Architectural renderings (which he did quite well) might have become an even larger component of Herschel's portfolios as a result of travelling through the visually rich cities of Belgium. But this journey was tragically cut short by news of the death of William Herschel. Although William had enjoyed a long and productive life, he and his son had drawn closer together in later years, and his death was understandably an enormous personal loss for John Herschel. But John's financial position was now assured and his philosophical mandate was clear. Forever banished was the feeling of uncertainty that had plagued him. A year before, when the possibility of a prestigious teaching post had been offered, Herschel had looked back on his days at Cambridge and observed that "a larger world & more varied scene are necessary for my happiness, & as far as mere science is concerned, I had rather pass my days among those who are advancing eagerly & rapidly & running a race with ardour, than in goading up hill the sluggish paces of any established institution under the Sun."[49] In what must have been a great source of satisfaction to them both, William had lived to see John embrace a way of life in science that had brought contentment.

A decade later in his *Preliminary Discourse*, John Herschel affirmed this inner tranquility: "and this is, in fact, one of the great sources of delight which the study of natural science imparts to its votaries. A mind which has once imbibed a taste for scientific enquiry, and has learnt the habit of applying its principles readily to the cases which occur, has within itself an inexhaustible source of pure and exciting contemplations: -- one would think that Shakspeare [sic] had such a mind in view when he describes a contemplative man as finding 'Tongues in trees -- books in the running brooks -- Sermons in stones -- and good in every thing.' Accustomed to trace the operation of general causes, and the exemplification of general laws, in circumstances where the uninformed and unenquiring eye perceives neither novelty nor beauty, he walks in the midst of wonders: every object which falls in his way elucidates some principle, affords some instruction, and impresses him with a sense of harmony and order.... A thousand questions are continually arising in his mind, a thousand subjects of enquiry presenting themselves, which keep his faculties in constant exercise, and his thoughts perpetually on the wing, so that lassitude is excluded from his life.... It is not one of the least advantages of these pursuits...that they are altogether independent of external circumstances, and are to be enjoyed in every situation in which a man can be placed in life.... They may be enjoyed, too, in the intervals of the most active business; and the calm and

dispassionate interest with which they fill the mind renders them a most delightful retreat from the agitations and dissensions of the world, and from the conflict of passions, prejudices, and interests in which the man of business finds himself continually involved." [50]

While John Herschel was now comfortably ensconced in the temple of science, the fates had one more test in store for him. His closest friend, travelling companion, and scientific colleague, Charles Babbage, had married, and married well. Perhaps as a wedding present, Herschel had transformed some of the *camera lucida* sketches from their 1821 journey into highly finished presentation drawings for Georgiana Babbage. The young family shared their joy with John and even named their first child after him. Faced with this image of marital happiness, John's own personal life seemed one of loneliness. His second attempt at a marriage proposal, to the daughter of his mother's solicitor, went tragically wrong. Months of distasteful negotiations with the family ensued, nearly bringing Herschel to the brink of a duel. Another continental trip, this time with only a servant, was to be the cure for his second broken heart.

"I have bagged vulcanos this season as other men bag partridges"

JOHN HERSCHEL, 1824 [51]

After a brief spate of scientific reunions in Paris in April 1824, Herschel set out for Italy. Thoughts of his troubles at home were soon crowded out by new experiences. From Turin, he reported to Babbage that "this is the most delicious spot on earth as you would say if you saw it in such weather & were enjoying here the luxury of repose, good feeding, & pleasant society after crossing Mt. Cenis in the snow and being at once scorched & frozen & buried alive. It was abominable, & the worst thing I ever met with at any time. I was such a child to as to double the miseries of it by getting into a sleigh at the top and sliding down by the force of gravity.... The rogue...who took me down...proceeded cautiously...for as it was starlight, I had regard enough for my neck not to let him turn the short corners of the precipices at full speed.... Next morning I rode up the old

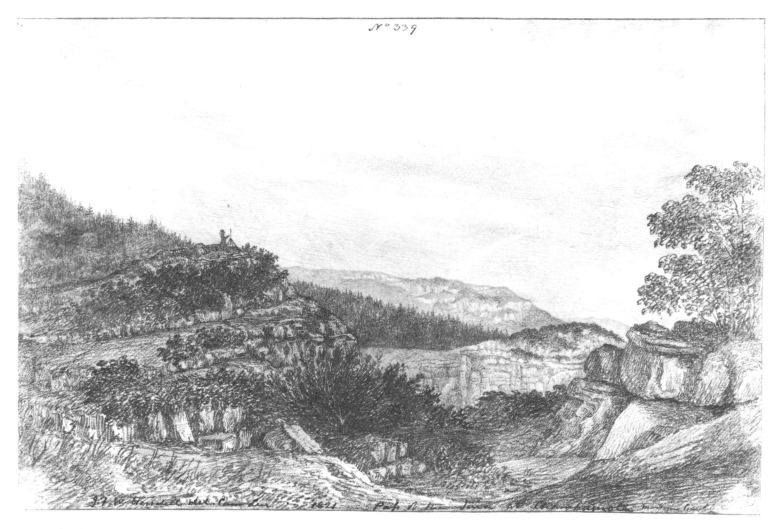

FIGURE 14. John Herschel, *Pass of the Jura at Champagnole Montagne Cornice.* Pencil *camera lucida* drawing, August 1821 or 1824? 19.9 x 29.9 cm. The *camera lucida* was only one of a battery of 'philosophical instruments' that Herschel travelled with. The device the explorer is using is an *actinometer,* an instrument of Herschel's invention which he is believed to have first built in 1824. Since the figure is rendered quite crudely, it is possible that it was added to an 1821 drawing at a later date (perhaps by one of his children). Herschel's *actinometer,* which measured the heating effect of solar radiation on a given area, was supposedly inspired by his contemplation of a severe sunburn Babbage received on a mountaintop. Being most effective above the filtering influence of the atmosphere, the *actinometer* fit in well with Herschel's mountain jaunts. No. 339, Graham Nash Collection.

road on mule back in the snow and when I saw by daylight the places we had shot down the night before I could not help shuddering. There was a kind of bridge in one place just wide enough for the sleigh to pass over a ravine of great depth.... I had remarked that he had dashed over this with great velocity (indeed it was impossible to do otherwise, for the descent to the spot was at an angle of at least 30 or 40°) and in spite of all I could say passed within a few inches of the edge, when the consequence of a slip would have been certain suffocation in a gulph of snow." [52]

Strangely, Italy had not appealed to Herschel when he had visited in 1821. But it wove its magic on him this time as it has done for so many over the years. By the beginning of May, hardly a month after leaving his

broken romance behind in England, he had cleared his spirits. Writing from Florence to his confidant, James Grahame, Herschel was able to say that "my mind is tranquil & I have fully succeeded in combating the recollection of past events. Indeed I have been so fully occupied with the present, as to leave little room for their intrusion -- for this purpose there is no recipe like travelling. I was mistaken in my impressions of Italy & ye Italian Character. I now see much to approve in it. I find them kind, open, & friendly, & natural."[53]

Herschel's *camera lucida* was kept busy again. If we are to judge by the quantity of surviving drawings, this journey may be considered the peak of his production with the instrument. The *camera lucida* had already served Herschel well and would continue to do so. His drawings from 1821 and earlier generally emphasized pictorial values. By the time of this 1824 expedition (all the while maintaining this high pictorial standard), Herschel began to introduce additional detail to meet specific

FIGURE 15. *Amici style camera lucida.* 5 x 4 cm. Giovan Amici introduced several variations on Wollaston design. In spite of their superiority, Amici's cameras were never very common, possibly because of manufacturing complexities and because of their increased size and weight. Figure 4, *Annales de Chimie et de Physique,* 1823. The Peabody Library, Baltimore.

scientific interests. At the same time, he became more willing to sketch selectively, sometimes concentrating the detail in areas of interest and only briefly suggesting the surround. Its testimony would soon help him grasp one of the fundamental scientific controversies of his day, the formation of the earth.

It is also likely that in the course of his 1824 trip Herschel was introduced to a new form of the *camera* that was superior for his purposes. He wrote to his mother that "I passed two days at Modena in very interesting company -- that of M. Amici, a man of sound science and an artist of the very first class. I mean an artist who works for the sake of science and with whom (as I can speak from my own knowledge) profit is a secondary consideration."[54] Herschel referred to Giovanni Battista Amici as an *artist* in the time-honoured sense of the word, more closely allied to our present term of *artisan*. Amici was one of the finest opticians of Europe, and an accomplished *camera lucida* sketcher as well. While using Wollaston's instrument, he had begun to consider possible improvements. The major drawback to Wollaston's design was that the image was seen through one medium (the glass of the prism) and the paper was seen through another (air). The eye had to fuse these two disparate images by careful placement right on the edge of the prism. In 1819, Amici announced several versions of a new design that circumvented this problem.[55] A triangular prism was cemented to a plate of glass that had perfectly parallel surfaces. The eye actually looked through this glass to see both the paper and the reflected image of nature. A broad slit kept the eye in alignment. As Sir David Brewster explained, "In using the ingenious *camera lucida,* invented by Dr. Wollaston...a practical difficulty has been experienced arising from the alternate appearance and disappearance of the point of the pencil by which the outline is traced...so that, by a slight motion of the eye, the pencil, or the ray, is seen indistinctly, according as the part of the pupil by which they are viewed becomes greater or smaller. [In Amici's design] as both the pencil and the rays are seen with the whole pupil, the object may be drawn with the greatest facility."[56]

Still, Amici's *camera lucida* was very difficult to

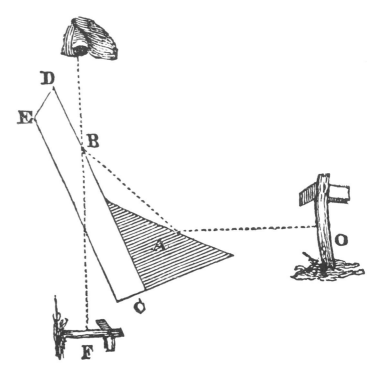

FIGURE 16. *Principle of the Amici camera lucida.* In Amici's design, the prism was mounted on a flat sheet of glass, which the eye looked through. In contrast to Wollaston's design (*Figure 8*), both the image of nature and the drawing paper were seen through the same medium, obviating many difficulties. *Magazine of Science,* 25 January 1840. Photography Collection, the Humanities Research Center, The University of Texas at Austin

manufacture; also, while still a compact instrument, its head was substantially larger and heavier than Wollaston's, a disadvantage for the traveller. Yet Herschel came to favor Amici's pattern, having most likely been introduced to it at the optician's home. When Amici visited London in 1827, Herschel insisted that "you must take up your residence at our house...if you are obliged to be in a hurry, you can easily reach London in two hours & a half or 3 hours from hence. The weather is I fear going to prove decidedly bad, so we shall have no astronomy. I sent your Camera Lucida by Mr. Lunn which I hope you got safe. The glass was broken when it was left at my home in Devonshire Street."[57]

Herschel's 1824 tour was directed by two major scientific enquiries, one of which was very much of his own making. He had devised an instrument for measuring

solar radiation, the *actinometer,* and was anxious to amass a body of readings with it. The *actinometer* was most effective at elevated altitudes, above the filtering influence of the atmosphere, but this fit in well with his primary goal. Herschel, like many of his contemporaries, was gripped by the swirling controversies about geology that were coming to a head. In one camp were the followers of Abraham Gottlob Werner, who is considered the father of modern geology. At the most basic level, the Wernerians believed that the earth had once been covered with water and that various types of rocks had been deposited from the sediment of these oceans. Volcanos, and the products of them, were seen as merely localized phenomena. Needless to say, some disciples introduced religious interpretations involving the Deluge. Werner's was a very static view of the planet earth, but one which was widely held, and its theories and observations contained many valuable components. In the opposite camp were the followers of the Scotsman, James Hutton. Inspired in 1772 by a chance observation of the roof of a salt mine, he had formulated a very different explanation from Werner's. Hutton's influential *Theory of the Earth,* published in 1795, postulated a world that was in a constant and repetitive pattern of change. Volcanos threw diverse matter out of the core, and erosion wore this matter down and eventually put much of it into the sea. For Hutton and his followers, the major forces that shaped the earth were still going on, and would continue to do so, on a time scale that would elude man's imagination.

In the best Baconian tradition, Herschel was determined to settle this question for himself by a direct appeal to nature. This quest led him to some of the most difficult terrain he had yet travelled. From the crater of Vesuvius he related to his mother that "as there is no possibility of descending to the bottom, or even ever so small a distance down the sides, I could not ascertain its depth.... I ascended to the highest peak called the Palo -- this point looks down on the valley -- ...and after witnessing M. Covelli's experiments, taking a drawing of the Crater with the Camera Lucida...descended at a full gallop, among the craters." [58] Sicily proved to be the biggest challenge and was perhaps the most richly rewarding. At 1:30 in the morning, under a brilliant starlit sky on the volcanic peak of Mount Etna, he wrote to Babbage "very comfortably

from Gemellaro's hut on the top of Etna with my guide snoring in his adjoining room and a formidable apparition of instruments and eatables besides me. I brought up a bed but it is full of fleas and as there is no mat to be had and the night is beautiful I shall divide my time till day light between my instruments & my friends." [59]

With strong convictions on this trip, and certainly by the time of a return journey in 1826, Herschel felt confident that he had grasped the underlying formative processes of the earth. He wrote to Babbage that "the Vulcanos in this country are superb. Today I walked up the Coupe (Crater) of Aisa or Ayzac which is close by Entraigues and from which has issued most evidently all the Basaltic Lava...filled the whole of a granite valley up to a given level -- and this valley has been again scooped; certainly not by Diluvian (i.e. violent & sudden causes) but by the slow action of causes now in operation. My ramble this Summer has made me an ultra-Huttonian.... I have bagged vulcanos this season as other men bag partridges...." [60] Indeed, in an 1866 essay, Sir John Herschel could claim that "though I have never been so fortunate as to have seen a volcano in eruption, or to have been shaken out of my bed by an earthquake, still I have climbed the cones of Vesuvius and Etna, hammer in hand and barometer on back, and have wandered over and geologized among...nearly all the principal scenes of extinct volcanic activity in Europe." [61]

Geology was not the only enterprise that filled Herschel's mind on his 1824 trip. The *camera lucida* was constantly busy. "At Puzzuoli I ran over the ruins and dispatched my Cicerone as soon as decency would permit, and took to my drawing board, for the spot is beautiful." [62] Sir William Watson had charged him with stories of the ancients. To his mother, Herschel observed that "Girgente is a most curious place & full of ruins the Rocks being all honeycombed with houses &c and the Temples superb. I have crammed my drawing cases with views of them." [63] To Watson, his father's old friend, he expressed deeper feelings: "In such melancholy solitudes are ye principal remains of Sicilian antiquity situated -- from the noble remains of ye Temple at Segestum, not a cottage can be discerned & hardly a tree or anything green. It stands surrounded with dry thistles in ye bosom

of a lofty hill -- on an opposite mountain is an amphitheatre, while the plain between, where once stood a flourishing city, seems as if the voices of man had never been heard there. The Gigantic ruins of Selinunte in like manner, lie in a dreary solitude, infested by the Malaria, by ye sea side. A passing sail in ye offing now & then reminds one that there is a world without, full of life & activity, which else one might forget in the dreams of other times -- & in the dead silence of the scene. Their ruins are indeed stupendous.... The ruins of ancient Agrigentum too stand now far aloof from the modern town w^h has retreated from ye pestilential influence of ye air to ye summit of a hill 2 or 3 miles off. It is incredible what an awful air this circumstance gives them. One must be on ye spot to feel its full effect. It seems as if they were preserved as monuments of wrath -- as if the curse which devastated still clove to them & caused them to be at once admired & shunned. It is indeed the beauty of desolation, for finer architectural remains can hardly be imagined." [64]

"Travelling, in the way I travel, is a real intellectual luxury -- it is eating little & often -- a continued feast"

JOHN HERSCHEL, 1824 [65]

While faced with an increasingly complicated life, Herschel would persist in his travels. He would never find the opportunity to return to Sicily, but it had provided a very full experience for him. His immediate reaction to Babbage also stressed just how difficult it had been: "I have now made the tour of Sicily and I thank heaven it is done. If it be pleasure to ride from 30 to 50 miles a day over roads all but impracticable for mules, under a scorching sun with the thermometer at 86 and over wilds & wastes where no verdure is to been seen, but groups of Cactus & hedge-rows of majestic Aloes from 20 to 30 feet high to break the monotony -- to be broiled all day and at night to be eaten -- to sketch ruins in the Sirocco & with the fear of mal-aria before one's eyes -- if this be pleasure, there is no doubt that I have been in Elysium for the last three weeks. But it is worth taking some pains & undergoing some hardships to have seen this curious & most interesting Country. I wish I had only been a month earlier -- & had more time at my disposal." [66]

VIEW OF EARTH-PILLARS OF RITTEN, ON THE FINSTERBACH, NEAR BOTZEN, TYROL.

(From the original Sketch of Sir John F. W. Herschel, taken with the Camera Lucida September 11, 1821.) See p. 330.

FIGURE 17. John Herschel, *View of Earth-Pillars of Ritten, on the Finsterbach, near Botzen, Tyrol*. Woodcut from a *camera lucida* sketch of 11 September 1824. 8.6 x 16.2 cm. These extraordinary natural formations were damaged by an earthquake in 1855; ten years later, Sir Charles Lyell wrote to Herschel, asking permission to use his *camera lucida* drawing as an illustration, and saying that "I could get no good photograph of these, and no engravings in the least degree comparable to your drawings." Plate from Lyell's *Principles of Geology*, 11th edition (New York, 1877). The Peabody Library, Baltimore. The original sketch is No. 305, Graham Nash Collection (the 1824 date is confirmed by Herschel's notebook entry and by the watermark on the original sketch).

The traveller departed Italy for an intellectual ramble homewards through the patchwork of Tyrol and Bavaria. John Herschel would probably have been content to wander through a world that only he populated. He did, of course, meet many people in his journeys, but most of them, and civilization in general, he could have happily done without. His poetry, often written in the field (sometimes even in the borders of his *camera lucida* drawings) rings accords with that of Wordsworth, expressing the satisfaction of communing quietly with nature. From Palermo, he had written his mother that "night is delicious in Sicily at a distance from the towns -- but in them, or near them it is 'made hideous' by every possible annoyance. In the mountain villages every peasant has a half starved, half wild dog, and the incessant barking of these detestable curs throughout the whole night, is only surpassed by the braying of hundreds of mules answering each other from hill to hill, & from house to house. The mule is the Sicilian <u>nightingale</u>." [67] Like tourists before and since, he fell pray to various hosts, and his letters are sprinkled with comments on them. Herschel

kept good track of his expenses: in Naples, he noted that he stayed at "a good enough Inn -- more of an Inn than any at Naples -- but extravagantly dear." [68] Other times he felt he got even less value for his money. "The Swiss do not actually <u>rob</u> you -- & therefore <u>they escape hanging</u> -- but they defraud & fleece you without mercy & with perfect impunity." [69] "Here I made sketches, collected petrifactions (which abound) got wet through the most tremendous rain I was ever exposed to -- caught a live salamander, and was desperately cheated by one of the most good natured, fat, honest-looking souls that ever (for wise purposes) was permitted to appear in the shape of a German landlord." [70] Even scientific colleagues whom he met in his travels could be a burden. "I fell in at Clermont (where I climbed the Puy de Domes and observed my Actinometer <u>which is good</u> on its top) with a pack of French men who bored me to death." Herschel recalled his servant, James Child (a very good travelling companion) remarking: "Sir I wonders you takes all them these people up the hills with you. You & I could do much better by ourselves & nobody no wiser for it -- besides the expense on it Sir." Herschel had to admit that "this remark...is most true. I never <u>was</u> so bored in all my life as by a man Cuivier introduced me to, a regular <u>Imbecile</u>." [71] Herschel, the 18th century philosopher, would have opted for a solitary commune with mistress nature. But Herschel, the 19th century man of progress, could not help but take an interest in human endeavours. "Mapmaking seems the rage in all parts through which I have passed, and road-making (of which in this part of the world I am sure there is great need) and a pretty general spirit of improvement is abroad." [72]

By the time John Herschel arrived in Munich in September, thoughts of his failed romance had been entirely supplanted by nature and science. Whilst in Munich, he had a fateful meeting. He "fell in here with a very agreeable & gentlemanly man a Captain Feilding, who with his wife (Lady Elisabeth Feilding) & his son (a Cambridge man) and his two daughters have been residing here some time, after travelling about the Continent for a good while and residing first at one place & then at another." [73] The 'Cambridge man,' who apparently made only a slight impression on Herschel in this first meeting, was William Henry Fox Talbot. Within a short time the

two men would be sharing friends and scientific interests. Did Herschel show Henry Talbot his *camera lucida* drawings while in Munich? It seems likely. Fifteen years later, of course, Talbot would startle the world with his announcement of the invention of *photogenic drawing*, the first photographic process on paper -- prompted by his failure to master Wollaston's *camera lucida*.

After 1824, Herschel's continental visits would become less frequent and more rushed, although of no less importance to him. When he returned to England that autumn, he was elected Secretary of The Royal Society.

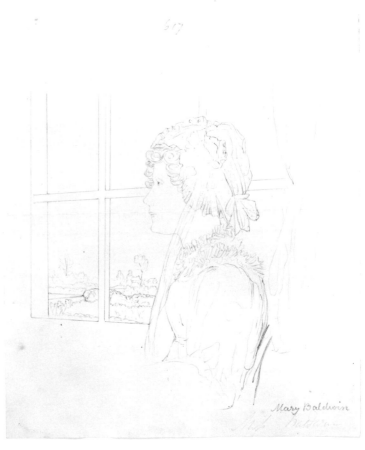

Mary Baldwin

FIGURE 18. John Herschel, *Miss Baldwin*. Pencil *camera lucida* drawing, ca. 1828. 22.9 x 18.8 cm. Herschel did very few portraits using the *camera lucida*. In this sketch of his cousin, Mary Baldwin, he employed a favorite theme of using a window as both a frame and a background. No. 617, Herschel Collection, the Humanities Research Center, The University of Texas at Austin.

FIGURE 19. John Herschel, *Sketch shewing the mode of proceeding in measuring the Lough Foyle Base*. Engraving from a *camera lucida* sketch made in September 1827. 22.5 x 27.5 cm. Just before Herschel's arrival in Ireland, a violent hurricane led to protecting the delicate trigonometric survey instruments with heavily anchored tents. Herschel and his companion, Charles Babbage, "expressed themselves much pleased" with the scientific procedures. Herschel, who must have surrendered his original *camera lucida* sketch to the engraver, later used the *camera lucida* to make a copy of the plate (No. 553, Graham Nash Collection). William Yolland, *Account of the Measurement of the Lough Foyle Base in Ireland* (London, 1847). Kresge Physical Science Library, Dartmouth College.

Within two years Herschel would become President of the Astronomical Society (later, the Royal Astronomical Society). These were tumultuous times within British scientific circles, however, and the political maneuverings and personal clashes repulsed the sensitive John Herschel. Responsibilities increased, and even a one-month journey to France in 1826, accompanied only by his loyal servant James Child, was a luxury and a relief. Gone were the leisurely months of continental wandering, but the *camera lucida* remained his companion. From Nîmes, he described to his mother: "the noble amphitheatre...of which though I staid here only the afternoon of one day...I had time (thanks to my Camera) to take two good views, an interior & an exterior, is really a superb thing."[74]

By 1827 there were increasing signs that Herschel had grown impatient with the machinations of the official scientific community, and he began to lay plans to withdraw. He would shortly confide in Charles Babbage

that he had "given up my residence in Town and shall in future reside only in Slough...I am perfectly sick of the life a <u>savant by profession</u> which leads to nothing but quarrels & misunderstandings in which every one's temper is soured and no ones real interests are advanced."[75] His departure was hastened by the overwhelming personal difficulties suffered by his longtime friend. First, one of Babbage's children died, and then his dear wife Georgiana, began to sicken. Herschel quietly made arrangements with Babbage's mother to support his friend in the inevitable collapse. In August, he promised her that he would apply the cure that had worked so well on himself: "immediately after the last melancholy rites are performed [I will] prevail on him to accompany me to some quiet corner where we may find occupation for his mind, or by changes of place and scene and such slight exertion as travelling renders necessary, detach it from dwelling on it."[76] As soon as Georgiana passed away, Herschel hustled Babbage off to Ireland for the month of September, taking *camera lucida* drawings of scientific activities and objects of interest along the way. Charles Babbage, a spirited and brilliant man, had been Herschel's closest friend. He would continue on alone for another year of travels, but he never recovered from his wife's death. Progress on his calculating machine -- his life obsession -- was disrupted in spite of Herschel's attempts to keep it going during the inventor's long absence, and Babbage's personality soured so much that their friendship slowly eroded.

John Herschel returned to Slough after a month in Ireland and formally announced his intention to resign as Secretary of The Royal Society. He had had enough. We might well speculate that the 1827 trip to Ireland, occasioned by his good friend's tragic loss, may have altered the course of the history of photography as well. Joseph Nicéphore Niépce was in England then, endeavouring to interest the scientific community in his invention of *heliographie,* the first form of photography. His entreaties, including those to members of The Royal Society, fell largely on deaf ears, and he returned in discouragement to France and died in obscurity. Had Herschel been in London that autumn, it is almost certain that he would have taken an active interest in Niépce's work. As Herschel's reaction to the introduction of photography

twelve years later would vividly demonstrate, however, while the new process was highly attractive to him as a scientific challenge, it certainly would not supplant his interest in *camera lucida* drawing.

"We go about sketching, reading, & hammering the hills, flute playing &c. &c."

JOHN HERSCHEL, ABOUT HIS NEW WIFE, 1829 [77]

Herschel's resignation as Secretary of The Royal Society in 1827 and as President of the Astronomical Society in 1829 freed him from the most onerous of his administrative and social burdens. His well-earned scientific reputation was secure, he had received many awards, and he had already published a number of his most elegant writings. The restlessness of earlier days was long since past, and to his old friend James Grahame, he revealed that "I would not wish a day of my life back but to use it better for I would not exchange the sober tranquility of my present state of mind for either the careless ignorant innocence of childhood -- or the romance of 18 -- or the tumult of passion at any age whatever. That is a conclusion worth arriving at at least."[78]

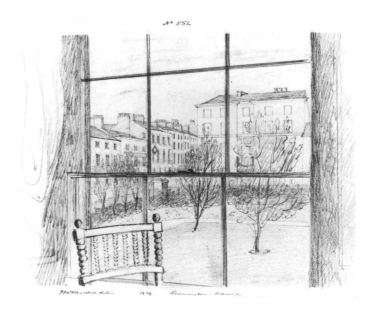

FIGURE 20. John Herschel, *View from Hotel Window, Leamington, Warwick*. Pencil *camera lucida* drawing, March 1829. 17.0 x 23.8 cm. Taken during his honeymoon with Maggie. No. 554, Graham Nash Collection.

FIGURE 21. John Herschel, *Fundamentals of the Wollaston versus the Amici Camera Lucida*. Detail of a rough pencil sketch, March 1829. Appearing on the verso of *figure 20*, it is likely that this impromptu sketch was made whilst John was explaining the drawing instruments to his new wife (who was herself an artist).

The only element missing from this otherwise rich life was someone intimate to share it with. Rapidly approaching the age of forty, the reclusive philosopher might easily have despaired of his situation. Grahame, with whom he had shared so many thoughts, again came to his rescue. An intellectual and a proud Scotsman, he knew exactly what type of woman his friend John Herschel needed. In a frankly engineered match, he brought Herschel into the circle of Emilia Calder Stewart, the widow of Dr. Alexander Stewart, a Gaelic scholar and a mathematician. The Stewart family was large and cheerful, and Grahame soon noted John's growing attachment for Margaret Brodie, the youngest and perhaps the most beautiful daughter. For a man like Herschel, her sweet countenance was only part of her beauty, for although she was only 19 years old, Maggie was a sympathetic soul who shared his intellectual interests. Mindful of his two disastrously failed earlier marriage proposals, Herschel was understandably cautious, but Grahame (a solicitor) continued to act as an enthusiastic counselor for both parties. In September 1828, Herschel met up with Grahame and "rowed with

him...by moonlight to Netley Abbey" to discuss his impending proposal to Margaret. The heavens, the source of so much of the Herschel family name, even conspired to help. The friends "passed an hour in a close & whispered confidence in the main aisle under the ash trees with the stars looking in above. An unearthly scene!"[79]

On the 3rd of March, 1829, John and Maggie were married. It was to prove a perfect and productive partnership, and an unending source of joy for both of them. Their honeymoon took them into Warwickshire, where they stayed in Leamington "at a most lovely place within a couple of miles of Warwick...in a marvelous Hotel."[80] It appears that it was in their hotel room that Maggie received her first tutelage in the use of a *camera lucida*. She was an accomplished painter (more so than what was routinely expected of young ladies in her day), but her drawing had been free-hand. On the back of the *camera lucida* drawing taken from their honeymoon window, there is the rough sketch John made while explaining the optical principle of Wollaston's invention. The productions of that instrument were to be shared by them throughout their lives.

After spending the spring in travels about England, Herschel seized the first opportunity to introduce his young wife to the Grand Tour. For two months they ranged through northern Europe. Margaret proved to be a fine and sturdy traveller, eager to share her husband's more adventurous side. He proudly boasted that they went "plunging through mud, stones, mountainous ruts & gulphs with a vortex of mud & water flying about on all sides it was like working thro' Chaos."[81] Maggie kept notes (and certainly must have painted) while her husband continued to sketch with his beloved *camera lucida*. John was absolutely thrilled by the richly varied life they had started to share. In an exuberant and joyous burst to his mother he exclaimed that "we go about sketching, reading, & hammering the hills, flute playing &c. &c." Geology, art, music, and, above all, intellectual fulfillment were there.[82] Maggie was usually by his side -- "Herschel took a lovely view of the ruin of the Drachenfalls" -- but she proved willing to defer to his interests -- "Herschel remained behind to sketch, & Johnny & I got

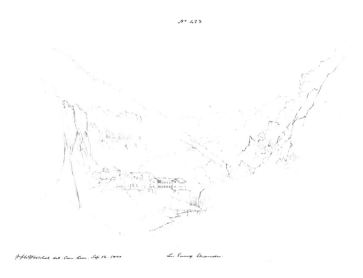

FIGURE 22. John Herschel, *Les Eaux Chaudes*. Pencil *camera lucida* drawing, 12 September 1850. 21.7 x 33.1 cm. Sir John was under enormous pressures as Master of the Mint during this period. Virtually all scientific and other pleasurable activities had to be suspended, and this trip to France with his family was one of the few breaks that he had. No. 423, Graham Nash Collection.

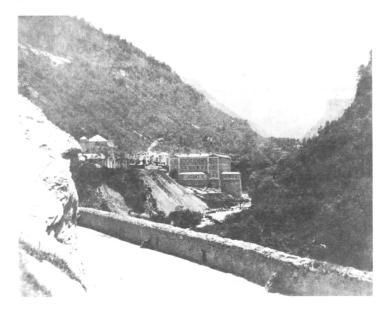

FIGURE 23. John Stewart, *Les Eaux Chaudes*. Salt print from a paper negative, September 1850? 19.7 x 23.4 cm. 'Johnny' had accompanied his older sister and her new husband, John Herschel, to the continent 21 years before. Herschel, his tutor in drawing, felt that Stewart drew well and "with practice from Nature will acquire 'freedom of hand' in abundance." When they travelled together in 1850, Herschel remained loyal to the *camera lucida*, while Stewart practiced the new art of photography. Graham Nash Collection.

on our beasts, & trudged homeward."[83] 'Johnny' was her fifteen year old brother, whom Herschel took under his artistic wing: "Johnnie & I are running a race which shall sketch most -- he draws very nicely & with practice from Nature will acquire 'freedom of hand' in abundance."[84] Within a few years, after photography had been made public, John Stewart would emerge as an exceptionally talented photographic artist, with both his technical skills and his pictorial sense shaped by contact with his brother-in-law. In fact, when the Herschels travelled with him through France in 1850, John Stewart took *calotypes* of some of the same scenes where John Herschel took *camera lucida* drawings.

In recognition of an already full life of scientific contribution, John Herschel was made Sir John Herschel in 1831. In 1838 he would receive his Baronetcy. The record of scientific achievement and awards continued throughout his life, and his beloved Margaret was an active partner and soulmate. The *camera lucida* remained a constant companion and a top priority as well.

The Table-cloth on the Table Mountain C.G.H. A North-wester coming on. Feldhausen, May 20, 1835.

FIGURE 25. Sir John Herschel, *The Table-cloth on the Table Mountain C.G.H. A North-wester coming on.* Engraving from a *camera lucida* sketch of 20 May 1835. 10.8 x 18.1 cm. Reproduced with Herschel's article on Meteorology for the *Encyclopaedia Britannica*, 8th edition, 1857. The Peabody Library, Baltimore.

Sir John Herschel took his family to the Cape of Good Hope for a four year period of astronomical observation. On reaching his new home on the 1st of February 1834, Herschel recorded in his diary that he was "occupied in unpacking, distributing, and arranging...till 11. Then took a camera sketch of the superb Mountains in front of our house, got out a table and under the Shade of the fir trees before the house, with a gentle breeze and splendid blue sky, passed an hour & a half or 2 hours in drawing with great enjoyment."[85] It was here that the Margaret and John undertook their most stunning cooperative venture with the *camera lucida*. "August 30, 1835. A splendid day. All the beautiful flowers coming out in such glory that M[t] & I in a pure rapture seized on them and neglecting all other duties & occupations set to work I outlining & she colouring them." This continued a practice Herschel himself had started at least as early as 1809. Nearly 100 of Herschel's exquisitely drawn *camera lucida* flowers, sensitively colored by Maggie, still remain with the Herschel family.

There is no portfolio of *camera lucida* sketches like that of Herschel's. His drawings combine meticulous draftsmanship, engaging subject matter, and a wealth of annotations that reveal the specifics of his use of the instrument. There is a sense of wonder and a sense of humour in them as well. The value of Herschel's drawings is further enhanced by the substantial body of documentary evidence that can be associated with them. As a resource for the study of the use of the *camera lucida* and understanding its effects, they have no equal. While a very few *camera lucida* artists could challenge Herschel in the production of line, no known artist approached his capacity to combine precise delineation of the form with equally precise production of tone. Only Edward William Lane's drawings (which will be discussed shortly) may be considered in the same category, but they are very different, with the tone being produced by washes rather than with the pencil that Herschel employed exclusively.

"Captain Basil Hall...that curious fellow, who takes charge of everyone's business without neglecting his own"

SIR WALTER SCOTT [86]

If one name were to be most closely associated with Wollaston's invention -- in Sir John's day or in ours -- it would be that of Herschel's close friend, Captain Basil Hall, a man Herschel respected as being "distinguished for the extent and variety of his attainments."[87] Indeed, the Captain's *Forty Etchings, from Sketches Made with the Camera Lucida, in North America, in 1827 and 1828* is the only generally known *camera lucida* work.[88] In his introduction to this highly popular book, Hall enthusiastically stated that "with his Sketch Book in one pocket, the Camera Lucida in the other...the amateur may rove where he pleases, possessed of a magical secret for recording the features of Nature with ease and fidelity, however complex they may be, while he is happily exempted from the triple misery of Perspective, Proportion, and Form, -- all responsibility respecting these being thus taken off his hands. In short, if Dr Wollaston, by this invention, [has] not actually discovered a Royal Road to Drawing, he has at least succeeded in Macadamising the way already known."

After a distinguished naval career that had displayed

FIGURE 24. Sir John Herschel, *Site of the Twenty Feet Reflector at Feldhausen, Cape of Good Hope.* Engraving from a *camera lucida* drawing, September 1834. 13.7 x 19.8 cm. Herschel used his *camera lucida* extensively during his four years of observing at the Cape, just before the introduction of photography. Frontispiece from Herschel's *Results of Astronomical Observations...at the Cape of Good Hope* (London, 1847). The Peabody Library, Baltimore.

the world to him, Hall married in 1825 and spent the rest of his life as an author and professional traveller. A Fellow of The Royal Society, Basil Hall came from a noteworthy Scottish family. His father, Sir James Hall, was the chief supporter of James Hutton's theories of the formation of the earth (which so motivated Herschel in his travels). Basil's younger brother, James, an advocate and amateur painter, also employed the *camera lucida,* most notably in making a portrait of Sir Walter Scott.[89] The path was smoothed by Basil, who wrote in advance to the bard that "my brother, Mr. James Hall...does not (just now, at all events) wish that you should sit to him, but -- not to mince the matter -- that you should <u>stand</u> to him. His desire is, to make a sketch of you, from top to toe, exactly as you

FIGURE 26. Captain Basil Hall, title page from *Forty Etchings, From Sketches made with the Camera Lucida in North America, in 1827 and 1828* (Edinburgh, 1829). Hall was the chief proponent of the value of the *camera lucida.* Probably because of the incorporation of the term in the title, this book is the most widely known work involving the instrument. S.F. Spira Collection.

stand, stick & all, the veritable laird of Abbotsford. In order to be quite correct about this matter, he proposes, at my suggestion, I believe, to make the drawing alluded to, with the Camera Lucida, and the whole affair will not occupy above a quarter of an hour -- or 20 minutes."[90]

There is such a disproportionately high number of links between Scotland and the *camera lucida* that one is tempted to believe the Hall family was at the center of the instrument's popularity. But a letter Basil wrote to his sister from Philadelphia in 1827 suggests that he was just then learning to use the instrument: "The camera Lucida outlines are so far valuable that as far as they go they are correct, & this is a great point -- for though what is given be very limited -- there is nothing erroneous & this circumstance I observe always gives more or less an appearance of truth to the very slightest jotting with the instrument. When I come back I shall have pleasure in showing you how to use it upon anything & everything."[91]

Basil Hall found the *camera lucida* quite appealing "from the accuracy which belongs to all its delineations, and which is quite consistent with the most perfect freedom of execution in the hands of those who possess taste or capacity to represent nature with spirit." He made no pretensions of being an artist, though. "Its chief advantage, however, lies in the power it confers on a person like myself, who knows little of drawing, who cannot, by any degree of effort, represent a complicated object correctly without this instrument, and to whom, though the rules of linear perspective are more or less familiar, the labour of applying them in a sketch is to the last degree irksome and discouraging. The use of the camera in such hands is a real source of pleasure, and its results may often be useful."[92]

Though Hall's drawings and poetry were markedly inferior to Herschel's, this in no way interfered with their mutual enjoyment of the two pastimes. They had known each other at least since 1821, and quite possibly earlier. The few surviving letters between them are candid and betray a true warmth sometimes lost in 19th century correspondence. The two men traded technical hints. It is from Hall that we learn that Herschel came to favor the Amici pattern of the *camera lucida.* In an 1830 letter from

FIGURE 27. Captain Basil Hall, *Termination of the Erie Canal at Buffalo with the commencement of the Niagara River.* Pencil *camera lucida* drawing, 11 July 1827. 12 x 21 cm. Reproduced as Plate XII in *Forty Etchings.* Lilly Library, Indiana University.

Paris, Hall wrote "I wish your opinion upon Amici's Camera Lucida, which I understand you have used a good deal. I have become so extremely familiar with Dr. Wollaston's Camera Lucida, & am so entirely unconscious of difficulty, or of effort in using it, under any circumstances, that I am really not a good judge of their comparative merits...I confess that I rather incline for Amici -- as being the most easy for beginners though it is probable that I shall always stick to my old friend."[93] Unfortunately, the reply to this letter has not been traced, for it would likely reveal more specifics about Herschel's working practice. It is clear that Basil Hall also helped Herschel solve the problem of the cumbersome *camera lucida* drawing board; while the instrument itself was diminuative, the drawing board necessary to use it was a burden to a travelling man. When his brother James sent him a newly invented sketch book, Basil lost no time in telling Herschel about it: "The invention consists in packing up about 50 pieces of drawing paper into a solid substance exactly like a board, but fastened together only at the edges & capable of being separated by the insertion of a penknife."[94] The paper became its own support.

At the end of 1839, Sir John was forced to take down the disintegrating wooden framework of his father's famous forty-foot telescope. This event occasioned a note

from Basil Hall to Margaret Herschel that anticipates a modern photography student arguing for a preferred brand of camera: "I cannot tell you how sorry I am to hear that the great telescope stand has been taken down as I had set my heart on making <u>such</u> a Camera sketch of it as never was seen before -- & now never can be seen. Nevertheless, as Sir John -- obviously out of envy -- has not chosen that the Wollaston Camera work should come into competition with his Amici work -- has chosen to steal a march on me & pull down his apparatus -- in order to prevent my sketching it, I must even see what I can do with the Tube -- & so, with your permission (I won't ask <u>his</u>) I'll bring my Camera with me & see what I can do with the things which remain."[95]

Hall exerted his personal influence on a broad range of friends in an effort to get the *camera lucida* more widely accepted. His guidelines were so practical and his manner so enthusiastic that at least two opticians had him write the instruction books for the instruments they made.[96] By the time of third edition of *Travels in North America* in 1830, Hall complained to his publisher that "I have of late been so often called upon to explain the method of using the Camera Lucida, that in order to save myself endless trouble, and to extend the use of the Instrument, I have written a letter to Mr. Dolland of St Paul's Church Yard, who is going to print it...to be given to the purchasers of his Cameras who have encreased [sic] greatly since the appearance of my Book."[97] His suggestion to include an appendix in future *Travels,* incorporating his text for Dolland, was in fact followed, and this forms a very useful little treatise. After the caveat that "the Camera, though possessed of great powers, has no means of supplying intellect, taste, or industry, to persons who by nature are destitute of these gifts," Hall went on to provide his readers with many valuable hints.[98] Hall's approach was somewhat unorthodox and quite different from that of Herschel. As has been pointed out, he had little use for the aperture normally employed to position the pupil: "as there is generally a great variety of lights and shades on the surface of every object, the eye-hole requires to be shifted backwards or forwards, according as a brilliant, or an indistinct, part of the object is looked at. It is, accordingly, far better to let this adjustment in the position of the eye to be regulated at the moment, by the person who is sketching, by merely advancing or withdrawing his eye, as occasion requires."[99] With the exception of finely detailed subjects such as architecture, Hall "generally found it best to draw all the shades first, and then to add the outlines. If the contrary plan be used, as in ordinary drawing, the outline is apt to be obliterated by the shading.... I have generally found it best, when drawing the human figure, or even in sketching landscapes, to use a soft pencil in preference to a hard one.... The quicker a sketch is done with the Camera, the more effective it generally is.... I should therefore recommend sketchers with this instrument to avoid minute particulars, and, having first thrown down on the paper all the largest and most conspicuous shades, to touch in the sharpest outlines, as well as those bits of shade which are deepest, without much regard to the actual form of the objects themselves. In this way the sketch will convey, upon the whole, a more correct idea of the object, to the mind of another person, than if twice the pains had been taken to render all its parts rigidly correct."[100]

Even more than the facility it provided, the innate truthfulness of *camera lucida* sketches appealed to Hall. "I am, therefore, decidedly of opinion that drawing masters, instead of discouraging the use of this instrument, would best consult their own interests, and the pleasure, as well as the advantage, of their pupils, and, through them, of the public, if they would exert themselves to bring the Camera into more general use. Were this advice adopted, we should see young persons employing themselves in making sketches, which should, at all events, have the merit of being accurate as far as they went; and those frigid caricatures of nature, which now disgust us almost every time we open an Album, would soon be discarded for something more true to good taste."[101]

There is a whimsical postscript to Basil Hall's *camera lucida* work -- one sure to warm the heart of anyone who has searched long for seemingly hopelessly missing historic artifacts. More than a century and a half ago, Basil Hall was forced to confess to his publisher that he had lost all his original drawings: "I have advertised them in vain. Would it not give them another chance for recovery, if you were to add a line to future Prospectuses...'The

FIGURE 28. Captain Basil Hall, *Mississagua Indians in Canada*. Engraving from a *camera lucida* drawing, 13.9 x 22.1 cm. Plate XIV of Hall's *Forty Etchings*. S.F. Spira Collection.

original Drawings for which these etchings were made, together with upwards of a hundred more, bound up in a folio Volume, were left in a hackney coach in London in July 1830. It is earnestly requested that if this meets the eye of any one who knows where they are, a letter to that effect may be written to the Publisher.'"[102] There is no indication that Hall ever learned the fate of his artistic output. Through an unknown path (perhaps the next cab rider had an appreciation of illustration) they were preserved, and turned up for sale in London in the 1940s. The portfolio of 169 drawings is now a prized part of a library collection.[103]

Of Artists, Travellers, Architects, & Geologizers

Known collections of *camera lucida* drawings like Herschel's and Basil Hall's are very rare. This rarity stems partly from our own ignorance, but there are also clear signs that artists tried to conceal its use. Wollaston's instrument was a far more pervasive influence in 19th century drawing than has generally been recognized. When John Sell Cotman received a *camera lucida* as a gift from a patron in 1817, he wrote in amazement to Dawson Turner (who, it turned out, already employed one himself) that "they are used by all ye artists I find! Chantrey draws everything by it, even to the splitting of

a Hair."[104] By 1831, Sir David Brewster would observe that the *camera lucida* "has come into very general use for drawing landscapes, delineating objects of natural history, and copying and reducing drawings."[105]

One *camera lucida* user, an artisan who found the device helpful for making drawings of complex cabinetry, contributed to an 1829 journal the thought that "I have known good artists who made frequent use of it, and who explained, that in case of emergency they could do without it, but they used it because it saved time, trouble, and thought." The editor seized on this as an opportunity to point out to his readers that "the Camera Lucida is, indeed, an admirable instrument, and, as our correspondent hints, is used to an extent that will scarcely be credited. It has been the means of furnishing us with nearly all our best illustrations of foreign scenery; many of the ancient Grecian antiques, too, have been copied in this way, and are familiarly known among artists by the appellation of 'Camera Lucida sketches.' Captain Basil Hall has very honestly acknowledged the assistance he derived from this instrument in his recent travels in the United States; and the number of such acknowledgments would be greater, could every writer of travels afford as well as Captain H. to assume no more merit than really belongs to him."[106]

Basil Hall (in a mercifully short missive to Herschel) stated his fidelity to nature, which for him was "the cause of truth -- which is the cause of Virtue -- which is the source of happiness -- & so ends my prose!"[107] He had little patience for those artists worried about a mechanical tool. "There is an idea in some people's minds that there is less merit attaching to a sketch made with the Camera, than to one made in the ordinary way, and they are apt to feel a sort of humiliation when borrowing instrumental assistance. It mortifies them to think, that so much previous labour should have been thrown away, in learning what is now mechanically done to their hand, almost without effort. But a little reflection will show, that the wish to gain credit for making sketches, is, or ought to be, altogether subordinate to the wish to represent natural objects correctly. And there is little fear that any amount of diligence or talents, however aided by previous instruction in drawing, will be able, even with the

help of the Camera, to come up to nature; and so long as this point is not reached, no sketcher has any reason to complain that his task is so easy, that it is unworthy of him."[108]

Hall observed that some drawing instructors actively discouraged the use of the *camera lucida* (out of fear of unemployment?), and it is quite rare to find hints on it in their manuals. Some spoke very cautiously, usually in the context of discussing the long-tolerated *camera obscura*: "the Camera Lucida is a more portable but a very difficult instrument."[109] Another begrudged that "if any instrument be employed for sketching, the camera lucida is undoubtedly the best, for this apparently lays the complete reduced image, upon the paper, in all its natural colours and shades."[110] Samuel Prout's frankly encouraging words were the exception: "the *camera lucida*, invented by the ingenious Dr. Wollaston,...is extremely simple in its structure, and enables the operator to take views of buildings, trees, rocks, vessels, or any other objects that are not in motion, with the utmost accuracy. Indeed, so simple are its parts, and so easy of comprehension, that persons entirely ignorant of drawing, have, in a short time, become capable of producing, with a lead-pencil, outlines of regular and most difficult architectural subjects, the proportions of which are mathematically correct."[111]

Sir Francis Chantrey captured many sitters (including Captain & Mrs. Basil Hall) in his *camera lucida:* "In Chantrey's large establishment, which was in fact an art manufactory, where the powers of one master-mind, and the skill of many dexterous hands were exquisitely combined...he took, by means of the *camera lucida,* three outlines of the head of the sitter, viz., with profile, three-quarter, and front face. These drawings were at once handed to a workman, who, guided by them, 'built up,' in clay, the first rude figure of the bust."[112] The precise form of *camera lucida* employed by Chantrey has been questioned, but it seems certain, since George Dolland chose Chantrey to draw the *camera lucida* frontispiece drawing for his instruction manual for the Wollaston model, that the artist routinely employed this pattern.[113] There are other indications of Chantrey's use. Sir David Brewster observed that "the photograph will

FIGURE 29. Sir Francis Chantrey, *Portrait of Captain Basil Hall, R.N.* Pencil *camera lucida?* drawing, ca. 1830. 49.8 x 33.7 cm. Chantrey is known to have based his busts on sketches produced with some form of *camera lucida.* This sketch was probably done shortly after Hall's return from the North American journey where he produced the drawings for his *Forty Etchings.* Alternatively, if it was done before departure (which is quite possible), perhaps Chantrey inspired Hall to take up the *camera lucida.* National Portrait Gallery, London.

differ considerably from any sketch which the artist may have himself made, owing to certain optical illusions to which his eye is subject. The hills and other vertical lines in the distance will be lower in the photograph than in his sketch." He then recalled that "Sir Francis Chantrey, the celebrated sculptor, shewed me, many years ago, a Sketch-Book, containing numerous drawings which he had made with the *Camera Lucida,* while travelling from London to Edinburgh by the Lakes. He pointed out to me

FIGURE 30. Frederick Fitzgerald DeRoos, *Water Works of Philadelphia on the Schuylkil.* Engraving based on a *camera lucida* sketch, 1826. 9.2 x 19.3 cm. DeRoos, a friend of Basil Hall's, had his own technique for using the *camera lucida.* He worked very rapidly with a damp brush to fill in the shadows first, adding the outlining as the last stage. From DeRoos *Personal Narrative of Travels in the United States and Canada in 1826* (London, 1827). The Peabody Library, Baltimore.

the flatness, or rather lowness, of hills, which to his own eye appeared much higher, but which, notwithstanding, gave to him the idea of a greater elevation. In order to put this opinion to the test of experiment, I had drawings made by a skilful artist of the three Eildon hills opposite my residence on the Tweed, and was surprised to obtain, by comparing them with their true perspective outlines, a striking confirmation of the observation made by Sir Francis Chantrey."[114]

This phenomenon -- the reality rather than the effect of nature -- confronted others who enlisted the aid of the *camera lucida.* "There is another consideration, connected with the principles of aerial perspective, which should direct the artist in the use of this, or any other mechanical contrivance. It frequently happens, that in attempting to draw an extended view with the Camera Lucida, we are surprised at the smallness of the distant objects; neither can we, by any care in the colouring, give them the importance they assume in nature. Now this shows that the instrument was misapplied, and that we should have done much better without it. Yet the representation is perspectively correct; there is, perhaps, no object in the foreground preposterously large; -- then how can anything be wrong? The fault results from the limited means of art, compared with nature. In painting,

the utmost range from white to perfect black, is but a small transition -- yet it is all we can accomplish to express the vast difference between the brilliant light and deepest shade of nature. The truth is, that in the instance now before us, our foreground and distance are much less different in intensity than they are in nature; the result is, that they must appear less removed from each other, and the distance, thus viewed under the same angle as it is in reality, without the same gradation of tint, naturally seems small and insignificant. Had the distant parts been drawn larger with respect to the whole picture, it would have been more faithful to the effect of nature, and not have exhibited so strikingly the defects of an imperfect art."[115] Samuel Butler bought a *camera lucida* in Paris and on his next journey "brought back many more sketches than usual because he drew with the camera lucida, but it distorted the perspective and had to be given up."[116] Herschel, of course, would have recoiled in horror at the thought that man's truth could somehow exceed nature's.

If professional artists were suspicious of either the merit (or the marketing implications) of using the faithful images of the *camera lucida,* other specialists had a different attitude. It was obvious to many architects, archaeologists, explorers, and scientists that they could benefit from seeking the testimony of its truth. It is within their published works that the most candid -- indeed enthusiastic -- references to the instrument are found. As might be expected, Basil Hall's friends could be counted amongst the users. Unlike Hall, Lieutenant Frederick DeRoos made no mention of the use of the *camera lucida* in his *Personal Narrative of Travels in the United States and Canada in 1826,*[117] but the plates in this work match the description of DeRoos' personal approach, which Hall later explained in a letter to Herschel: "my friend Cap' De Roos in using the Camera was in the practice of washing in his shadows with a brush slightly wetted -- so as hardly to damp the paper -- certainly not to pucker it up -- & the whole soon dried sufficiently to allow him to mark in the hard lines either with pen & ink or with a black pencil. The effect was very striking & the saving of time great. I have never tried this much, but what few experiments I have made satisfy me that a great deal might be done by using merely a little Indian ink or

bister to give the broad shades first, & then to trace over the whole, carefully, with the requisite number & intensity of lines."[118]

Another friend whom Basil Hall interested in the *camera lucida* was James David Forbes, St. Andrews University's "man of science." A *camera lucida* was part of his "Travelling Equipment" on his geological trips to the continent.[119] Basil Hall, not surprisingly, took an active interest in Forbes' students at St. Andrews. In 1836, Hall sent Forbes "the sketch I made with the camera lucida of the hanging tower at Pisa...which, if you please, you may hand round your class. It was drawn with much care.... When you come to lecture, as perhaps you will, on the use of such instruments as the Camera, I shall be happy to furnish you with such specimens of drawing showing the capacity of the instrument -- & as I have used it a great deal, I might, perhaps, be able to give you one or two practical hints respecting its use, calculated to interest your pupils."[120] Forbes must have expressed interest, for Hall later wrote that "I wish if you should happen to be passing this door, you would look in to see my Camera Lucida, which is fitted up rather differently

FIGURE 31. Sir William Gell, *Pompeii; View in the Forum.* Engraving from a *camera lucida* sketch, ca. 1817. 10.3 x 16.0 cm. First published in 1819, Gell's *Pompeiana* was a tremendously popular work. In his preface to the 1832 edition, Gell assured the reader that "the views and pictures have been uniformly made by the Author, as before, with the prism of Dr. Wollaston." *Pompeiana* (London, 1817-1819). The Peabody Library, Baltimore.

FIGURE 32. Wilhelm Zahn, *Pompei*. Engraving from a *camera lucida* drawing, ca. 1826. 26.2 x 37.8 cm. Gell used one of Zahn's *camera lucida* drawings in his *Pompeiana*. In Zahn's own publications, the feeling of his original sketches is preserved quite well. From Zahn's *Die Schönsten Ornamente* (Berlin, 1828-59). The Peabody Library, Baltimore.

from any that I have seen. It is too clumsy for the lighthorse kind of journies which I presume you make -- but it answers well for fixed stations in a journey."[121] Hall eventually donated an Amici pattern *camera lucida* for use in the Natural Philosophy Classrooms at St. Andrews, and it would be expected that a ramble through the lives of Forbes' students would reveal additional *camera lucida* artists.[122]

Sir William Gell, the classical archaeologist and traveller, was one of the first to recognize the advantages of the new instrument. In the first edition of his enormously popular *Pompeiana* there was a cautious note that "it may be proper to state, that the original drawings for this work were made with the *camera lucida*, by Sir William Gell." In later editions, this was proudly displayed as testimony: "The views and pictures have been uniformly made by the Author, as before, with the prism of Dr. Wollaston."[123] At least one of the drawings in later editions of *Pompeiana* was contributed by Gell's "friend M. Zahn, architectural painter to the Elector of Hesse Cassell;" in addition, Wilhelm Zahn was to publish his *camera lucida* drawings over a span of 30 years.[124] On his 1824 trip, John Herschel dined with Gell (an old friend

of his mother's) in Naples, and surely they must have discussed the portfolio John was building.[125] Gell's mother was re-married, to Thomas Blore, a topographer who was the father of Edward Blore, the architect, artist, and friend of Sir Walter Scott. Although no specific references have yet been traced to Blore's use of the *camera lucida,* his extensive collection of drawings (preserved at the British Museum) is fertile ground for study. There is at least one Basil Hall *camera lucida* drawing in the group, and many others that appear to have been made by the instrument.

Another writer on architecture (and another Scot), James Fergusson, "was an expert draughtsman with a camera lucida, and no sooner was he free from business ties than he set forth to explore India."[126] In reference to the plates in his *Ancient Architecture in Hindostan*, Fergusson proudly claimed that he could "answer for their correctness, as they are all from sketches taken on the spot with the camera lucida, and never afterwards touched till put in the hands of the artist here. The foregrounds and the skies are generally the artist's, as I seldom put them in on the spot; but in all cases I have insisted on the buildings being literal transcripts of my sketches, and in no instance have I allowed any liberty to be taken with them. At the same time it must be confessed that it is quite impossible for any artist who never saw a building of the class he is drawing, and has no knowledge of the style himself, nor any means, from real specimens, of acquiring it, to render that peculiar character or physiognomy which the style possesses.... Whatever defects my views may have as pictures, I feel perfectly certain that they are the most correct delineations of Indian Architecture that have yet been given to the public."[127]

Explorers from many countries took advantage of the *camera lucida*. Charles Wilkes mentions the instrument frequently and proudly in his narratives of the American Exploring Expeditions (which were conducted around the time of the introduction of photography). Whilst on the Mauno Loa volcano, he employed his day in "becoming acquainted with its paths, and in making sketches. One made by Mr. Drayton, with the camera lucida, is very characteristic, and was taken from one of the best positions for viewing this wonderful place, on the north

bank, near its west side. These sketches I conceived would enable me to ascertain if any, and what, alterations should take place between our two visits, for I could not but imagine it must be constantly undergoing change. For this purpose we multiplied our camera lucida drawings, and I descended again nearly to the black ledge for this purpose." Like Herschel, he found the *camera lucida*

FIGURE 33. James Fergusson, *Jaina Tower, Cheetore*. Lithograph from a *camera lucida* drawing. 40.3 x 30.4 cm. "With regard to the plates, I can answer for their correctness, as they are all from sketches taken on the spot with the camera lucida, and never afterwards touched till put in the hands of the artist here...I feel perfectly certain that they are the most correct delineations of Indian Architecture that have yet been given to the public." From Fergusson's *Picturesque Illustrations of Ancient Architecture in Hindostan* (London, 1848). The Peabody Library, Baltimore.

FIGURE 34. Joseph Drayton, *Walls of Crater, Kilauea*. Engraving from a *camera lucida* sketch. 17.8 x 11.6 cm. Drayton was the civilian artist for the 1838-1842 expedition of Commander Charles Wilkes. Wilkes, who employed the *camera lucida* himself, said that Drayton's view was "taken from a camera lucida sketch...and gives an idea of the stratification of the walls around the crater." Wilkes, *Narrative of the United States Exploring Expedition* (New York, 1856). The Peabody Library, Baltimore.

very useful for geological recording: "the annexed plate is taken from a camera lucida sketch, by Mr. Drayton; and gives an idea of the stratification of the walls around the crater." Wilkes also found the instrument handy for portraiture: "these two were good specimens of the Flathead Indians, and I was therefore pleased at having an opportunity of sketching them with the camera lucida...."[128]

By the time George Hoskins explored Ethiopia in 1835, he had already "acquired considerable experience in architectural drawing, and he took care, by the use of the *camera lucida,* to secure the accuracy of his outline. He had, likewise, the good fortune to engage the services of a very able Italian artist."[129] In his *Visit to The Great Oasis of the Libyan Desert*, Hoskins assured the reader that "the plates are selected from a large portfolio of drawings, made by the Author with the Camera Lucida, and finished on the spot."[130]

If the Scotsman Basil Hall should be crowned the Sage of the *camera lucida*, his fellow countryman Robert Hay would have to be considered its patron saint. Using his patrimony wisely, Hay supported a number of *camera lucida* artists in a series of expeditions in Egypt. He worked variously with the artists Frederick Catherwood, Joseph Bonomi (the younger), Francis Arundale (an architect and pupil of Augustus Pugin), and Edward William Lane. Hay himself was accomplished with the *camera lucida* and his extensive collections in the British Museum contain many of his own and his colleagues' drawings made with the instrument. Some -- particularly several large panoramas -- are of the highest quality and interest. While the collection is frequently used by Egyptologists, there has been no serious study of the contribution of Wollaston's instrument to Hay's legacy.[131] Many of the drawings are not yet attributed to a specific artist.

The artist from Hay's circle who has attracted the most attention from historians to date is Frederick Catherwood, partially because of his early (and unhappy) involvement with the *daguerreotype*.[132] As John L. Stephens related in his 1843 *Incidents of Travel in Yucatan*, "Mr. Catherwood...as on our former expedition...made all his drawings with the camera lucida, for the purpose of obtaining the utmost accuracy of proportion and detail. Besides which, we had with us a Daguerreotype apparatus, the best that could be procured in New York, with which, immediately on our arrival at Uxmal, Mr. Catherwood began taking views; but the results were not sufficiently perfect to suit his ideas. At times the projecting cornices and ornaments threw parts of the subject in shade, while others were in broad sunshine; so that, while parts were brought out well, other parts required pencil drawings to supply their defects. They gave a

FIGURE 35. George Hoskins, *El Kharger and the Tombs of the Sheakhs*. Lithograph from a *camera lucida* drawing, 1830s. 10.1 x 17.3 cm. "The plates are selected from a large portfolio of drawings, made by the Author with the Camera Lucida, and finished on the spot." Hoskins, *Visit to the Great Oasis of the Libyan Desert* (London, 1837). The Peabody Library, Baltimore.

FIGURE 36. Frederick Catherwood, *Exterior of the Casa del Gobernador*. Woodcut from a *camera lucida* drawing of 1842. 9.5 x 10.0 cm. "Mr. Catherwood made minute architectural drawings of the whole...as on our former expedition, he made all his drawing with the camera lucida, for the purpose of obtaining the utmost accuracy of proportion and detail." From John L. Stephens, *Incidents of Travel in Yucatan* (New York, 1843). The Peabody Library, Baltimore.

general idea of the character of the buildings, but would not do to put into the hands of the engraver without copying the views on paper, and introducing the defective parts, which would require more labour than that of making at once complete original drawings. He therefore completed everything with his pencil and camera lucida, while Doctor Cabot and myself took up the Daguerreotype; and, in order to ensure the utmost accuracy, the Daguerreotype views were placed with the drawings in the hands of the engravers for their guidance."[133] Catherwood was a colorful figure who found the diminutive size of the *camera lucida* to his advantage. Entering a mosque in Jerusalem, he was "determined to take in my camera lucida, and sit down and make a drawing; a proceeding certain to attract the attention of the most indifferent, and expose me to dangerous consequences."[134] Far better the petite *camera lucida* in such circumstances than the bulky *camera obscura*. Would Dr. Wollaston's discreet *camera lucida* have altered the fate of the 17th century Mr. Nelville in discharging *The Draughtsman's Contract*?

The most accomplished of Hay's talented entourage was Edward William Lane, an Arabic scholar best known for his dashing appearance and his excellent translation of *One Thousand and One Arabian Nights*. Lane's mother, Sophia Gardner, was a niece of Gainsborough's, and Edward followed the family artistic tradition by joining his brother's lithography business in London. He eventually turned to engraving, and may have been introduced to the *camera lucida* as a means of transferring images to the plate. Declining health, however, forced a change of climate, and in 1825 he made the first of his visits to Egypt. "After two months spent in Cairo...Lane again visited the Pyramids, this time for a fortnight, armed with stores and necessaries for living, and with materials for drawing and surveying, above all the camera lucida, with which all his drawings were made."[135] Much of the work in the Hay Collection is by Lane, including the original drawing for his *Great Pyramid (from the North East), Drawn with the Camera Lucida in the year 1827, and on stone in 1830 by Edward Lane*, which was lithographed by Hullmandel. Lane's great effort was his proposed book, the *Description of Egypt*, which unfortunately was never published. The material for this, including many splendid original *camera lucida* drawings, is in the British Museum. Lane's

manuscript title page for it is "Notes and Views in Egypt and Nubia, made during the years 1825, -26, -27, & -28. Chiefly consisting of a series of descriptions & delineations of the monuments, scenery, &c of those countries; the views, with few exceptions, made with the camera-lucida: by Edw^d W^m Lane." Later, from London, he added "Note In a few of my drawings I have left some parts...to be finished hereafter; but no part that may not be done with equal correctness here as on the spot."

Edward Lane's biographer stressed that "in every thing he wrote, the prominent characteristic was perfect clearness, and nowhere is this more conspicuous than in the 'Description of Egypt.' But further, to prevent the scant possibility of mistaking the words, the work was illustrated by 101 sepia drawings, made with the camera lucida, (the invention of his friend, Dr. Wollaston,) and therefore as exact as photography could make them, and far more pleasing to the eye. Those whose function it is to criticise artistic productions have unanimously expressed their admiration of these drawings. And though Lane would always say that the credit belonged to the instrument and not to himself, it is easy to see that they are the work of a fine pencil-hand, and could not have been done by any one who chose to look through a camera lucida. Altogether, both in drawings and descriptions, the

FIGURE 37. Edward William Lane, *The Great Temple of Aboo-Simbil, or Absembel*. Pencil *camera lucida* drawing with india ink wash, ca. 1827. 10.1 x 17.5 cm. Lane, one of the artists (along with Catherwood) who accompanied Robert Hay in his explorations, was a master of laying tone onto his *camera lucida* sketches. The British Museum.

book is unique of its kind. It has never been published."[136] Though written by a descendant, this is a fair evaluation, for Lane combined a delicacy of line with sensitive tonal washes. These enhance the reality of the drawings without detracting from the draftsmanship. Lane's drawings have a very different feeling from those by Herschel, but both men demonstrated how versatile and precise a *camera lucida* could be in the right hands.

"I shall hope for much pleasure in shewing you the sketches I have made during this & other excursions. Being done with the Camera Lucida, they may be relied on as accurate"

Ready facility with the *camera lucida* modulated John Herschel's reaction to the announcement of photography in 1839. As soon as he heard that such a thing had been accomplished, without seeing a photograph or even so much as hearing a brief physical description of one, he instantly grasped how to accomplish the phenomenon. His colleague and friend, Henry Talbot, who he had first met in Munich 15 years before, was the English inventor of photography on paper. The open correspondence between the men make it clear that they had not discussed anything about Talbot's work previous to the public disclosure. Once that announcement was made (on January 25th), Henry Talbot hastened to meet with Sir John. Although Herschel had been largely confined to a sickbed, and was forced to work under the restrictions of a gloomy English winter sky, when Talbot came to visit him six days later he was faced with Herschel's first photographs! So complete was Herschel's understanding of chemistry and optics, so agile was his mind, that once presented with the idea of photography, he independently invented it in less than a week. He made his prints permanent with hypo (the properties of which he had explored 20 years earlier in his post-Cambridge days), and so perfect was this choice that hypo remains the mainstay of darkrooms to this day.

Why didn't Herschel invent photography decades sooner, as surely he could have? The reply to this decidedly complex question must involve his satisfaction

with the *camera lucida*. Its portability suited his working methods and its accuracy met his visual needs. More importantly, the very nature of building a sketch with the device fit him philosophically as well. The *camera lucida* gave Herschel the opportunity to study the various details of the scene that he was recording -- and nothing was calculated to bring him greater inner peace. Indeed, the *camera lucida* simultaneously encouraged and compelled him to meet his Baconian duty to report on what he saw. *Camera lucida* drawing was analytical rather than exploitative; the fleeting action of taking a photograph would have robbed him of this opportunity. Talbot gloated that his new art "can make the powers of nature work for you, and no wonder that your work is well and

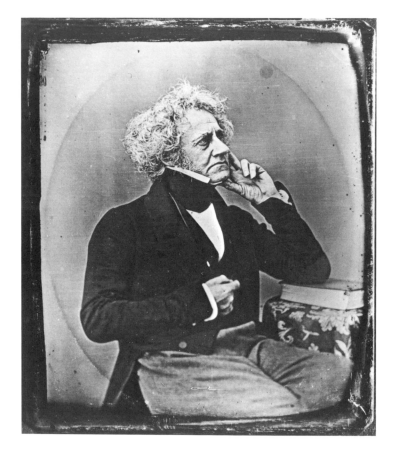

FIGURE 38. John Mayall, *Portrait of Sir John Herschel*. Daguerreotype, ca. 1848. 8.5 x 7.0 cm. After his brilliant start in photochemical research, Herschel was overwhelmed by other responsibilities, and by the time this studio portrait was made, he had been reluctantly torn from his "first love" of light. John Herschel-Shorland.

quickly done."[138] In his *Pencil of Nature*, Talbot expressed delight that the time of the day was unconsciously recorded on a clock tower in one of his photographs. Herschel would have been disappointed in himself not to have noticed the clock in the first place. It would have been a part of his *camera lucida* drawing.

Photography could make nothing of the 'chamber of light,' and demanded the use of a *camera obscura* instead. Aside from the objection to its bulk for a traveller, the *camera obscura* posed a more significant shortcoming. Herschel knew as much about lenses as anyone and in fact campaigned for the right type of lenses to be employed by photographers. Strict adherence to proportion and perspective was all-important to Herschel, and he knew that the distortions endemic to the curved surfaces of even the best lenses of his day could not be circumvented. The prism of the *camera lucida* would not distort the truth. Talbot lamented to Herschel that it was "a pity that artists should object to the convergence of vertical parallel lines since it is founded in nature and only violates the <u>conventional</u> rules of Art."[139] Herschel was not the least bit concerned with the conventions of artists, but he selected his vantage point carefully to present the maximum of nature's truth.

It would be a mistake, however, to assume that Herschel rejected photography. In the crucial early days beginning in 1839, he was one of its chief proponents, and his generous personality and powerful connections did much to hold the fledgling art together in Britain. He provided critical support for Talbot, who was beseiged by French competition.[140] Through all this, however, Herschel's interests lay not in setting aside his *camera lucida* in the creation of imagery, but rather in exploring the physical basis of photochemistry. But the timing was wrong: he was also feeling the heavy responsibility of publishing his astronomical observations, and reluctantly turned his full attention to them. "Don't be enraged against my poor photography" he lamented to Maggie in 1841. "You cannot grasp by what links <u>this</u> department of science holds me captive -- I see it sliding out of my hands while I have been <u>dallying</u> with the stars. <u>Light</u> was my first love! In an evil hour I quitted her for those brute & heavy bodies which tumbling along thro' ether, startle

FIGURE 39. Sir John Herschel, *Experimental photograph of his father's 40-foot reflector telescope*. Silver negative on paper, 10 February 1839. 8.0 x 8.4 cm. So complete was Herschel's chemical and optical knowledge that he independently invented his own process a week after first hearing of the idea. This negative, the oldest known surviving Herschel photograph, was fixed with hypo less than two weeks after he invented the process. Still, the *camera lucida* remained his favored means of producing images. The Science Museum, London.

her from her deep recesses and drive her trembling and sensitive into our view."[141] If light was John Herschel's first love, the 'chamber of light' was his most exquisite means of expressing that love. The *camera lucida* had been an integral part of his vision for more than 50 years.

In 1861, nearing the age of 70, whilst collating a lifetime of work, John Herschel started his manuscript notebook, *General list of all my drawings and sketches*.[142] The vast majority of his personal selections for his portfolio proved to have been accomplished with the *camera lucida*. The final entry in his list is for a *camera lucida* sketch taken on the lawn of his Kent home on June 14th, 1870, at the age of 78. Sir John died peacefully at Collingwood, surrounded by his large and loving family, on May 11th the following year.

NOTES TO THE TEXT

1. Augustus Frederick, the Duke of Sussex, "Presidential Address for 1833," *Philosophical Transactions Abstracts*, v. 3, 1830-1837.

2. Obituary, *Proceedings of the Royal Society of London*, v. 20, 1872, p. xvii.

3. These are summarized in Larry Schaaf's "Sir John Herschel's 1839 Royal Society Paper on Photography," *History of Photography*, v. 3, n. 1, January 1979, pp. 47-60.

4. Obituary, *Athenaeum*, n. 2273, 20 May 1871, p. 624.

5. Richard A. Proctor, *Essays on Astronomy* (London: Longmans, Green, and Co., 1872), p. 1.

6. N.S. Dodge, "Memoir of Sir John Frederick William Herschel," *Annual Report of The Board of Regents of the Smithsonian Institution...for the Year 1871* (Washington: Government Printing Office, 1873), pp. 125-6.

7. More than a century after Sir John Herschel's death, the only biography (termed, too modestly, by its author as only a 'sketch'), is Günther Buttman's *The Shadow of the Telescope; a biography of John Herschel*, translated by B.E.J. Pagel, introduction by David S. Evans (New York: Charles Scribner's Sons, 1970).

8. Obituary, *Proceedings of the American Academy of Arts and Sciences*, v. 8, 4 June 1872, p. 470.

9. Biographical note on John by Caroline Herschel, 27 May 1838. M1084, Herschel Collection, the Humanities Research Center, The University of Texas at Austin. The reference is most likely to Wilhelm Müller (1783-1846), a Hanover mathematician, geographer, and astronomer who strengthened his friendship with Caroline when she returned to Hanover.

10. Letter, Miss Savage to Samuel Butler, 11 October 1882. Henry Festing Jones, *Samuel Butler, Author of Erewhon* (London: MacMillan and Co., 1919), v. 1, p. 378.

11. John Ayton Paris, *The Life of Sir Humphrey Davy* (London: Henry Colburn and Richard Bentley, 1831), v. 1, p. 148 note.

12. Rev. Henry Hasted, "Reminiscences of Dr. Wollaston," *Proceedings of the Bury & West Suffolk Archaeological Institute*, v. 1, n. 4, March 1850 (read 20 December 1849), p. 126.

13. Patent No. 2993, 4 December 1806, "For an Instrument Whereby any Person May Draw in Perspective, or May Copy or Reduce any Print or Drawing." *The Repertory of Arts, Manufactures, and Agriculture*, 2nd series, v. 10, n. 57, February 1807, pp. 161-4.

14. Robert Hooke, "A Contrivance to make the Picture of any thing appear on a Wall, Cup-board, or within a Picture-frame, &c. in the midst of a Light room in the Day-time...," *Philosophical Transactions*, v. 3, n. 38, 17 August 1668, pp. 741-3. Hooke's 'Light room' (a device for optical illusion and entertainment) was first translated into the Latin *camera lucida* by George Lewis Scott in his *Supplement to Mr. Chamber's Cyclopaedia; or, Universal Dictionary of Arts and Sciences* (London: printed for W. Innys and J. Richardson, 1753), v. 1. Scott (1708-1780), a Fellow of the Royal Society who introduced many scientific terms into the publication, was not overly pedantic, and perhaps merely felt Hooke's invention would do nicely if placed in proximity to the *camera obscura*.

15. Heinrich Schwarz, "Vermeer and the Camera Obscura," *Pantheon*, v. 24, 1966, p. 170. This claim is thoroughly refuted in Hammond & Austin, *Camera Lucida*, pp. 16-17.

16. Wollaston, "Description of the camera lucida," *Philosophical Magazine*, v. 27, n. 108, May 1807, p. 347.

17. Wollaston, "Description," p. 345.

18. Hall, *Travels in North America, in the Years 1827 and 1828* (Edinburgh: Printed for Robert Cadell, 1830) Third edition, v. 3, *Appendix on the Use of the Camera Lucida*, p. 3.

19. John H. Hammond and Jill Austin, *The Camera Lucida in Art and Science* (Bristol: Adam Hilger, 1987), p. 15.

20. Robison, "Notice regarding a cheap and easily used Camera Lucida, applicable to the delineation of Flowers and other small objects," exhibited 8 March 1841, *Transactions of the Royal Scottish Society of Arts*, v. 2, p. 85.

21. H. Fox Talbot, *The Pencil of Nature* (London: Longman, Brown, Green, & Longmans, 1844-46). No. 1, "Brief Historical Sketch of the Invention of the Art." The steps leading up to Talbot's invention of the art are discussed in Larry Schaaf's *Introductory Volume* to *H. Fox Talbot's The Pencil of Nature, Anniversary Facsimile* (New York: Hans P. Kraus, Jr. Inc., 1989).

22. Heath, *Vernon Heath's Recollections* (London: Cassell & Company, 1892), pp. 47-8.

23. E.T. Cook, *The Works of John Ruskin* (London: George Allen, 1908), library edition, v. 35, p. 455. One morning in France, Ruskin recorded with disgust in his diary that he was "up rather late this morning, and lost time before breakfast over camera-lucida...," p. 457.

24. "The Camera Lucida," *Athenaeum*, n. 148, 28 August 1840, p. 540.

25. See, for example, T. Sheldrake's highly critical comments in "On the Use of the *Camera Lucida* as a Substitute for the Camera Obscura," *Nicholson's Journal*, v. 25, March 1810, pp. 175-6.

26. Sydney D. Kitson, *The Life of John Sell Cotman* (London: Faber and Faber, 1937), p. 194.

27. R.B. Bate, "On the Camera Lucida," *Nicholson's Journal*, v. 24, October 1809, p. 149.

28. Letter of 17 July 1830, from H.J. of Exeter to the editor, *Mechanics Magazine*, v. 13, n. 363, 24 July 1830, p. 345.

29. On 19 May 1837, Herschel recorded "Drawing & carpentering up the Panorama board wʰ seems likely to answer." His panoramic *camera lucida* drawings are held in the Cape Town Library. A "Plan of a concave table for taking accurate drawings with the Camera Lucida," devised by Joseph Bonomi, is shown in Catherine Delano Major's "Illustrating, B.C. (Before Cameras)," *Archaeology*, v. 24, n. 1, January 1971, pp. 44-51. The technical information given in this article, however, is not to be relied on.

30. Letter, Herschel to Babbage, 10 October 1816. HS2:68, Herschel Correspondence, The Royal Society, London.

31. Charles Pritchard, *Monthly Notices of the Royal Astronomical Society*, v. 32, n. 4, 9 February 1872, p. 126.

32. Letter, Herschel to Babbage, October 1813. HS2:19, Herschel Correspondence, The Royal Society, London.

33. Letter, Herschel to Babbage, 14 July 1816. HS2:64, Herschel Correspondence, The Royal Society, London.

34. Letter, Herschel to Babbage, 10 October 1816. HS2:68, Herschel Correspondence, The Royal Society, London.

35. Letter, Herschel to Babbage, 14 July 1816. HS2:64, Herschel Correspondence, The Royal Society, London.

36. Herschel, *Preliminary Discourse on the Study of Natural Philosophy*. New edition (London: Longman, Rees, Orme, Brown, & Green, 1830), pp. 105 & 108.

37. Herschel, *Preliminary Discourse*, p. 118.

38. Letter, Herschel to Babbage, 9 November 1818. HS2:97, Herschel Correspondence, The Royal Society, London.

39. Letter, Herschel to Babbage, 27 April 1818. HS2:92, Herschel Correspondence, The Royal Society, London.

40. The properties of this chemical that would later become relevant to photography were set out by Herschel in "On the hyposulphurous acid and its compounds," *The Edinburgh Philosophical Journal*, v. 1, n. 1, June 1819, pp. 8-29, and in two subsequent articles. For a discussion of the introduction of hypo into Talbot's work, see Larry Schaaf, "Herschel, Talbot, and Photography: Spring 1831 and Spring 1839," *History of Photography*, v. 4, n. 3, July 1980, pp. 181-204.

41. Letter, Babbage to Herschel, 11 November 1817. HS2:88, Herschel Correspondence, The Royal Society, London.

42. Letter, Herschel to Babbage, 12 July 1820. HS2:138, Herschel Correspondence, The Royal Society, London.

43. Letter, Herschel to Babbage, 12 August 1820. HS2:142, Herschel Correspondence, The Royal Society, London.

44. Letter, Herschel to James Gordon, 15 Aug 1821. John Herschel-Shorland.

45. Notebook, *JFWH's Tour in France 1821 July 21ˢᵗ to Aug 31ˢᵗ*. W0054, Herschel Collection, the Humanities Research Center, The University of Texas at Austin.

46. Herschel diary, 5 August 1821. W0054, Herschel Collection, the

Humanities Research Center, The University of Texas at Austin.

47. Letter, Herschel to Gordon, from Chamouni, 15 Aug 1821. John Herschel-Shorland.

48. Letter, Herschel to his mother, 15 August 1821. L0515, Herschel Collection, the Humanities Research Center, The University of Texas at Austin.

49. Letter, Herschel to Babbage, 2 December 1821. HS2:168, Herschel Correspondence, The Royal Society, London.

50. Herschel, *Preliminary Discourse*, pp. 14-16.

51. Letter, Herschel to Babbage, 25 September 1826, from Entraigues. HS2:204, Herschel Correspondence, The Royal Society, London.

52. Letter, Herschel to Babbage, 20 April 1824. HS2:194, Herschel Correspondence, The Royal Society, London.

53. Draft of letter, Herschel to Grahame, 2 May 1824. HS8:319, Herschel Correspondence, The Royal Society, London.

54. Letter, Herschel to his mother, 2 May 1824. L0517, Herschel Collection, the Humanities Research Center, The University of Texas at Austin.

55. Amici, "Sopra le camere lucide," *Opuscoli Scientifici*, v. 3, n. 13, 1819, pp. 25-35.

56. David Brewster, "Professor Amici's Improved Camera Lucida," *The Edinburgh Journal of Science*, v. 3, n. 1, July 1825, p. 157.

57. Letter, Herschel to Amici, 29 June 1827. Amici Archive, Biblioteca Estense, Modena.

58. Letter, Herschel to his mother, 8 June 1824. L0517, Herschel Collection, the Humanities Research Center, The University of Texas at Austin.

59. Letter, Herschel to Babbage, from Etna, 4 July 1824. HS2:197, Herschel Correspondence, The Royal Society, London.

60. Letter, Herschel to Babbage, from Entraigues, 25 September 1826. HS2:204, Herschel Correspondence, The Royal Society, London.

61. Herschel, *Familiar Lectures on Scientific Subjects* (London: Alexander Strahan, 1866), p. 1.

62. Letter, Herschel to his mother, from Naples, 17 June 1824. LO517, Herschel Collection, the Humanities Research Center, The University of Texas at Austin.

63. Letter, Herschel to his mother, from Catania, 1 July 1824. LO517, Herschel Collection, the Humanities Research Center, The University of Texas at Austin.

64. Letter, Herschel to Sir William Watson, from Palermo, 16 July 1824. L0494, Herschel Collection, the Humanities Research Center, The University of Texas at Austin.

65. Draft of letter, Herschel to James Grahame, from Munich, 18 Sep 1824. HS8:319, Herschel Correspondence, The Royal Society, London.

66. Letter, Herschel to Babbage, from Palermo, 11 July 1824. HS2:197, Herschel Correspondence, The Royal Society, London.

67. Letter, Herschel to his mother, 12 July 1824. L0517, Herschel Collection, the Humanities Research Center, The University of Texas at Austin.

68. Annotation, in Herschel's hand, for his bill from *The Victory Hotel*, July 1824. The Graham Nash Collection.

69. Herschel to his mother, from the Valley of Seiss, Tyrol, 9 September 1824. L0517, Herschel Collection, the Humanities Research Center, The University of Texas at Austin.

70. Letter, Herschel to his mother, on the road from Gother to Gottingen, 28 September 1824. L0517, Herschel Collection, the Humanities Research Center, The University of Texas at Austin.

71. Letter, Herschel to Babbage, from Entraigues, 25 September 1826. HS2:204, Herschel Correspondence, The Royal Society, London.

72. Letter, Herschel to Babbage, from Hanover. HS2:199, Herschel Correspondence, The Royal Society, London.

73. Letter, Herschel to his mother, from Munich, 20 September 1824. L0517, Herschel Collection, the Humanities Research Center, The University of Texas at Austin.

74. Letter, Herschel to his mother, from Montelimart, 22 September 1826. L0518, Herschel Collection, the Humanities Research Center, The University of Texas at Austin.

75. Letter, Herschel to Babbage, 12 February 1828. HS2:219, Herschel Correspondence, The Royal Society, London.

76. Letter, Herschel to Mrs. Babbage, 31 August 1827. HS2:213, Herschel Correspondence, The Royal Society, London.

77. Letter, Herschel to his mother, from Baden-Baden, 2 July 1829. L0521, Herschel Collection, the Humanities Research Center, The University of Texas at Austin.

78. Draft of letter, Herschel to James Grahame, from Munich, 18 Sep 1824. HS8:319, Herschel Correspondence, The Royal Society, London.

79. Herschel diary, 22 September 1828. W0010, Herschel Collection, the Humanities Research Center, The University of Texas at Austin.

80. Letter, Herschel to his Aunt Caroline, from Leamington, 19 March 1829. L0574, Herschel Collection, the Humanities Research Center, The University of Texas at Austin.

81. Herschel, *Travel Journal XI: 1829-36*. W0063, Herschel Collection, the Humanities Research Center, The University of Texas at Austin.

82. Letter, Herschel to his mother, from Baden-Baden, 2 July 1829. L0521, Herschel Collection, the Humanities Research Center, The University of

83. Margaret's 1829 Travel Journal, June 12-13. W0062, Herschel Collection, the Humanities Research Center, The University of Texas at Austin.

84. Letter, Herschel to his mother, 15 June 1829. L0521, Herschel Collection, the Humanities Research Center, The University of Texas at Austin.

85. This, and three dozen other references to Herschel's *camera lucida* work, are noted in *Herschel at the Cape: Diaries and Correspondence of Sir John Herschel, 1834-1838*. Edited by David S. Evans, Terence J. Deeming, Betty Hall Evans, Stephen Goldfarb (Austin: University of Texas Press, 1969).

86. Quoted in Sir William Gell, *Reminiscences of Sir Walter Scott's Residence in Italy, 1832*. Edited by James C. Corson (London: Thomas Nelson and Sons, 1957), p. xiv.

87. Herschel, *Preliminary Discourse*, p. 28.

88. Hall, *Forty Etchings, from Sketches Made with the Camera Lucida, in North America, in 1827 and 1828* (Edinburgh: Cadell & Co, 1829).

89. Described in Helen Smailes, "Thomas Campbell and the 'camera lucida': The Buccleuch statue of the 1st Duke of Wellington," *The Burlington Magazine*, v. 79, n. 1016, November 1987, pp. 709-714.

90. Letter, Hall to Scott, 28 July 1830. MS 3919, f250, The National Library of Scotland.

91. Letter, Basil Hall to his sister Katy, from Philadelphia, 6 December 1827. MS3220, f143, The National Library of Scotland.

92. Hall, "Drawing and Description of the Capstan Lately Recovered from the Royal George," *United Services Journal and Naval and Military Magazine*, part III, 1839, p. 379.

93. Letter, Hall to Herschel, 12 February 1830. HS9:165, Herschel Correspondence, The Royal Society, London.

94. Letter, Hall to Herschel, 3 September 1832. HS9:171, Herschel Correspondence, The Royal Society, London.

95. P.S. to a letter from Margaret Hall to Lady Herschel, 11 Dec 1839. HS9:190, Herschel Correspondence, The Royal Society, London.

96. George Dolland, *Description of the Camera Lucida, an Instrument for Drawing in True Perspective, and for Copying, Reducing, or Enlarging Other Drawings. To Which is Added, by Permission, a Letter on the Use of the Camera, by Capt. Basil Hall, R.N., F.R.S.* (London: Printed by Stewart and Murray, 1830); Francis West, *A Description of the Camera-Lucida, for Drawing in True Perspective, the Invention of Dr. Wollaston...* (London: Effingham Wilson, 1831).

97. Letter, Hall to Robert Cadell, 17 May 1830. MS 21007, ff. 200/200v, The National Library of Scotland.

98. Hall, *Travels in North America, in the Years 1827 and 1828* (Edinburgh:

Printed for Robert Cadell, 1830). Third edition, v. 3: *Appendix on the Use of the Camera Lucida*, p. 2.

99. Hall, *Appendix*, p. 3.

100. Hall, *Appendix*, p. 9.

101. Hall, *Appendix*, p. 8.

102. Letter, Hall to Robert Cadell, 22 November 1830. MS 21007, f264, The National Library of Scotland.

103. Special Collections, The Lilly Library, Indiana University, Bloomington, Indiana.

104. Letter, Cotman to Turner, 12 June 1817. H. Isherwood Kay, "John Sell Cotman's Letters from Normandy," *Walpole Society 1925-1926*, v. 14, p 94.

105. Brewster, *A Treatise on Optics* (London: Printed for Longman, Rees, Ormé, Brown & Green, 1831), p. 333.

106. J., "Utility of the Camera Lucida," *Mechanics Magazine*, v. 11, n. 311, 25 July 1829, p. 382.

107. Letter, Hall to Herschel, 24 April 1833. HS9:176, Herschel Correspondence, The Royal Society, London.

108. Hall, *Appendix*, pp. 6-7.

109. M.H. Shuttleworth, *Remarks on Landscape Painting in Water Colours*. Fourth edition (London: Houghton and Co., 1845), p.41.

110. William Ford Stanley, *A Descriptive Treatise on Mathematical Drawing Instruments* (London: published by the Author, 1866), p. 114.

111. Samuel Prout, *Rudiments of Landscape: In Progressive Studies. Drawn, and Etched in Imitation of Chalk, by Samuel Prout* (London: R. Ackermann, 1813), p. 16.

112. John Holland, *Memorials of Sir Francis Chantrey, R.A.* (London: Longman, Green, Brown, and Longman, 1851), p. 295.

113. Questions about the instruments Chantrey employed have been raised by Richard Walker in his *Regency Portraits* (London: National Portrait Gallery, 1985), v. 1, p. 624. There are 202 such Chantrey drawings in the NPG. Chantrey did the frontis for George Dolland's *Description of the Camera Lucida, an Instrument for Drawing in True Perspective, and for Copying, Reducing, or Enlarging Other Drawings. To Which is Added, by Permission, a Letter on the Use of the Camera, by Capt. Basil Hall, R.N., F.R.S.* (London: Printed by Stewart and Murray, 1830).

114. Brewster, *The Stereoscope* (London: John Murray, 1856), pp. 171-2.

115. "The Camera Lucida," *Athenaeum*, n. 148, 28 August 1840, pp. 540-1.

116. Henry Festing Jones, *Samuel Butler, Author of Erewhon* (London: MacMillan and Co., 1919), v. 1, p. 391.

117. DeRoos, *Personal Narrative of Travels in the United States and Canada in 1826* (London: William Harrison Ainsworth, 1827). DeRoos, an FRS, also published under the spelling of I.F. DeRos.

118. Letter, Hall to Herschel, 22 July 1832. HS 9:170, Herschel Correspondence, The Royal Society, London.

119. Cited, for example, in his 1832 Diary, *Memoranda of Travelling Equipment*, under "Instruments Brought from Britain. Special Collections, The Library, University of St. Andrews.

120. Letter, Hall to Forbes, 4 December 1836. Special Collections, The Library, University of St. Andrews.

121. Letter, Hall to Forbes, 22 April 1837. Special Collections, The Library, University of St. Andrews.

122. A Bates 1832 model of Amici's Camera Lucida, presented by Capt. Hall, is cited in Forbes' *notebook*: "This Volume contains the Catalogue of Apparatus in the Natural Philosophy Classrooms, which were my property at the date of 1st May 1845." Special Collections, The Library, University of St. Andrews.

123. Sir William Gell, F.R.S. F.S.A. &c. and John P. Gandy, Architect, *Pompeiana: The Topography, Edifices, and Ornaments of Pompeii* (London: Printed for Rodwell and Martin, 1817-19), p. xvi; 1835 edition (London: Lewis A. Lewis), v. 1, pp. xxiii-xxiv.

124. Gell, *Pompeiana*, 1835 edition, v. 1, p. 109. Zahn's drawings were published in his lavish *Die Schönsten Ornamente und Merkwürdigsten Gemälde aus Pompeji, Herculanum und Stabiae* (Berlin: Dietrich Reimer, 1828-1859).

125. The meeting is cited in a letter from Herschel to his mother, 22 July 1824. L0517, Herschel Collection, the Humanities Research Center, The University of Texas at Austin.

126. Obituary, *The Athenaeum*, n. 3039, 16 Jan 1886, p. 109.

127. Fergusson, *Ancient Architecture in Hindostan* (London: J. Hogarth, 1848), p. iv.

128. Charles Wilkes, *Narrative of the United States Exploring Expedition During the Years 1838, 1839, 1840, 1841, 1842* (New York: G.P. Putnam & Co., 1856), v. 4, pp. 125, 171; v. 5, p. 115. Other American users of the *camera lucida* are cited in Josephine Cobb's "Prints, The Camera, and Historical Accuracy," *American Printmaking Before 1876. Fact, Fiction, and Fantasy* (Washington: Library of Congress, 1975), pp. 1-10.

129. Hoskins, *Travels in Ethiopia* (London: Longman, Rees, Orme, Brown, Green, & Longman, 1835), p. vi.

130. Hoskins, *Visit to The Great Oasis of the Libyan Desert* (London: Longman, Rees, Orme, Brown, Green, & Longman, 1837), p. 8.

131. Appreciations are given in Catherine Delano Major's "Illustrating, B.C. (Before Cameras)," *Archaeology*, v. 24, n. 1, January 1971, pp. 44-51; and in John Romer's *Valley of the Kings* (New York: William Morrow and Company, 1981), pp. 107-114.

132. Victor Wolfgang von Hagen, *F. Catherwood. Architect-Explorer of Two Worlds* (Barre, Mass.: Barre Publishers, 1968). This book is most valuable for drawing attention to Catherwood's enthusiasm for the *camera lucida*. Not all the drawings cited from the Hay Collection can be attributed to Catherwood with any certainty, however, and the book is unfortunately weak on technical matters. The *camera lucida* is thus described: "By means of a series of prisms, formed by a certain arrangement of lenses, it causes an external image to be projected on a sheet of paper; outlines can be faithfully traced." *Note*, p. 35.

133. John L. Stephens, *Incidents of Travel in Yucatan* (New York: Harper & Brothers, 1843), v. I, pp. 174-5.

134. Quoted from a Catherwood letter reproduced in W.H. Bartlett's, *Walks about the City and Environs of Jerusalem* (London: George Virtue, 1844), pp. 162-3.

135. Stanley Lane Poole, *Life of Edward William Lane* (London: Williams and Norgate, 1877), p. 35. Unfortunately for the study of Lane's work, Poole (his great-nephew) reveals in his preface that he has not had "the smallest help from letters. Mr. Lane had a deep-rooted objection to the publication of letters meant only for private friends, and he unfortunately took care to have all his own letters from Egypt destroyed."

136. Poole, *Life*, pp. 35-6.

137. Letter, Herschel to his mother, from Chamouni, 15 August 1821. L0515, Herschel Collection, the Humanities Research Center, The University of Texas at Austin.

138. Talbot, letter of 30 January 1839 to the editor of *The Literary Gazette*, n. 1150, 2 February 1839, p. 74.

139. Letter, Talbot to Herschel, 26 October 1847. HS17.319, Herschel Correspondence, The Royal Society, London.

140. This relationship is discussed in Larry Schaaf's "L'Amour de la Lumière: Herschel, Talbot, et la Photographie," *Les Multiples Inventions de la Photographie* (Paris: Association Française Pour la Diffusion du Patrimoine Photographique, 1989), pp. 115-124.

141. Letter, Herschel to his wife, 10 August 1841. L0539, Herschel Collection, the Humanities Research Center, The University of Texas at Austin.

142. MW0019, Herschel Collection, the Humanities Research Center, The University of Texas at Austin.

The following *camera lucida* drawings were made between 1821 and 1865 by Sir John Herschel. All are from the Graham Nash Collection. Technical comments about the markings on these drawings, along with transcriptions of some of Herschel's notations, will be found in the *Catalogue* section at the end.

The first three pairs are exceptional in that they illustrate the transformation of Herschel's *camera lucida* field drawings into highly finished presentation pieces. The *enlarged* versions (as Herschel termed them), far from being fanciful, reveal the wealth of detail that he observed through the *camera lucida* and coded into his original drawings. They also testify to his mastery of line and shading. A few other *camera lucida* artists equalled Herschel in line, but none accomplished his balance of precise delineation and sensitive pencil shading. These three presentation drawings were given to Georgiana, the wife of Herschel's close friend Charles Babbage, the pioneer computer inventor. Babbage and Herschel became friends while students at Cambridge, significantly influencing the teaching of mathematics there, and shared the excitement of their first *Grand Tour* in 1821. In his affection for this young family, Herschel felt the contentment of domestic life that he lacked. The Babbages even named their first child after him. The *enlarged* versions were probably made soon after Herschel's return in 1821, and in any case, well before the premature and tragic death of Georgiana in September 1827.

PLATE 1. *No. 322. J.F.W. Herschel delin Cam. Luc. Sep 5, 1821. Glacier of Zermatt with the summit (1) ascended on Sep 7.* 20.1 x 29.9 cm. Original camera lucida drawing.
PLATE 2. *No. 517.* 21.0 x 30.7 cm. Recorded in Herschel's manuscript NOTEBOOK as "enlarged copy... made for Mrs. Babbage."

PLATE 3. *No. 507. J.F.W. Herschel delin Cam. Luc. Sep 23, 1821. The Lake of Brienz from Iseltwald.* 20.2 x 30.5 cm. Original camera lucida drawing.
PLATE 4. *No. 519. Lake of Brienz from Iseltwald.* 20.8 x 30.8 cm. Enlarged copy made for Mrs. Babbage.

Sir John, along with his wife, daughters, and friends, based paintings on his original *camera lucida* drawings. In 1844, he wrote to a friend: "thank you for the very, very sweet picture you have created out of my poor sketch of Iseltwald, which brings back the scene in so lively a manner that it makes 20 years disappear and I can fancy myself just disembarking from the old flap sailed boat among the merry groupe you have inserted in your foreground.... I hope you will not hesitate to make use of any of the subjects in my portfolio which will at all times be at your command." [1]

PLATE 5. *No. 320. J.F.W. Herschel del. Cam. Luc. Sep 4, 1821. Clay Columns at Stalde in the Visp Thal, Valais.* 19.2 x 29.4 cm.
PLATE 6. *No. 516. Copied from the original Camera Lucida drawing of Sep 4, 1821 by JFWH. Earth Columns at Stalde in the Visp-Thal. Switzerland.* 19.3 x 29.4 cm. Enlarged copy made for Mrs. Babbage.

Geological questions directed many of Herschel's rambles; consequently, many of his landscapes (however pleasing their pictorial qualities) were made with express scientific intent. These pillars of soft rock were protected from erosion by a cap of harder material. Eventually, of course, water seeping through cracks would destroy them. The famous geologist, Sir Charles Lyell, engraved one of Herschel's drawings of Stalde for his *Principles of Geology*. After comparing Sir John's "excellent drawings" with what remained of these pillars ten years after an earthquake, Lyell told him that "I could get no good photograph of these...and no engravings in the least comparable to your drawings. I am therefore very desirous...to use your drawings of the Ritten pillars...for my new edition." [2]

1. Notebook, *JFWH's Tour in France 1821 July 21ˢᵗ to Aug 31ˢᵗ*. W0054, Herschel Collection, the Humanities Research Center, The University of Texas at Austin.
2. Letter of 28 November 1865, quoted in Katherine Lyell's *Life, Letters and Journals of Sir Charles Lyell, Bart.* (London: John Murray, 1881), v. 2, pp. 404-5.

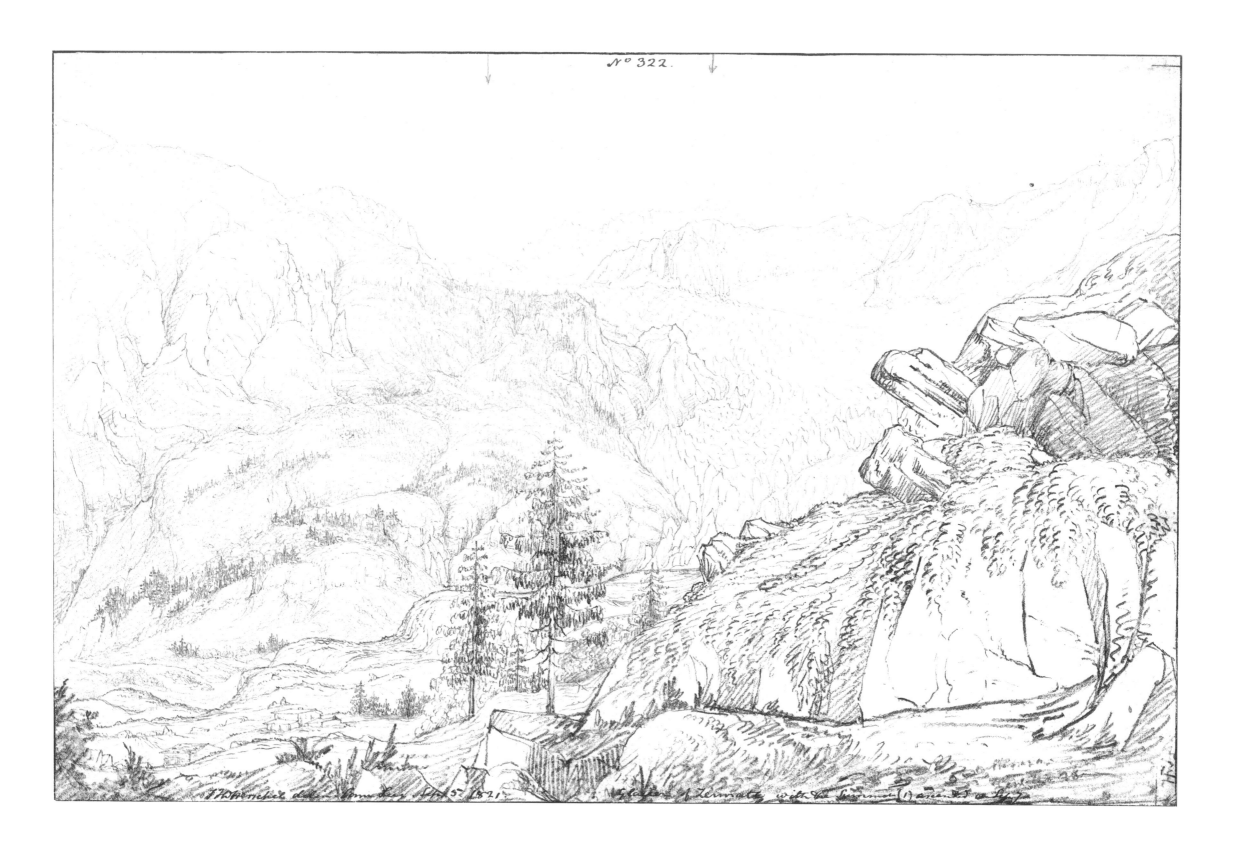

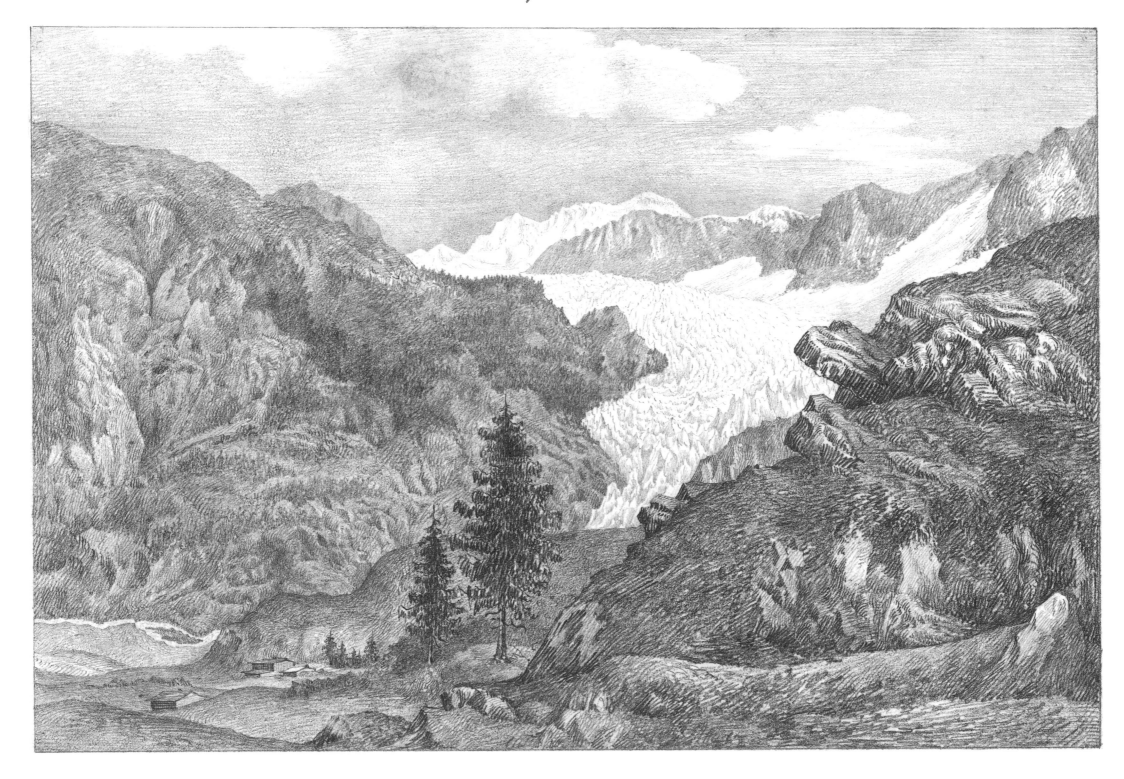

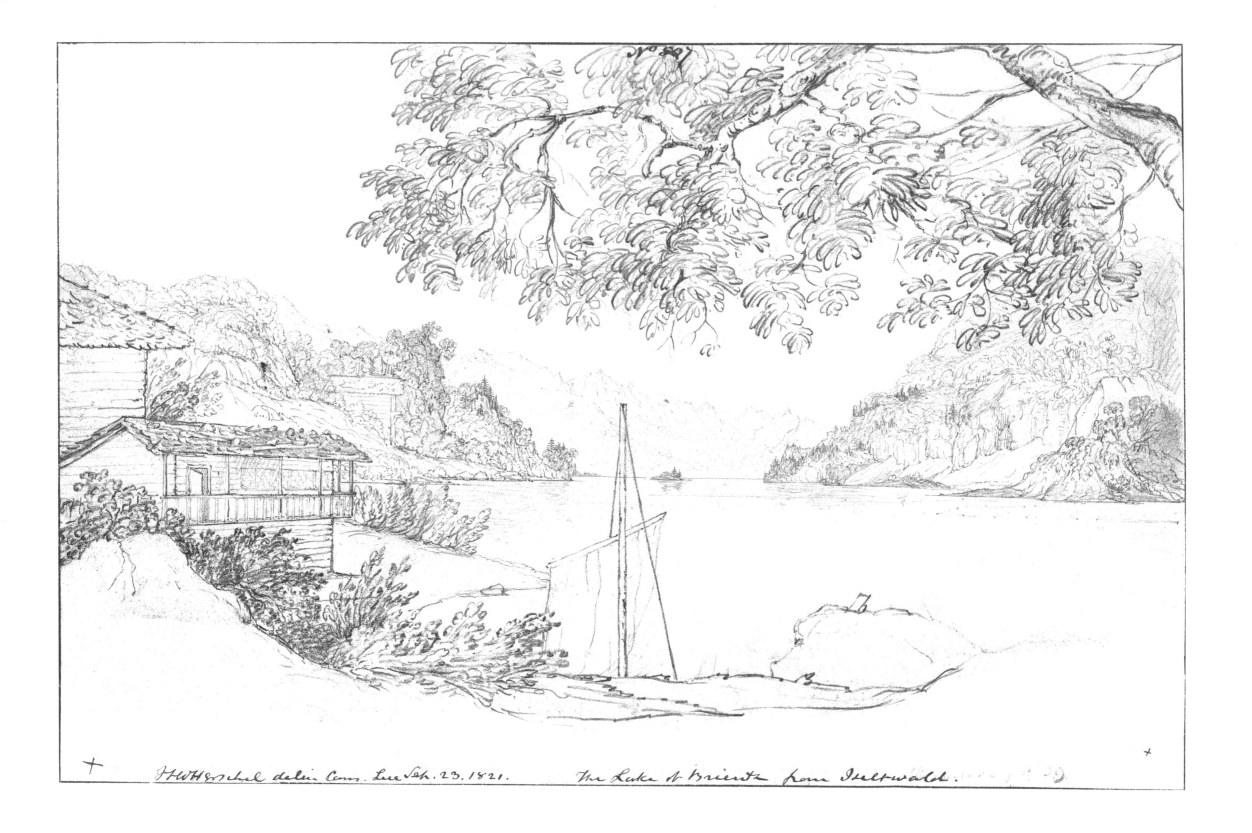

JFWHerschel delin. Cam. Luc. Sep. 23. 1821. The Lake of Brientz from Iseltwald.

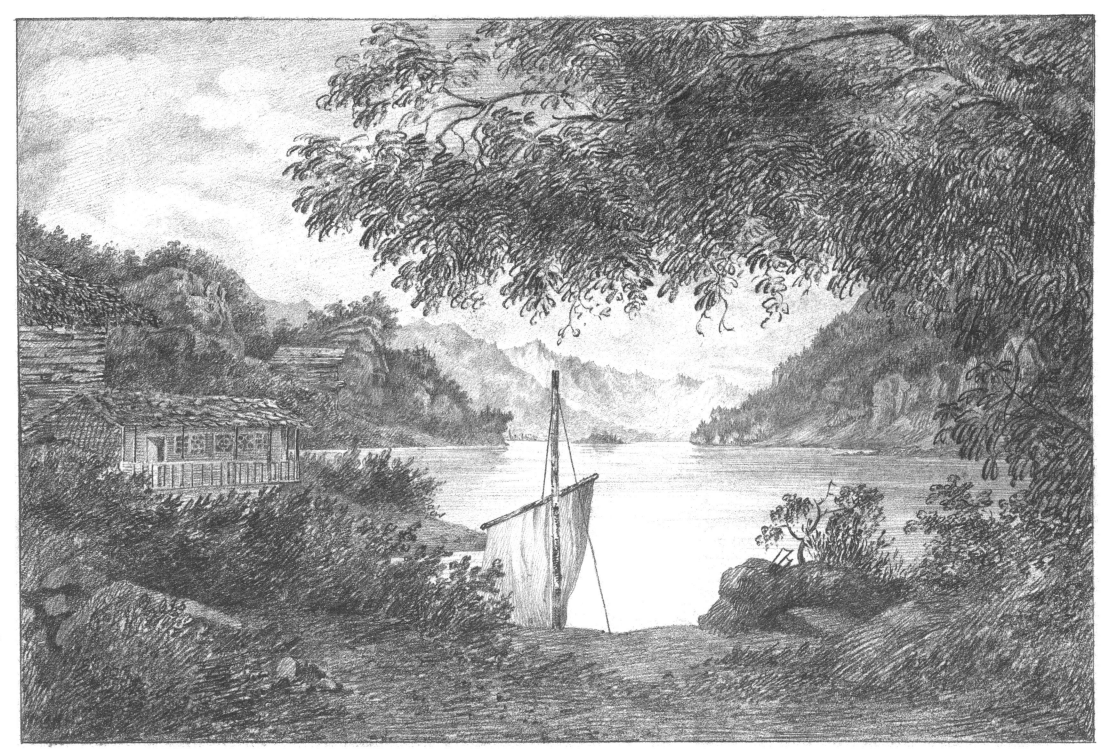

Lake of Brienz from Iseltwald.

Wetterstein bei Correden Sep. 4 1821

J. F. W. Herschel. Copied from the Original Camera Lucida drawing of Sep. 4. 1821. by J. F. W. H. Earth Columns at Stalde in the Visp-Thal. Switzerland.

PLATE 7. *No. 338. J.F.W. Herschel del. Cam. Luc. Sep 15, 1821. Castle of Chillon near view. Dent du Midi &tc.* 18.3 x 28.3 cm.

PLATE 8. *No. 328. J.F.W. Herschel del. Cam. Luc. Aug 1821. Defile of the Arveinn "Les horreurs."* 18.2 x 28.2 cm.

In spite of indifferent health, Herschel was an active and courageous explorer. Writing to his mother from Chamouni, he related that the party returned "into the valley of Zermatt whence we came. The highest crest of the mountain now only remained to climb. It was tremendous, being literally a sharp edge of snow along which a cat might have walked. Our tour guides from Zermatt here refused to go a step further.... Coutet and I set out together...and, making a circuit so as to avoid the edge of the precipice, succeeded in happily reaching the Summit...thus I had the pleasure of being the only Englishman, and but the second or third individual who has ever set foot on the summit of this stupendous mountain."[1] It was a great test of will, but by the time Herschel returned to this peak three years later, he had been convinced that "we were not on Mt. Rosa at all, but on the Little Mont Cervin, otherwise called the Bright Horn and which now will be brighter than ever, having been illuminated by our presence."[2]

1. Letter, Herschel to his mother, from Chamouni, 15 August 1821. L0515, Herschel Collection, the Humanities Research Center, The University of Texas at Austin.
2. Letter, Herschel to Babbage, 3 October 1824, from Hanover. HS2:199, Herschel Correspondence, The Royal Society, London.

PLATE 9. *No. 351. J.F.W. Herschel del. Cam. Luc.* [18 April] *1824. Turin with the chain of the Alps. from the roof of the Observatory.* 20.2 x 31.0 cm.

Herschel, now travelling with just a servant on his second *Grand Tour,* wrote to his friend Charles Babbage that "the view of the Alps from the observatory Roof at Turin...is the finest thing conceivable we missed this when we were there together...this is the most delicious spot on earth as you would say if you saw it in such weather & were enjoying here the luxury of repose, good feeding, & pleasant society after crossing Mt. Cenis in the snow and being at once scorched & frozen & buried alive."[1] To his mother, he enthused that "the glorious spectacle of the Alps which surround the town like a bulwark of ice at the distance of fifty to a hundred miles...is the finest sight in the world;" he promised that "you shall see a drawing of it I took from the top of the Observatory yesterday."[2]

1. Letter, Herschel to Babbage, from Aiguebelle 11 April 1824, continued on 22 April. HS2:194, Herschel Correspondence, The Royal Society, London.
2. Letter, Herschel to his mother, from Turin, 19 April 1824. L0517, Herschel Collection, the Humanities Research Center, The University of Texas at Austin.

Coord. of
Roche Invention x = 7·065, y = 3·65
Dome des Jesuites x = 7·4 y = 2·65
Cloche des Jesuites x = 7·81 y = 2·95

Turin from the Observatory

J.F.W. Herschel del. Cam. Luc. . .. 1824 Turin with the Chain of the Alps. From the Roof of the Observatory.

PLATE 10. *No. 353. J.F.W. Herschel delin 1824 Cam. Luc. Padua with the Euganean Hills, from the roof of the Observatory, looking nearly W.S.W. 21.6 x 32.4 cm.*

Monte Corvo
Stazione trigonometrica
Monte Rua
Monte Venda
Monte Madonna

J.F.W. Herschel delin. 1824. Cam. Luc. Padua with the Euganean Hills. From the Roof of the Observatory. Looking nearly, W.S.W.

PLATE 11. *No. 354. J.F.W. Herschel delin Cam. Luc. 1824. Church of S^{to.} Antonio, Padua.* 19.9 x 30.6 cm.

The 'telescopic lens' effect of this is caused by Herschel's choice of an unusually long extension of the prism above the drawing paper -- 19 inches in this case, about twice the normal height.

JHW Herschel delin. Cam. Luc. 1824. Church of Stᵒ Antonio, Padua

PLATE 12. *No. 355. J.F.W. Herschel del. Cam. Luc. 1824. Florence from the Church of Monte alla Croce. Looking North West.* 19.9 x 30.8 cm.

On his first visit in 1821, Herschel reacted with surprise to the manners of Italians, particularly those of Italian women. His second trip, like the first, was prompted by an escape from failed love. Italy won him over, however, and to James Grahame he confided that "my mind is tranquil & I have fully succeeded in combatting the recollection of past events. Indeed I have been so fully occupied with the present, as to leave little room for their intrusion--for this purpose there is no recipe like travelling. I was mistaken in my impressions of Italy & ye Italian Character. I now see much to approve in it. I find them kind, open, & friendly, & natural."[1]

1. Draft of a letter from Herschel to Grahame, from Florence, 2 May 1824. HS8:319, Herschel Correspondence, The Royal Society, London.

JF Herschel del. Cam. Luc. 1824. Florence from the Church of Monte alle Croce Looking North West.

PLATE 13. *No. 358. J.F.W. Herschel del. Cam. Luc. 1824. Colossal Statue "Father Apennine" by John of Bologna in the Grand-ducal garden of Pratolino near Florence.* 19.9 x 30.8 cm.

Herschel found this a "very extraordinary...hoary giant shaggy with icicles which descend from his hair and beard and bowed with a weight of snow...it is finely imagined and of enormous magnitude, as you will easily suppose when I tell you I climbed into his head through a gallery hollowed out in his throat. There is a tolerable representation of this figure in the 'hundred wonders' but the <u>situation</u> of it there is supplied from fancy being quite different from reality. I returned to Florence from this excursion...desperately tired, though much gratified, and exclaiming against Italian heat -- Italian dust -- Italian mules -- and Italian hunger (having been near nine hours on foot). While poor James [his servant, James Child], who carried my drawing apparatus and some other necessary implements, was quite done up."[1]

1. Letter, Herschel to his mother, from Vallombrosa, 11 May 1824. LO517, Herschel Collection, the Humanities Research Center, The University of Texas at Austin.

JFWHerschel del Cam. Luc. ·1824· Colossal Statue "Father Apennine" by John of Bologna in the Grand-ducal Garden of Pratolino near Florence

PLATE 14. *No. 373. J.F.W. Herschel delin Cam. Luc. August 1824. Tivoli. Principal fall and Temple of Vesta.* 21.7 x 31.0 cm.

Two years after Herschel's visit, massive flooding of the Anio led to a change in its course, threatening the town. Emergency diversion tunnels were constructed between 1826 and 1835, forever changing the appearance of this site.

$ab = 53° 22'$
$eye \ 9·0$

JFWHerschel delin. Cam.Luc. August. 1824 Tivoli. Principal fall and Temple of Vesta.

PLATE 15. *No. 368. J.F.W. Herschel del. Cam. Luc. May 18, 1824. View of the Capitol, arch of Septimius Severus. Temples of Concord, &tc, taken with Extreme care & precision. 20.4 x 30.7 cm.*

Campo Vaccino Rome

JFW Herschel del. Corn. Luc. May 18. 1824 View of the Capitol, Arch of Septimicus Severus, Temple of Concord, &c. Taken with extreme care & precision

PLATE 16. *No. 367. J.F.W. Herschel del. Cam. Luc. Aug 8, 1824. Rome from the Pincian Terrace Beyond the Villa Medici.* 20.1 x 30.9 cm.

JFW Herschel del. Comn. Luc. August 8. 1824 Rome from the Pincian Terrace beyond the Villa Medici

PLATE 17. *No. 369. J.F.W. Herschel del. Cam. Luc. May 17, 1824. The Coliseum, Rome (with extreme care & precision).* 20.1 x 30.8 cm.

J.F.W.Herschel del. Cam. Luc. May 17. 1824. The Coliseum, Rome (with some care & pains)

PLATE 18. *No. 377. J.F.W. Herschel delin Cam. Luc. June 9, 1824. Interior of the Crater of Vesuvius.* 21.6 x 34.3 cm.

Herschel reported that "as there is no possibility of descending to the bottom, or even ever so small a distance down the sides, I could not ascertain its depth...while M. Covelli was arranging some chemical experiments...I ascended to the highest peak called the Palo--this point looks down on the valley...and after witnessing M. Covelli's experiments, taking a drawing of the Crater with the Camera Lucida...descended at a full gallop, among the craters."[1]

1. Letter, Herschel to his mother, from the Crater of Vesuvius, 8 June 1824. L0517, Herschel Collection, the Humanities Research Center, The University of Texas at Austin.

Crater of Vesuvius

JFW Herschel delin Cam. Luc. June 9. 1824.　　　Interior of the Crater of Vesuvius

PLATE 19. *No. 389. J.F.W. Herschel delin Cam. Luc. June 24, 1824. Temple of Segestum, Sicily.* 18.8 x 31.6 cm.

Herschel wrote to Sir William Watson that "in such melancholy solitudes are ye principal remains of Sicilian antiquity situated from the noble remains of ye Temple at Segestum, not a cottage can be discerned & hardly a tree or anything green. It stands surrounded with dry thistles in ye bosom of a lofty hill on an opposite mountain is an amphitheatre, while the plain between, where once stood a flourishing city, seems as if the voices of man had never been heard there."[1]

1. Letter, Herschel to Watson, from Palermo, 16 July 1824. LO494, Herschel Collection, the Humanities Research Center, The University of Texas at Austin.

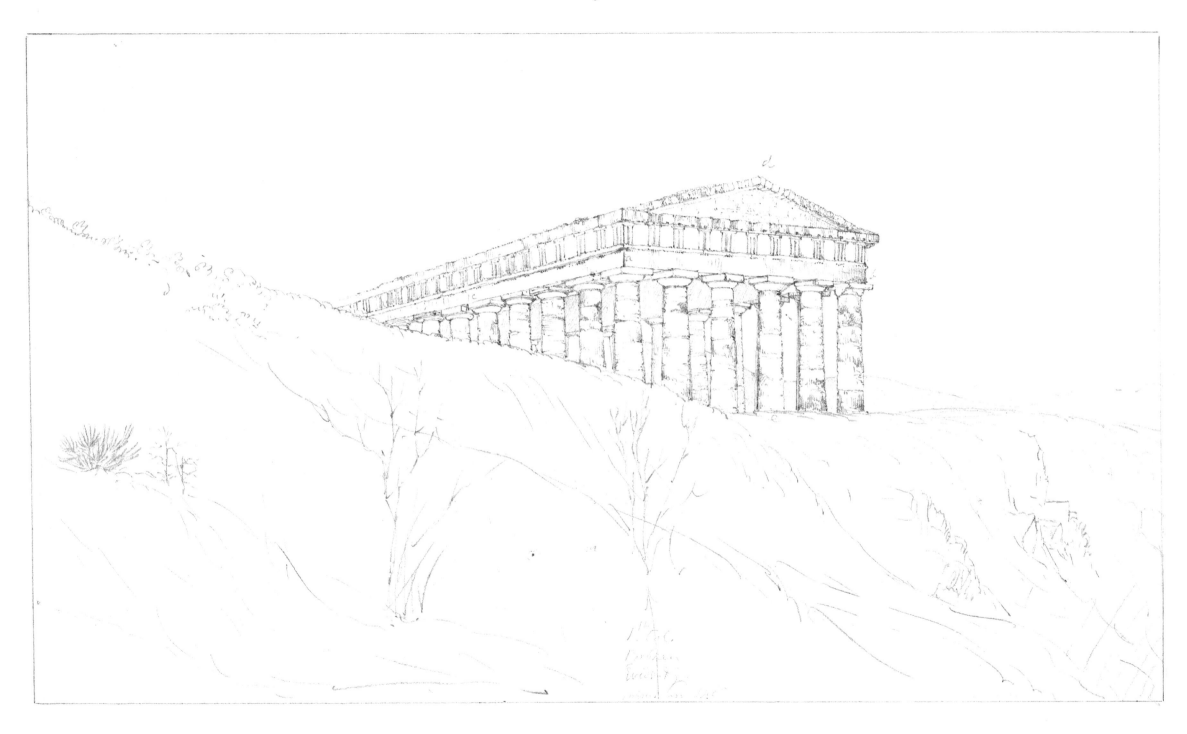

JFW Herschel delin. Cam. Luc. June 24. 1824. Temple of Segestum, Sicily

PLATE 20. *No. 390. J.F.W. Herschel delin Cam. Luc. June 25, 1824. Ruins of the 1st or Great Temple at Selinunte, Sicily.* 18.9 x 33.2 cm.

What at first appears to be an exercise in drawing three-dimensional forms in fact records the extraordinary aftermath of an ancient earthquake. "The Gigantic ruins of Selinunte...lie in a dreary solitude, infested by the Malaria, by ye sea side. A passing sail in ye offing now & then reminds one that there is a world without, full of life & activity, which else one might forget in the dreams of other times & in the dead silence of the scene. Their ruins are indeed stupendous...."[1]

1. Letter, Herschel to Sir William Watson, from Palermo, 16 July 1824. L0494, Herschel Collection, the Humanities Research Center, The University of Texas at Austin.

JHFHerschel delin Camr Luc June 25. 1824. Ruins of the 1st or great Temple at Selinunte, Sicily

PLATE 21. *No. 391. J.F.W. Herschel del. Cam. Luc. June 27, 1824. View from below the temple of Juno. Girgenti. Sicily. Temple of Concord in the distance.* 19.9 x 30.9 cm.

Herschel told his mother that he found it "a most curious place & full of ruins the Rocks being all honeycombed with houses &c and the Temples superb. I have crammed my drawing cases with views of them."[1] To Sir William Watson, however, he was more philosophical: "the ruins of ancient Agrigentum...stand now far aloof from the modern town w^h has retreated from ye pestilential influence of ye air to ye summit of a hill 2 or 3 miles off. It is incredible what an awful air this circumstance gives them. One must be on ye spot to feel its full effect. It seems as if they were preserved as monuments of wrath as if the curse which devastated still clove to them & caused them to be at once admired & shunned. It is indeed the beauty of desolation, for finer architectural remains can hardly be imagined."[2] In 1928, Girgenti reverted to its classical name of Agrigentum.

1. Letter, Herschel to his mother, from Catania, 1 July 1824. LO517, Herschel Collection, the Humanities Research Center, The University of Texas at Austin.
2. Letter, Herschel to Watson, from Palermo, 16 July 1824. L0494, Herschel Collection, the Humanities Research Center, The University of Texas at Austin.

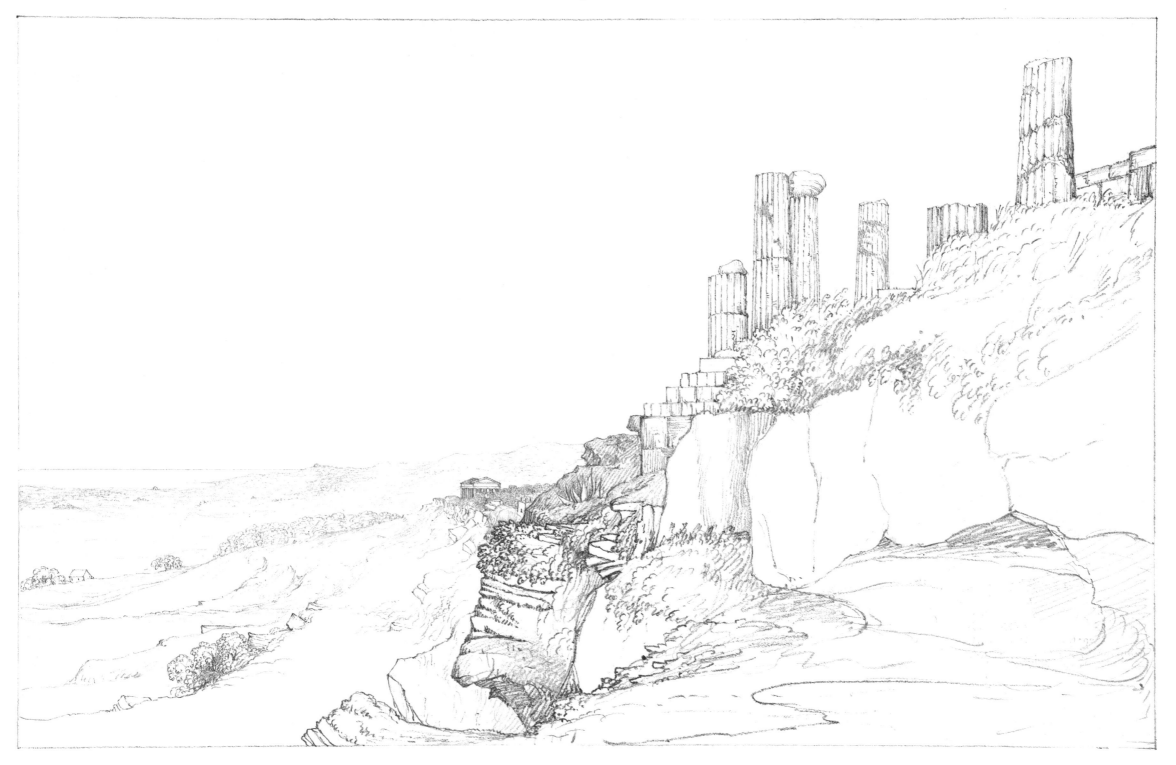

JF Herschel del Cam. Luc. June 27. 1824. View from below the Temple of Juno. Girgenti Sicily. Temple of Concord in the distance

PLATE 22. *No. 398. J.F.W. Herschel del. Cam. Luc. July 4, 1824. Crater of Etna looking Northward along the Western rim. The Lipari Islands in the distance.* 19.9 x 33.3 cm.

To his aunt Caroline, Herschel wrote that "we soon reached the limit of vegetation & a long, desolate scorched slope, knee deep in ashes, extends for about 5 miles to a little hut where I passed the night (a glorious starlight one)...and the next morning mounted the Crater by a desperate scramble up a cone of lava & ashes about 1000 feet high.... On the highest point of the crater I was enveloped in suffocating sulphurous vapours & was glad enough to make my observations...and get down...reached Catania the same night almost dead with the morning scramble and the dreadful descent of near 30 miles where the mules (which can be used for a considerable part of the way) could scarce keep their feet."[1] He was a little more candid about his circumstances with his former travelling companion, Charles Babbage: "I am writing to you very comfortably from Gemellaro's hut on the top of Etna with my guide snoring in his adjoining room and a formidable apparition of instruments and eatables besides me. I brought up a bed but it is full of fleas and as there is no mat to be had and the night is beautiful I shall divide my time till day light between my instruments & my friends." From Palermo, he continued on 11 July: "It is easier to begin a letter from the top of Etna than to finish it there, as this is a proof. I have now made the tour of Sicily and I thank heaven it is done. If it be pleasure to ride from 30 to 50 miles a day over roads all but impracticable for mules, under a scorching sun with the thermometer at 86 and over wilds & wastes where no verdure is to been seen, but groups of Cactus & hedge-rows of majestic Aloes from 20 to 30 feet high to break the monotony to be <u>broiled</u> all day and at night to be <u>eaten</u> to sketch ruins in the Sirocco & with the fear of mal-aria before one's eyes if this be pleasure, there is no doubt that I have been in Elysium for the last three weeks. But it is worth taking some pains & undergoing some hardships to have seen this curious & most interesting Country. I wish I had only been a month earlier & had more time at my disposal."[2]

1. Letter, Herschel to Caroline; Sicily, 2 July 1824 and continued from Naples, 20 August 1824. L0569, Herschel Collection, the Humanities Research Center, The University of Texas at Austin.
2. Letter, Herschel to Babbage, from Etna, 4 July 1824. HS2:197, Herschel Correspondence, The Royal Society, London.

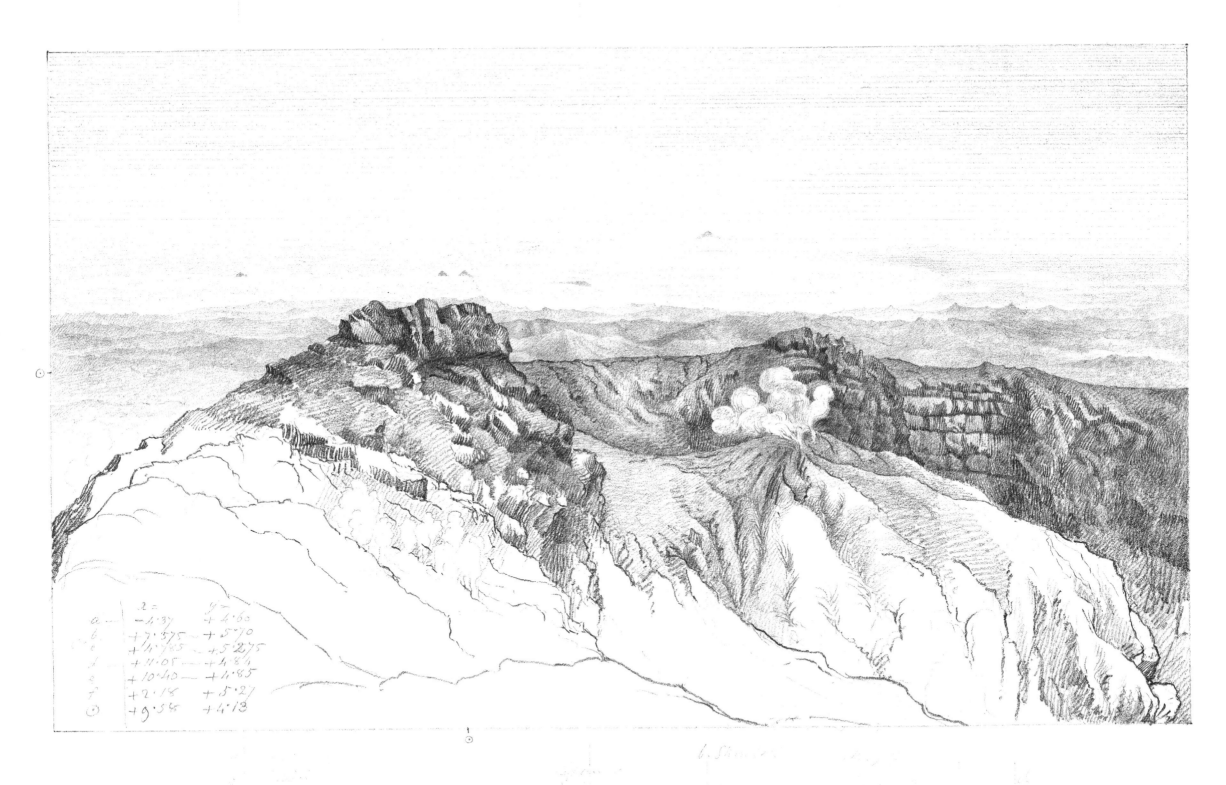

	$x =$	$y =$
a	−4·37	+4·60
b	+7·375	+5·70
c	+4·85	+5·275
d	+4·05	+4·84
e	+10·40	+4·85
f	+2·18	+5·27
⊙	+9·58	+4·13

J. F. W. Herschel del. Cam. Luc. July 4. 1824. Crater of Etna. Looking northward along the Western Rim. The Lipari Islands in the distance

PLATE 23. *No. 292. J.F.W. Herschel del. Cam. Luc. 1824. Waterfall between the Walcher-see & the Kochl-see, Bavaria.* 19.9 x 30.8 cm.

Herschel made this "very hasty sketch" while travelling towards Munich. Less than a week later, he "fell in here with a very agreeable & gentlemanly man a Captain Feilding, who with his wife (Lady Elisabeth Feilding) & his son (a Cambridge man) and his two daughters have been residing here some time, after travelling about the Continent for a good while and residing first at one place & then at another."[1] The 'Cambridge man' was William Henry Fox Talbot, who appears not to have made much of an impression on Herschel at this, their first meeting. Their shared scientific and mathematical interests soon made them friends. Seven years after this meeting, Talbot invented photography as a result of his frustration with trying to use the camera lucida. Had Herschel shown the family his portfolio of drawings while in Munich?

1. Letter, Herschel to his mother, from Munich, 20 September 1824. L0517, Herschel Collection, the Humanities Research Center, The University of Texas at Austin.

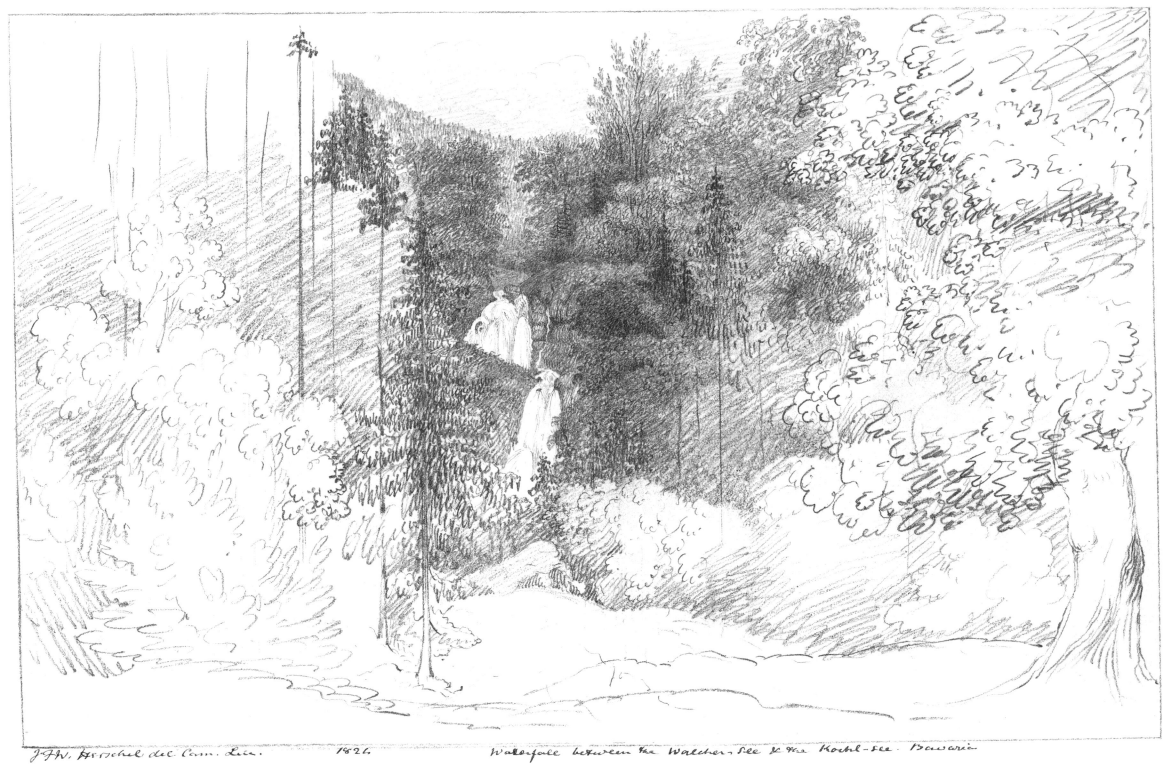

J.F.W. Herschel del. Cam. Luc. 1826 Waterfall between the Walchen-See & the Kochl-See. Bavaria

PLATE 24. *No. 451. J.F.W. Herschel delin Cam. Luc. Sep 21, 1826. 3ʰ 45ᵐ PM. Exterior view of the Amphitheatre, Nismes.* 21.8 x 32.9 cm.

Nîmes, the ancient Nemausus, claims the best preserved amphitheatre in France. Built in the 1st or 2nd century, it had become occupied during the middle ages by a special quarter, but the 440' long elliptical bowl was cleared in 1809. Herschel found that the "noble amphitheatre, of which though I staid here only the afternoon of one day...I had time (thanks to my Camera) to take two good views, an interior & an exterior, is really a superb thing."[1]

1. Letter, Herschel to his mother, from Montelimart, 22 September 1826. L0518, Herschel Collection, the Humanities Research Center, The University of Texas at Austin.

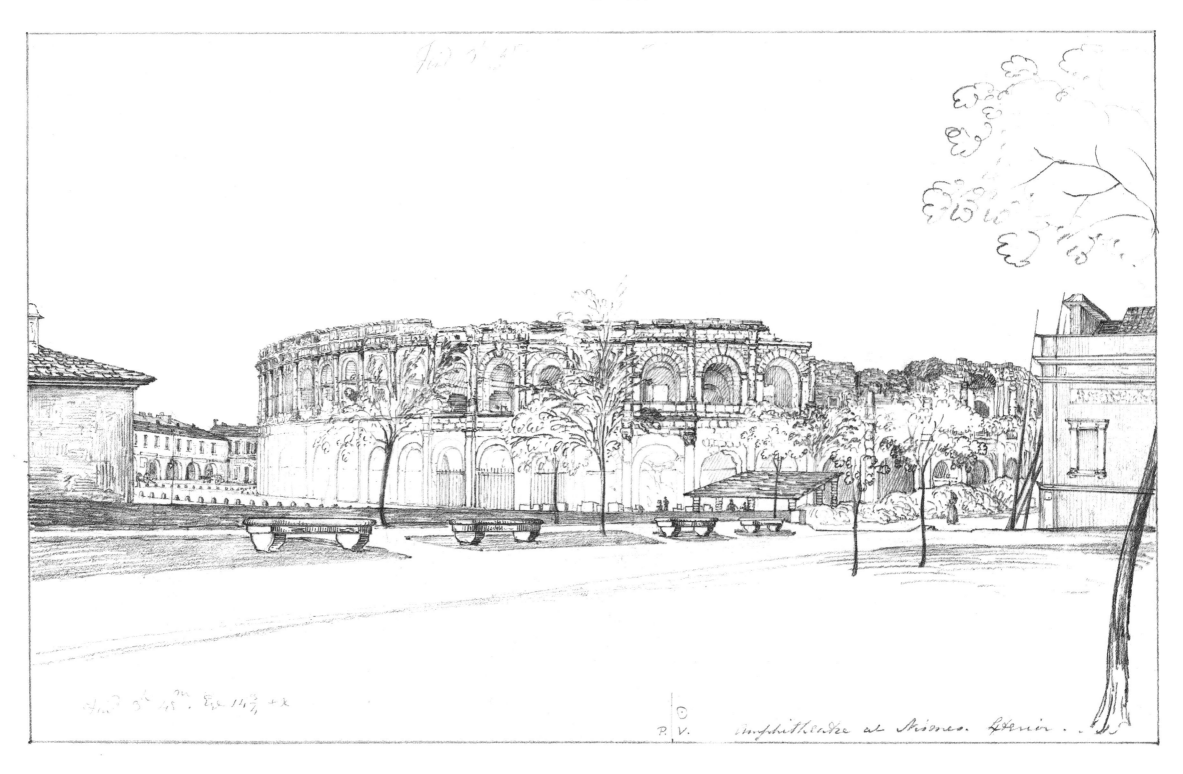

P. V. Amphitheatre at Nismes. Exterior.

JFW Herschel delin Cam. Luc. Sep 21. 1826. 3ʰ 45ᵐ P.M. Exterior view of the Amphitheatre, Nismes.

PLATE 25. *No. 450. J.F.W. Herschel delin Cam. Luc. Sep 21, 1850 [sic]. Interior of the Amphitheatre, Nismes.* 21.8 x 34.2 cm.

Although labelled 1850, Herschel recorded this view in his manuscript notebook as having been taken less than two hours after No. 451, in 1826.

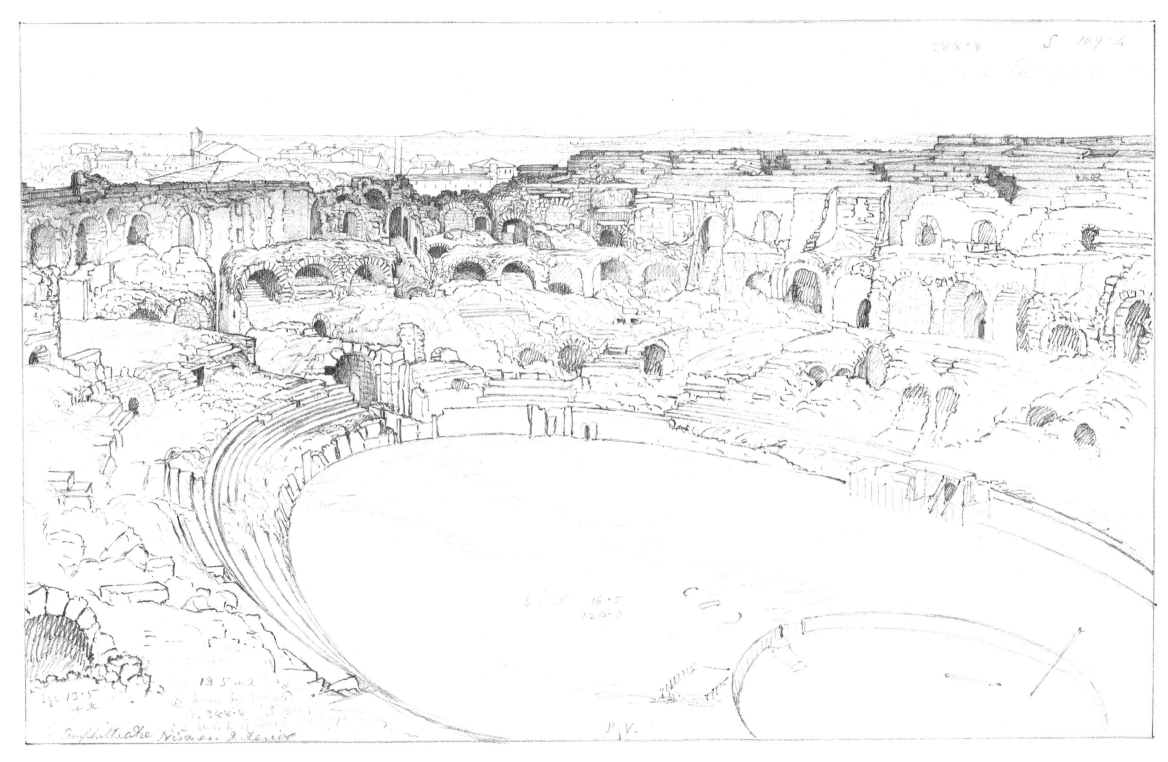

JFWHerschel delin. Cam. Luc. Sep. 21. 1850 Interior of the Amphitheatre, Nismes.

PLATE 26. *No. 480. J.F.W. Herschel del. Cam. Luc. Sep 27, 1826. Town of Entraigues shewing the situation of the "Fromage" on the Granite Rock.* 21.4 x 34.9 cm.

To Babbage, Herschel wrote that "I wish I could give you half an idea of the magnificence of scenery which exists in this valley. It is all of the <u>home</u> kind. Glorious Chesnuts & Walnuts of a Century's date canopy the whole road (20-feet wide)." To his mother, he added that "the valley...is a most magnificent piece of scenery and the geological drawings I made there have a touch of the romantic & picturesque which geological drawings do not always possess. I could have staid a month there. A painter would be out of his wits in such a spot."[1]

1. Letter, Herschel to his mother, from Lyons, 1 October 1826. L0518, Herschel Collection, the Humanities Research Center, The University of Texas at Austin.

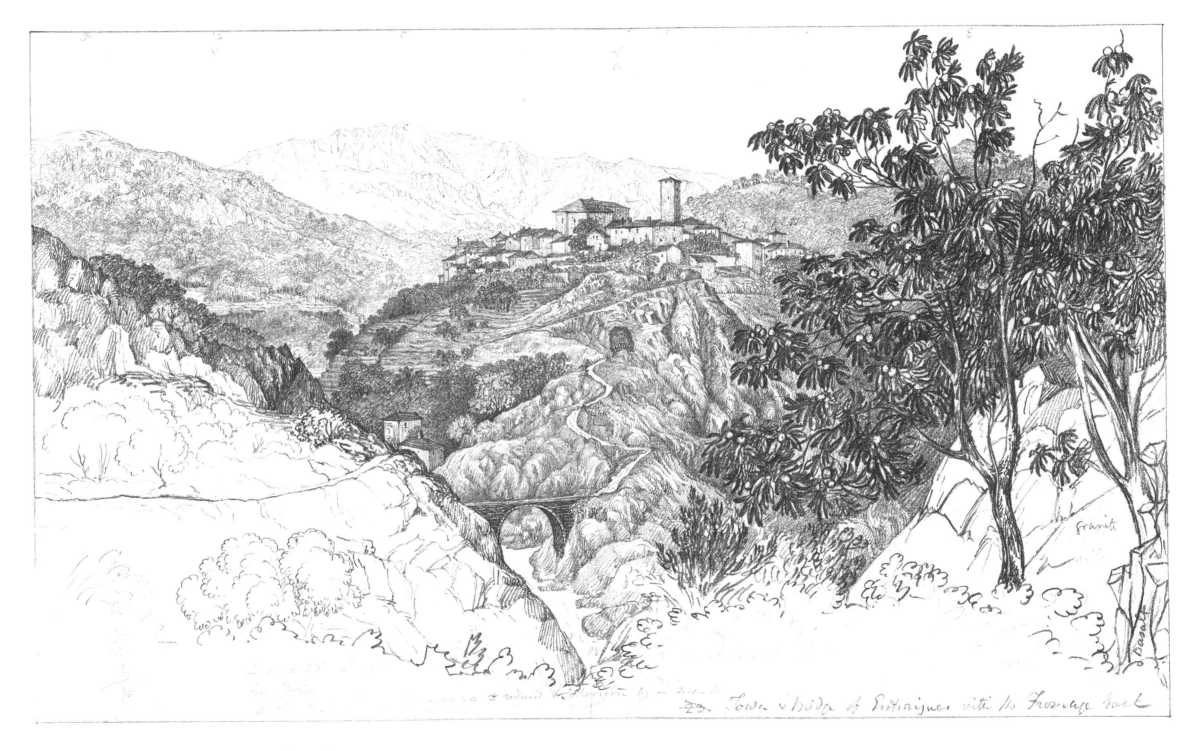

granite

Tower & bridge of Entraigues with the Fromage Rock

JFWHerschel del. Cam. Luc. Sep 27. 1826 Town of Entraigues shewing the situation of the "Fromage" on the Granite Rock.

PLATE 27. *No. 566. J.F.W. Herschel delin Cam. Luc. Sep 29, 1827. Menai Suspension Bridge from the Beach on the Anglesea side.* 19.7 x 30.9 cm.

Herschel was a man split between two centuries and two ways of life. Escaping the pressures of London, with all the entanglements of organized science, the 18th century John Herschel fled to Ireland. However, his 19th century side, thrilled by the astounding accomplishments industrialized man was beginning to achieve, could not help but marvel at this colossal structure. In Herschel's influential *Preliminary Discourse on the Study of Natural Philosophy,* he held the Menai Bridge up as "one of the most stupendous works of art that has been raised by man in modern ages." It "consists of a mass of iron, not less than four millions of pounds in weight, suspended at a medium height of about 120 feet above the sea."[1]

1. (London: Longman, Rees, Orme, Brown, & Green, 1830), p. 60.

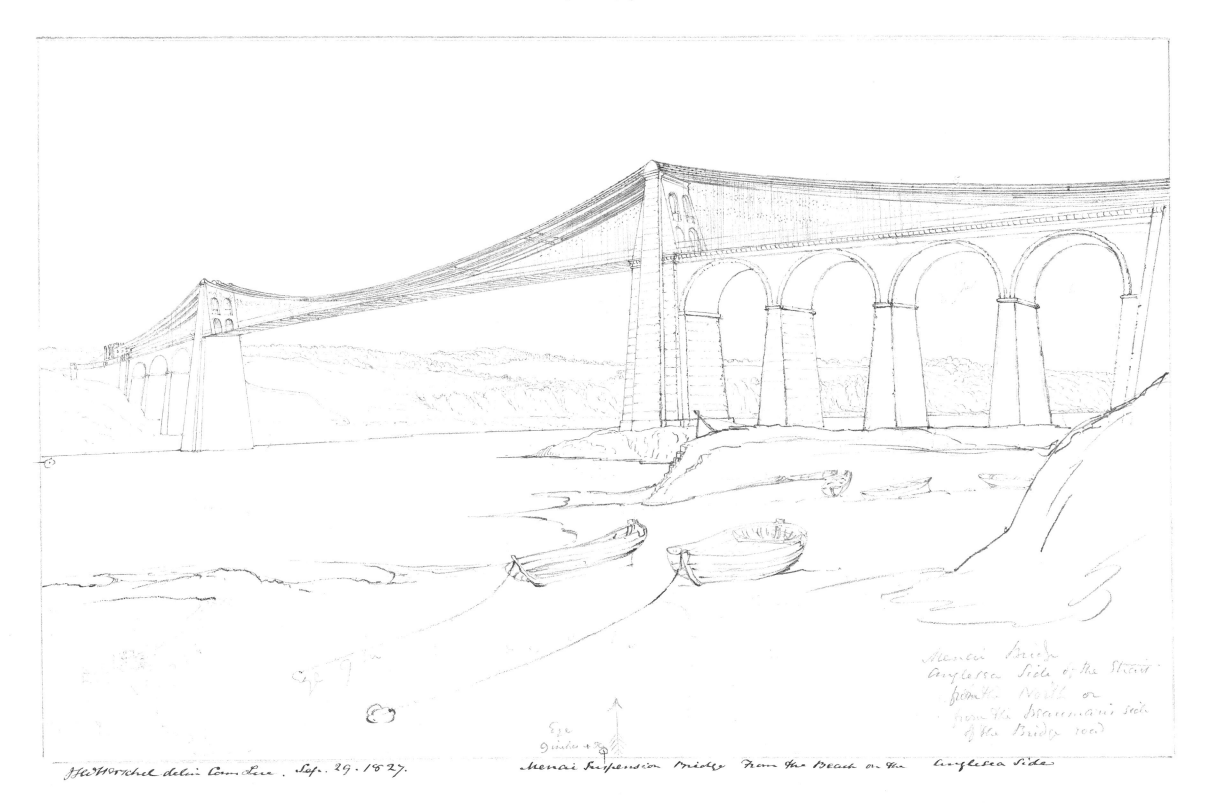

JF W Herschel delin Camm Lure. Sep. 29. 1827.

Menai Suspension Bridge from the Beach on the Anglesea Side

Menai Bridge
Anglesea Side of the Strait
from the North or
from the Beaumaris side
of the Bridge road

PLATE 28. *No. 550. J.F.W. Herschel del. Cam. Luc. Bengore Head. Giant's Causeway. Antrim, Ireland.* [September 1827] 20.7 x 31.0 cm.

Herschel cautioned in his marginal note that this was "drawn in a heavy rain the paper streaming with water & under every unfavourable circumstance for the use of the camera, but the general outline may be relied on — only query the course of the red layers marked a a a being put in afterwards in conformity with parts marked Red and red rock." This complex area had long been of interest to him. In 1820, when he and Babbage were first starting their mineralogical jaunts, Herschel wrote that "when our Cornish expedition is done (if we do not break our necks by the way) I have a plan...for making a trajectory from St. David's to Hereford & then fairly cutting across Ireland to the Lake of Killarney. If this does not satiate my wandering propensities there is no remedy but a tooth & nail attack on the Giants Causeway."[1]

1. Letter, Herschel to Babbage, 12 July 1820. HS2:138, Herschel Correspondence, The Royal Society, London.

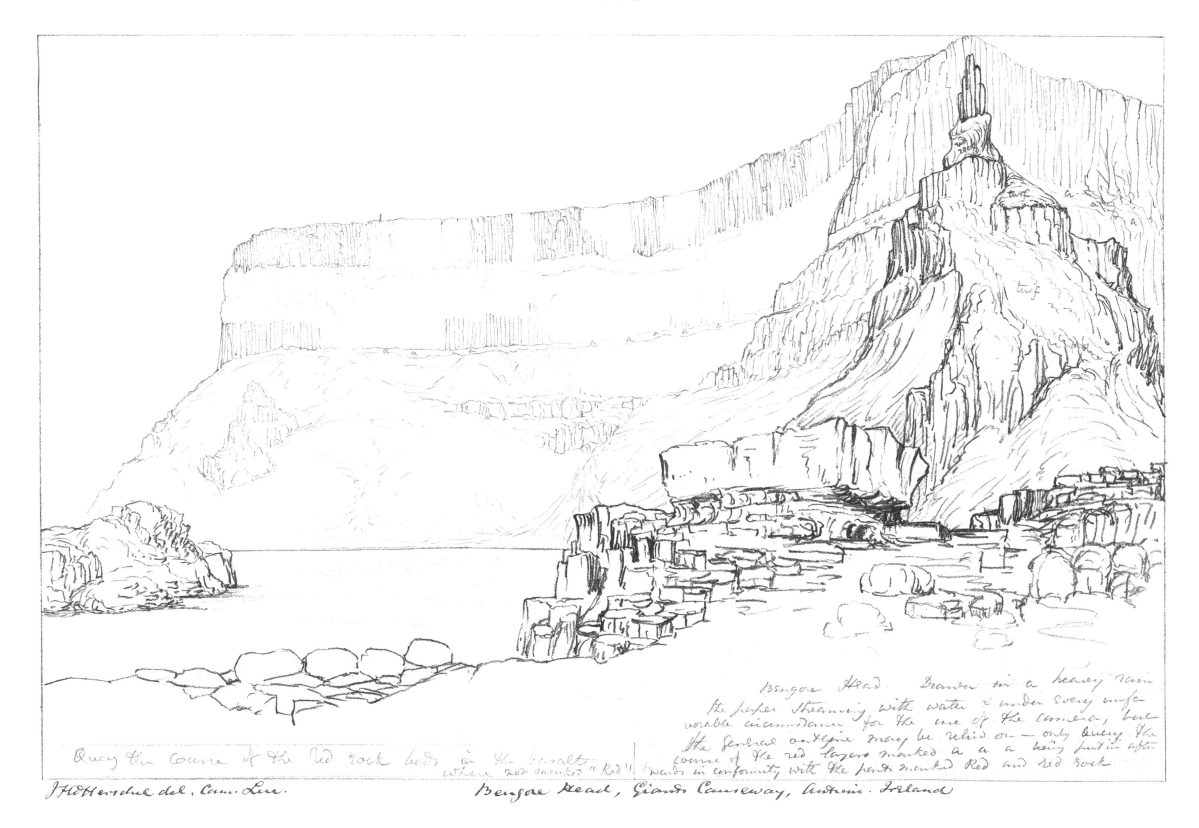

Bengore Head. Drawn in a heavy rain
the paper streaming with water & under every unfa
vorable circumstance for the use of the camera, but
the general outline may be relied on — only query the
course of the red layers marked a a a being put in after
wards in conformity with the parts marked Red and red rock

Query the course of the Red rock beds in the basalt
where not marked "Red"

JFW Herschel del. Cam. Luc.

Bengore Head, Giants Causeway, Antrim. Ireland

PLATE 29. *No. 267. J.F.W. Herschel delin Cam. Luc. Antwerp Cathedral.* [16 Oct. 1824] 19.3 x 29.2 cm.

This was Herschel's first drawing of the finest Gothic church in Belgium. Started in the 14th century, the second 400' foot tower originally planned was never built.

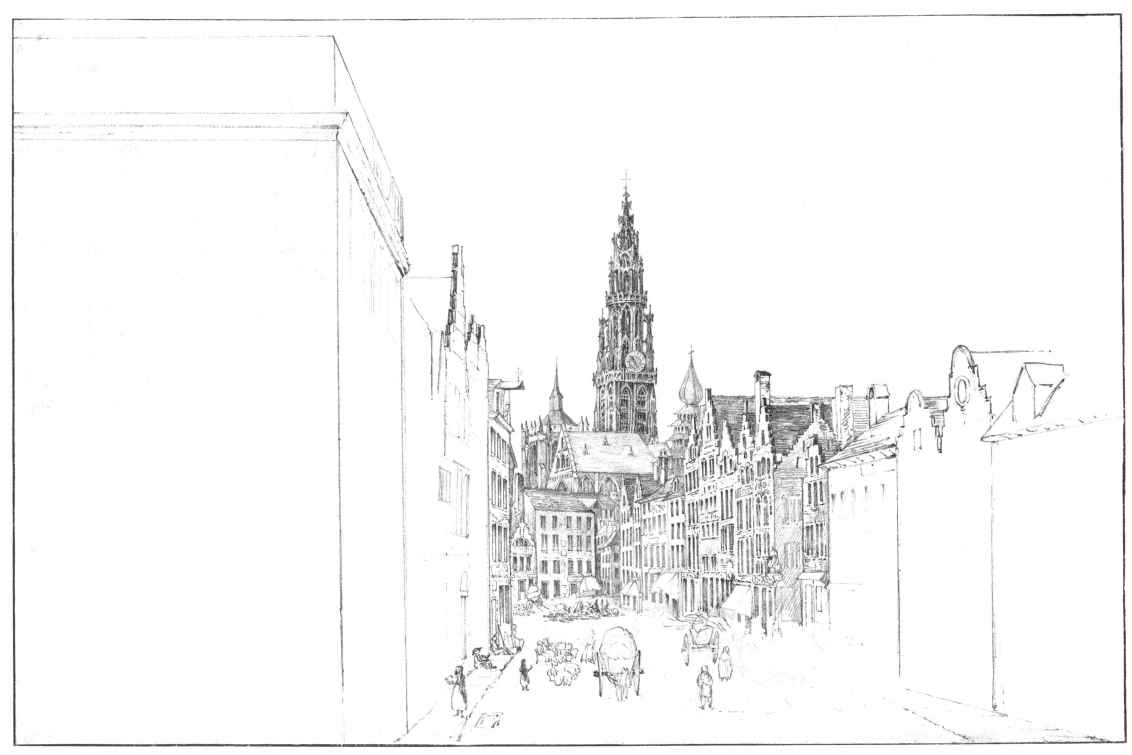

J. F. W. Herschel delin. Cam. Luc.

Antwerp Cathedral

PLATE 30. *No. 264. J.F.W. Herschel del. Cam. Luc. May 24, 1829. Ruins of the Abbey of St. Bertin, St. Omer.* 20.1 x 31.0 cm.

The heartbroken scientific traveller of 1824 now had companions. His new wife, Margaret, and her younger brother, John Stewart (later to become an accomplished photographer), joined Herschel. 'Maggie' recorded in her journal that "the materials of the Abbey being sold at the time of the revolution, it narrowly escaped being all taken down. The steeple remains & most of the arches a beautiful specimen of the florid Gothic."[1]

1. Margaret Herschel's 1829 Travel Journal. W0062, Herschel Collection, the Humanities Research Center, The University of Texas at Austin.

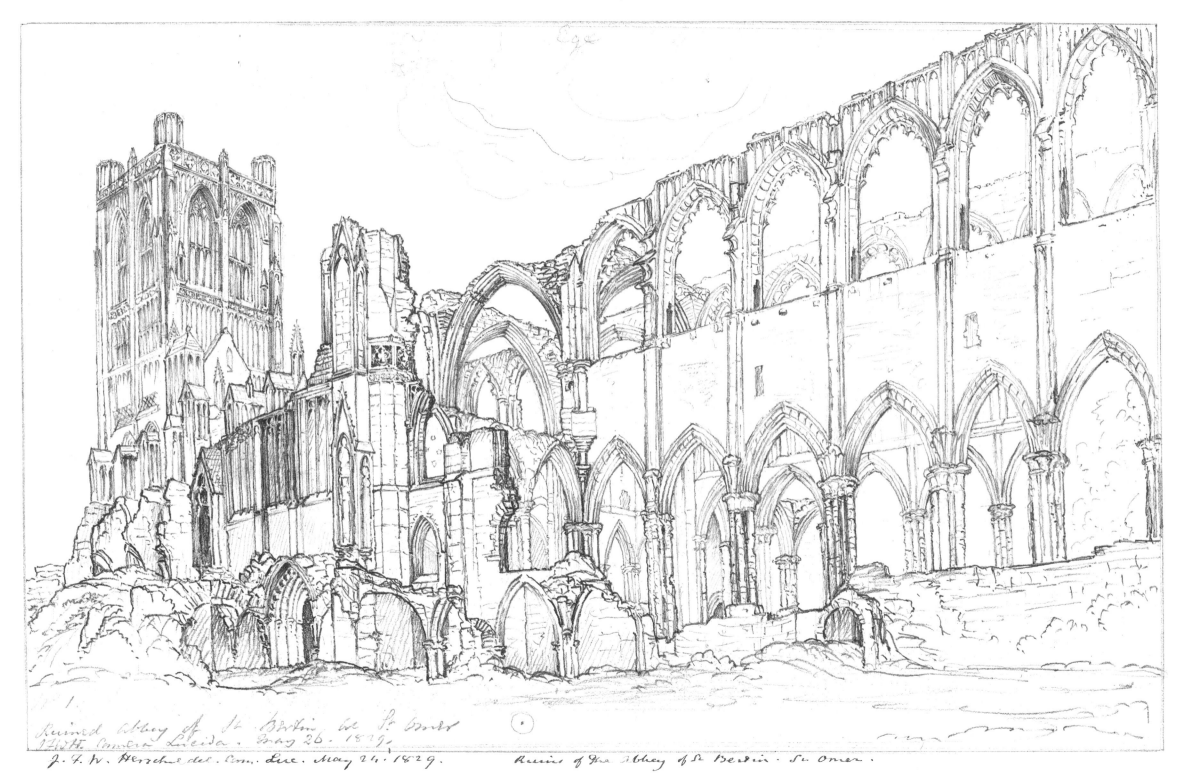

Ruined Abbey of St Bertin at St Omer
With Camera Lucida. May 26. 1829.

J. F. W. Herschel del. Cam. Luc. May 24. 1829. Ruins of the Abbey of St Bertin. St Omer.

PLATE 31. *No. 282. J.F.W. Herschel delin Cam. Luc. July 2, 1829. The Old Schloss Baden Baden.* 19.2 x 32.0 cm.

Herschel's tours in 1821 and 1824 had been prompted by broken romances. This journey was different. Married just four months to Maggie Stewart, John exulted in travelling with a beautiful and plucky partner who shared his artistic, scientific, and intellectual interests. From Baden-Baden, he wrote of an idyllic existence: "we go about sketching, reading, & hammering the hills, flute playing &c. &c." [1]

1. Letter, Herschel to his mother, from Baden Baden, 2 July 1829. L0521, Herschel Collection, the Humanities Research Center, The University of Texas at Austin.

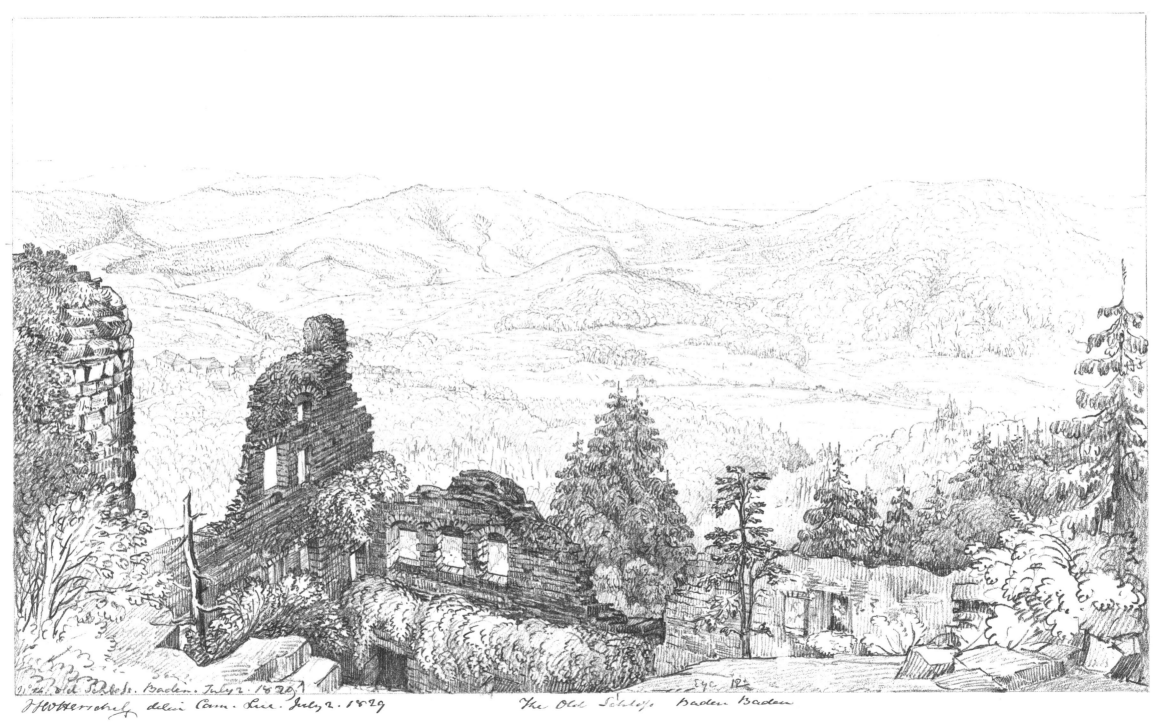

N° 26 old Schloss. Baden. July 2. 1829

JFWHerschel delin Cam. Luc. July 2. 1829

The Old Schloss Baden Baden

PLATE 32. *No. 557. J.F.W. Herschel delin Cam. Luc. 1829. Worcester Cathedral.* 19.9 x 32.1 cm.

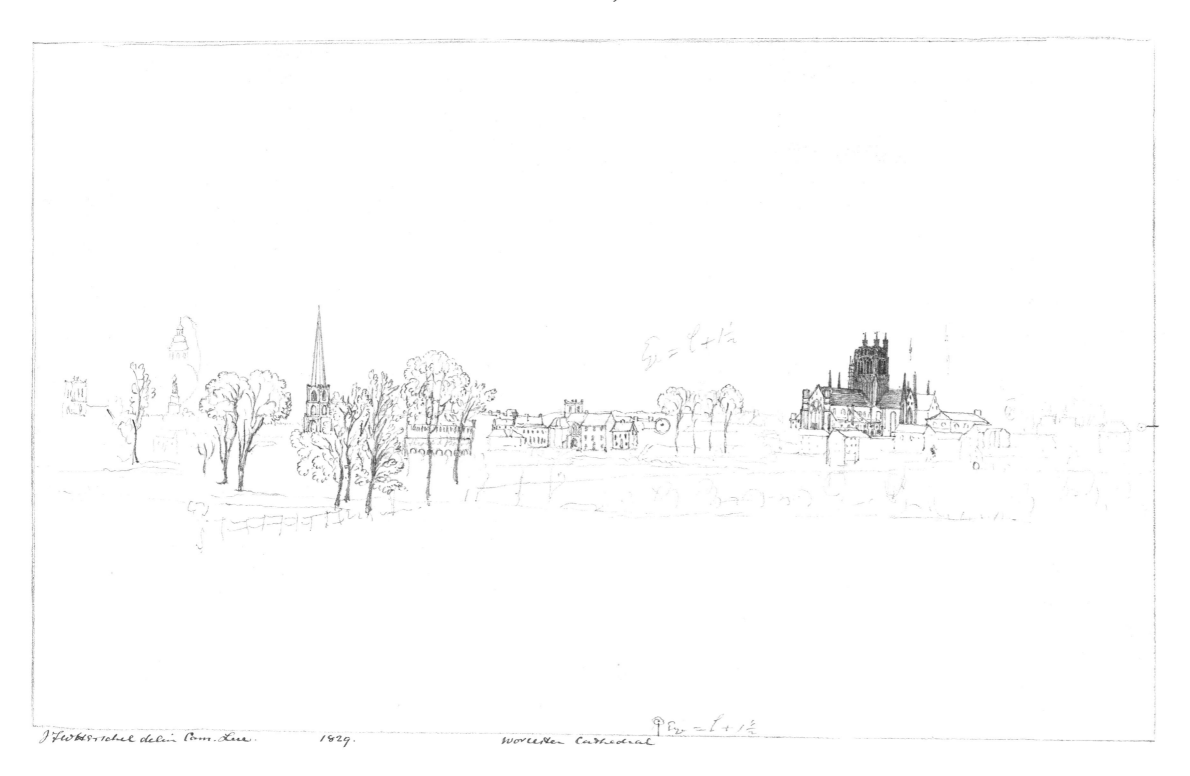

$$E_2 = l + \tfrac{1}{2}$$

$E_2 = l + \tfrac{1}{2}$

JFW Herschel delin Cam. Luc. 1829. Worcester Cathedral

PLATE 33. *No. 544. J.F.W. Herschel delin Cam. Luc. July...1831. Scratchell's Bay near Freshwater. Isle of Wight.* 20.2 x 33.0 cm.

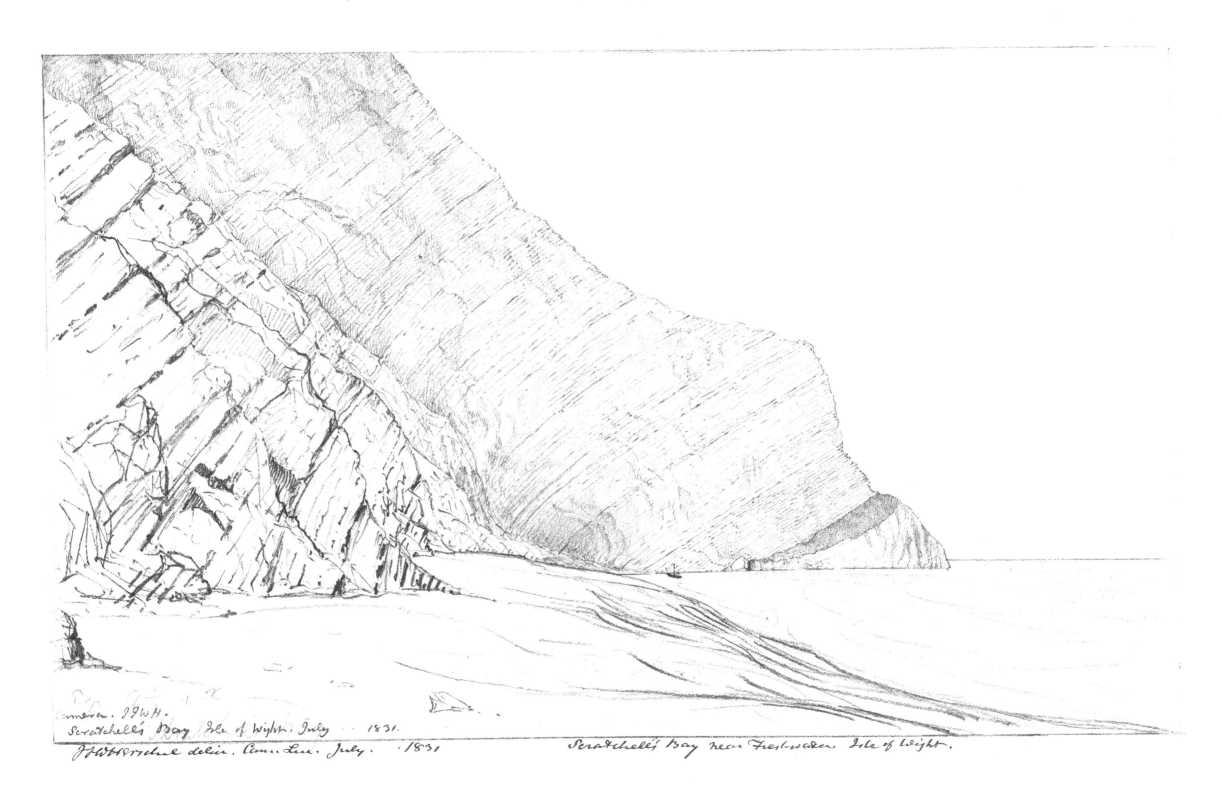

Camera. IIWH.
Scratchell's Bay. Isle of Wight. July . . 1831.

JFWHerschel delin. Cam. Luc. July. . 1831. Scratchell's Bay near Freshwater. Isle of Wight.

PLATE 34. *No. 548. J.F.W. Herschel delin Cam. Luc. July...1832. Netley Abbey. Southampton. Nave & West Window.*

In 1828, a close friend, James Grahame, and Herschel had "rowed by moonlight to Netley Abbey" and discussed his impending proposal to Margaret Brodie Stewart. They "passed an hour in a close and whispered confidence in the main aisle under the ash trees, with the stars looking in above. An unearthly scene!"[1]

1. Herschel diary entry, 22 September 1828. Diary W0010, Herschel Collection, the Humanities Research Center, The University of Texas at Austin.

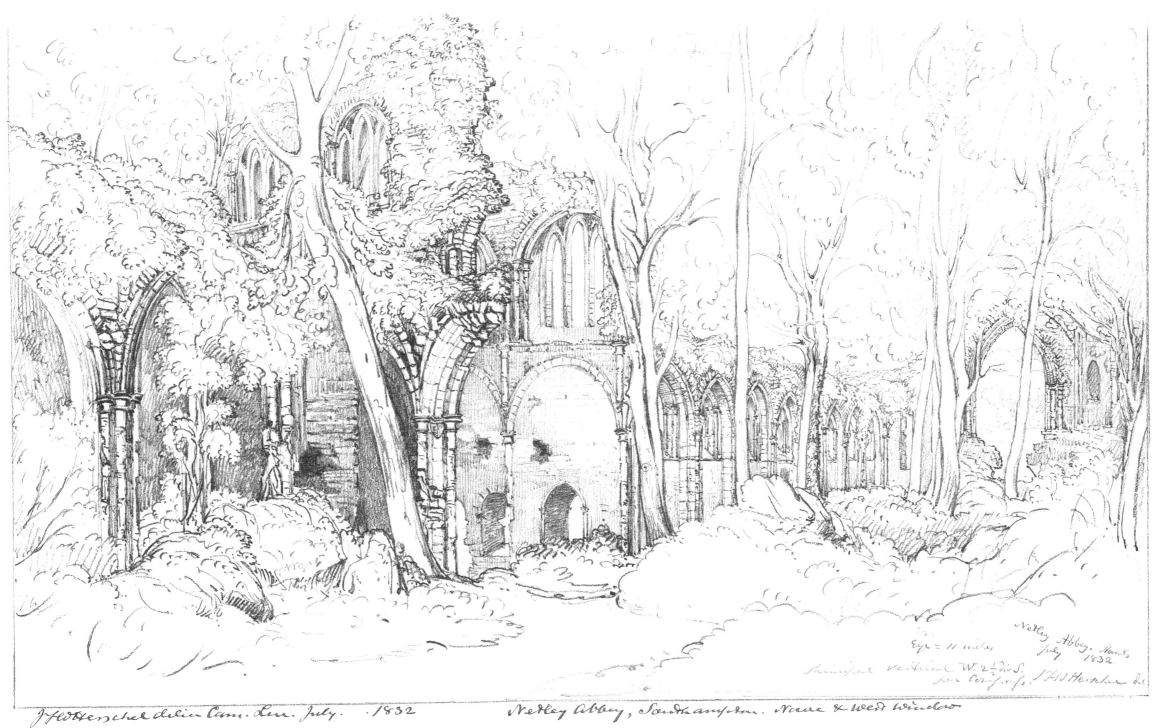

J.F.W Herschel delin Cam. Luc. July. 1832 Netley Abbey, Southampton. Nave & West Window

PLATE 35. *No. 567. J.F.W. Herschel del. Cam. Luc. Sep 1, 1846. Bayham Abbey near Lamberhurst, Sussex.* 21.6 x 33.7 cm.

Herschel recorded in his diary that he "accompanied M.BH and Caroline, Bella, Louisa, & Miss Rufenacht to Bayham Abbey where met Dr. & Mrs. Wrench & party and Pic nic'ed & sketched...got 2 good sketches with Cam[a] & all the party sketched & painted violently."[1]

1. Diary, 1 September 1846. W0029, Herschel Collection, the Humanities Research Center, The University of Texas at Austin.

JHW Herschel del. Cam. Luc. Sep. 1. 1846. Bayham Abbey near Lamberhurst, Sussex.

PLATE 36. *No. 570. J.F.W. Herschel del. Cam. Luc. Aug 29, 1849. Bayham, Lord Camden's house near the Abbey.* 22.5 x 34.1 cm.

JF.W.Herschel del. Cam. Luc. Aug 29. 1849. Bayham. Lord Camden's house near the Abbey

PLATE 37. *No. 454. J.F.W. Herschel del. Cam. Luc. Oct 3, 1850. Pont du Gard near Nismes. View from the S.W.* [Nîmes, France] 21.6 x 33.5 cm.

JFW Herschel del. Cam. Luc. Oct 3. 1850 Pont du Gard near Nismes. View from the S.W.

PLATE 38. *No. 460. J.F.W. Herschel del. Cam. Luc. Oct 1850. Interior view of the Ancient Theatre, Arles.* 21.4 x 35.7

Not all was idyllic on Herschel's travels. His note in the corner of the drawing reads: "Chequered neckcloth. Green coat. Black waistcoat. Dress of the fellow who kept slinging stones at me while drawing."

JFWHerschel del. Cam. Luc. Oct. 1850. Interior View of the Ancient Theatre, Arles.

PLATE 39. *No. 495. J.F.W. Herschel del. Cam. Luc. Oct 19, 1850. Le Puy. From across the bridge. The Church of St Michel bearing ENE. The Rocher du Corneille N.E. by E. (by compass) & the Cathedral.* 21.5 x 33.2 cm.

ENE

NEbE

JFW Herschel del. Cam Luc. Oct. 19. 1850 Le Puy. From acrof. the bridge. The Church of St Michel bearing ENE, the Rocher des Corneilles NE by E. & the Cathedral
(by Compas)

PLATE 40. *No. 757. J.F.W. Herschel del. Cam. Luc. Aug 12, 1865. Stone Henge.* 25.1 x 38.3 cm.

Drawn when the artist was aged 73, half a century after he first took up the camera lucida.

757

J. F. W. Herschel, del. Cam. Luc. Aug 12. 1861 Stone Henge

FIGURE 40. Sir John Herschel, *Cascade D'Enfer. Val de Lys. Bagneres de Luchon*. Pencil *camera lucida* drawing, 1850. 38.1 x 25.1 cm. No. 445, Graham Nash Collection.

How sweet at each turn of the mountain
The shepherd's hut rises to view
Within its grass & its knoll & its fountain!
Oh would I had nothing to do
But to spend my life here in dreaming
Of all that these vallies conceal
And forget this bad world & its scheming
Its struggles, its woe, and its weal
Should my heart e'er be bursting with anguish
And fortune frown dark on my path
For a scene such as this I might languish
And gasp for this sweet mountain air.

FIGURE 41. Julia Margaret Cameron, *The Astronomer*. Portrait of Sir John Herschel. Albumen print, 1867. 35.2 x 26.5 cm. Museum of Art, Rhode Island School of Design.

SIR JOHN HERSCHEL'S DRAWINGS IN THE GRAHAM NASH COLLECTION

Sir John Herschel began to compile his life output of drawings in 1861 and continued adding to the collection for the rest of his life. Of the 763 drawings that he eventually selected, 310 are now preserved in the *Graham Nash Collection*. Included are the majority of Herschel's Continental views, along with some British subjects; most reflect his scientific and classical interests developed during 'Grand Tours.' Several pairings of field sketches with highly finished presentation pieces are included.

The majority of these drawings are of special interest because Herschel employed the *camera lucida* to make them. Virtually all are pencil drawings on Whatman's paper, titled and dated in Herschel's hand. Many have geological and other scientific notations on the recto, and many include technical details of how the *camera lucida* was employed. On some, Herschel wrote poetry or recorded his local observations.

The *Nash Collection* represents not only the largest single group of Herschel's drawings, but also the largest identified body of known camera lucida work by any artist. The documentation on these drawings is as rich as their subject matter. Herschel inventoried them all in a manuscript notebook: *General list of all my drawings and sketches (made out July 1861)*. Copious references to specific drawings can be found in his letters and personal diaries.[1]

Herschel's drawing collection was part of the extensive family archives preserved by his great-granddaughter, Eileen Shorland, which were dispersed when Observatory House had to be vacated. The entry in the 1958 *Sotheby's* catalogue reads:

Lot 390. Herschel (Sir John) A collection of 286 pencil drawings and 8 water-colour drawings of scenery in England, Wales, Ireland, France, Switzerland, Belgium, Germany, North Italy, Sicily, etc., made by Sir John Herschel with his camera lucida, about 20 cm by 31 cms, mounted in 3 folio albums, half morocco.[2]

In fact, 310 drawings and some inserted material were included in the albums. Some drawings were removed prior to the sale (notably a group of 67 South African scenes donated to the Cape Town Public Library in 1952). Purchased at the sale by Maggs, the London bookseller, the volumes were finally acquired in 1974 for the *Nash Collection*. The drawings have been dismounted, with the original albums carefully preserved; the volumes are labelled:

III. (originally Vol. I)
IV. (originally Vol. III)
V. (originally Vol. II)

KEY TO ENTRIES

The number preceding each entry is from the system Herschel established in 1861; most drawings are numbered in Herschel's hand; all are recorded in his manuscript NOTEBOOK. Herschel arranged his drawings geographically in his NOTEBOOK; the section titling is from this. The volume/folio number from the original albums follows in parentheses. Herschel's formal titling and dating, generally in ink in the lower border of the drawing in italics (most of these titles, applied in 1861 or later, derive from earlier labelling in the

print). The spelling of foreign names is frequently unstandardized and conventions have often changed over time. Herschel's usage has been preserved without notation except in the few cases where this might cause confusion. Dates in brackets have been ascertained from evidence in letters and travel diaries and are reasonably certain; those followed by a '?' are attributed using external evidence. The 'GENL N° ____' (General Number) is the most important of several earlier classification systems. Selected notes found RECTO and VERSO and in the NOTEBOOK follow; these are included only if of visual interest or if they deviate from the formal titling.

⊙records the position of the *camera lucida* prism above the paper and makes it possible to reconstruct the original perspective. The distance of the prism above the paper (which affected the size of the representation) and the coordinates x y z are also noted in some cases. A pencil note by Sir John in his manuscript NOTEBOOK explains that:

X Y Z are the coordinates of the eye in inches. X reckons from the left hand boundary line along the lower horizontal line to the right. Y upwards from the lower horizontal boundary line. Z from the plane of the paper to the eye perpendicularly. ⊙ is the azimuth of the vertical passing through the point of light by compass.

Typically, the ruled outline that was used as an aid in positioning the eye is present on the paper, and this is the dimension that is given. If no reference frame is present (NRF), the paper size is given. The *camera lucida* was a versatile tool that could be used to copy or to re-scale drawings. Herschel frequently recorded enlisting its aid in this fashion, but his use of the term *enlarged* might be confusing in this context: it does not refer to size, but instead to a drawing that had been worked up to make it more richly detailed or visually dramatic. *Eye-drafts* are free-hand sketches where Herschel did not employ the *camera lucida*.

[1] MW0019, The Humanities Research Center, The University of Texas at Austin. The HRC's holdings, which include most of Herschel's personal diaries, and significant groupings of letters, are of particular relevance to the drawing collection. The largest body of Herschel correspondence is in the Archives of The Royal Society in London. Smaller holdings are in several institutions, with some still remaining with the descendants.

[2] *Catalogue of Valuable Printed Books...The Important Collection of Printed Books, Autograph MSS., Early Photographs; Scientific Apparatus and Portraits of Sir William Herschel (1788-1822), his sister Caroline and son Sir John Herschel, Removed from Observatory House, Slough...* (Sothebys, March 3rd & 4th, 1958). Maggs purchased lot 390 for £17/0/0; they also acquired lot 462, under *Scientific Apparatus used by Sir John Herschel*: "a camera, lucida, in wooden case," the present whereabouts of which is unknown.

[3] The reason for the discrepancy with Sotheby's count is unknown. The albums also contained 6 loose inserts, 8 watercolours, by Herschel or his family, and two salt prints by his brother-in-law, John Stewart.

VIEWS IN BELGIUM, THE RHINE, GERMANY, ITALY, SICILY, TYROL, SAVOY, AND SOUTHERN SWITZERLAND

No. 264 (IV. f1) *J.F.W. Herschel del. Cam. Luc. May 24, 1829. Ruins of the Abbey of St. Bertin, St. Omer.* GENL N° 115; RECTO ⊙ May 26, 1829; VERSO No. 1 May 26, 1829. 20.1 x 31.0 cm.

No. 265 (IV. f2) *J.F.W. Herschel delin Cam. Luc. Belfoire & Cathedral—Tournay.* [27 May 1829] GENL N° 116; WM: J. Whatman; mounted on a signed and titled paper mount. 19.0 x 28.4 cm.

No. 266 (IV. f3) *J.F.W. Herschel delin Cam. Luc. Cathedral from one of the Quais, Tournay.* [27 May 1829] verso fragment of another sketch; mounted on a signed and titled paper mount, WM J. Whatman 1852. 18.9 x 28.4 cm.

No. 267 (IV. f4) *J.F.W. Herschel delin Cam. Luc. Antwerp Cathedral.* [16 Oct. 1824] GENL N° 119; notebook Antwerp Cathedral, Spire, 1st view; mounted on a titled paper mount. 19.3 x 29.2 cm.

LOOSE INSERT @ No. 267 (IV. f4): Note (not in JFWH's hand) about temples, pencil "392" in corner.

LOOSE INSERT @ No. 267 (IV. f4): Tracing? of No. 358, "Father Apennine," on thin translucent paper; WM J. Whatman Turkey Mill.

No. 268 (IV. f5) *J.F.W. Herschel del. Cam. Luc. Antwerp Cathedral.* [16 Oct. 1824] GENL N° 120; RECTO ⊙; NOTEBOOK Spire, 2nd view. 30.7 x 17.4 cm.

No. 269 (IV. f6) *J.F.W. Herschel del. Cam. Luc. May 30, 1829. Brussels Cathedral. Church of St. Gudule.* GENL N° 118; RECTO ⊙ No. 2 "Query whether this be any building. It looks like some deserted tower. JFWH 1863." 19.9 x 31.1 cm.

No. 270 (IV. f7) *J.F.W. Herschel delin Cam. Luc. June 9, 1829. Aix la Chapelle. The Stadt-haus.* GENL N° 121; RECTO No. 3 Hotel de Ville; NOTEBOOK: Town-house; WM J. Whatman Turkey Mill. 21.1 x 31.8 cm.

No. 271 (IV. f8) *J.F.W. Herschel del. Cam. Luc. June 19, 1829. The Rhine from St. Goar.* GENL N° 122; VERSO No. 8. 20.1 x 31.1 cm.

No. 272 (IV. f9) *J.F.W. Herschel del. Cam. Luc. June 14, 1829. The Siebengebirge from Bonn.* GENL N° 123; RECTO ⊙. 19.8 x 30.8 cm.

No. 273 (IV. f10) *J.F.W. Herschel del. Cam. Luc. June 12, 1829. The Siebengebirge from the Drachenfels.* GENL N° 124; RECTO No. 4; VERSO from the Drachenfels Castle; WM J. Whatman Turkey Mill 1824. 20.1 x 30.7 cm.

No. 274 (IV. f11) *J.F.W. Herschel delin Cam. Luc. June 13, 1829. The Siebengebirge from the L × owenberg.* GENL N° 125; RECTO View from the lower border of the wood No. 6. 20.1 x 32.0 cm.

No. 275 (IV. f12) *J.F.W. Herschel delin Cam. Luc. June 12, 1829. The Rhine & the Drachenfels, from the Wolkenberg.* GENL N° 126; *RECTO* View of the Rhine, Drachenfels Ruin from the top of the Wolkenberg No. 5 ⊙. 19.6 x 31.8 cm.

No. 276 (IV. f13) *J.F.W. Herschel del. Cam. Luc. June 19, 1829. The Lurlei Rocks, on the Rhine.* GENL N° 127; RECTO The Rocks of Lurlie near S'. Goar No. 9; WM J. Whatman Turkey Mill. 18.3 x 31.7 cm.

BADEN-BADEN

No. 277 (IV. f14) *J.F.W. Herschel del. Cam. Luc. 1829. View from the Hotel window, Baden-Baden.* GENL N° 128. 21.6 x 32.3 cm.

No. 278 (IV. f15) *J.F.W. Herschel del. Cam. Luc. 1829. Baden-Baden. View from above Saal Haus.* GENL N° 129. 21.3 x 31.8 cm.

No. 279 (IV. f16) *J.F.W. Herschel del. Cam. Luc. 1829. View of Baden Baden from the Root House.* GENL N° 130; RECTO Baden from above the bridge ⊙ Eye 10•0 +

2; VERSO No. 10. 19.8 x 30.6 cm.

No. 280 (IV. f17) *J.F.W. Herschel del. Cam. Luc. July 1, 1839 [sic]. Baden Baden from the Gernsbach Road.* GENL N° 130; RECTO No. 11 July 1, 1829; NOTEBOOK July 1/29; WM J. Whatman Turkey Mill. 19.8 x 30.9 cm.

No. 281 (IV. f18) *J.F.W. Herschel delin Cam. Luc. June 28, 1829. Cascade de la Butte, Baden Baden.* GENL N° 132; RECTO ⊙ No. 15; WM J. Whatman Turkey Mill. 19.8 x 30.8 cm.

No. 282 (IV. f19) *J.F.W. Herschel delin Cam. Luc. July 2, 1829. The Old Schloss Baden Baden.* GENL N° 133; RECTO ⊙ No. 14 Eye 12. 19.2 x 32.0 cm.

No. 283 (IV. f20) *J.F.W. Herschel del. Cam. Luc. June 26, 1829. View from the Old Schloss Baden Baden.* GENL N° 134; RECTO ⊙; VERSO No. 12 View from the window at the old castle; WM J. Whatman Turkey Mill. 19.5 x 31.9 cm.

No. 284 (IV. f21) *J.F.W. Herschel del. Cam. Luc. June 26, 1829. Scene in the forest of Bademerburg. Baden Baden.* GENL N° 135; RECTO No. 13 View from the woods...below the old castle; WM J. Whatman Turkey Mill. 18.4 x 32.0 cm.

No. 285 (IV. f22) *J.F.W. Herschel del. Cam. Luc. July 2, 1829. Ebersteinberg near Baden Baden.* GENL N° 136; RECTO ⊙ 10½ No. 16; WM J. Whatman Turkey Mill. 19.5 x 30.1 cm.

No. 286 (IV. f23) *J.F.W. Herschel del. Cam. Luc. July 3, 1829. Stauffenberg near Gernsbach Baden Baden.* GENL N° 137; RECTO 12h 50m Eye 12in from picture. 19.5 x 30.3 cm.

No. 287 (IV. f24) *J.F.W. Herschel delin. July 3, 1829. Cam. Luc. The Murgthal from Aue, looking up the Valley.* GENL N° 138; RECTO above Gernsbach; NOTEBOOK looking upwards. 20.0 x 30.9 cm.

No. 288 (IV. f25) *J.F.W. Herschel delin Cam. Luc. July 3, 1829. View from Aue in the Murgthal looking down the Valley.* GENL N° 139; RECTO No. 18 Eye 11½; NOTEBOOK looking downwards. 19.9 x 31.0 cm.

BAVARIA

No. 289 (IV. f26) *J.F.W. Herschel delin Cam. Luc. 1824. Schloss Neudeck, near Muggendorff, Bavaria.* [Sep.] GENL N° 140; RECTO ⊙ Eye 16•6 looking S 2 div E. 19.9 x 30.7 cm.

No. 290 (IV. f27) *J.F.W. Herschel delin Cam. Luc. 1824. Valley of Muggendorff near Gaylenreuth, Bavaria.* [Sep.] GENL N° 141; RECTO ⊙ Looking N + 2div W; WM J. Whatman Turkey Mill 1823. 20.0 x 30.9 cm.

No. 291 (IV. f28) *J.F.W. Herschel delin Cam. Luc. 1824. The Bone Caverns of Gaylenreuth in the Valley of Muggendorff.* [Sep.] GENL N° 142; RECTO bd = 38o 35' de = 22• 0' looking W 2½ N Eye = 13.0 ⊙ point of sight. 20.1 x 30.7 cm.

No. 292 (IV. f29) *J.F.W. Herschel del. Cam. Luc. 1824. Waterfall between the Walcher-see & the Kochl-see, Bavaria.* [15 Sep.] GENL N° 143; NOTEBOOK eye-draft (very hasty sketch). 19.9 x 30.8 cm.

No. 293 (IV. f30) *J.F.W. Herschel delin Cam. Luc. Aug 31, 1824 8h 40m AM. View in the Valley of St. Lugano near the Osteria of Pausche Tyrol.* RECTO All wood entirely covered Eye 10•6 Veil of cloud before the more distant hill ⊙ perp. 20.0 x 30.8 cm.

No. 294 (IV. f31) *J.F.W. Herschel delin Cam. Luc. 1824. Cavalese, in the Valley of Fassa, Tyrol.* RECTO Point

of sight ⊙ supplied by memory (ie, the exact place in vertical) A mahogany board stuck full of horsehair. I had got thru 3 holes & appd again. Church of Cavelese looking S 3 div W. Eye 15•3 Church S div E. 20.1 x 30.9 cm.

No. 295 (IV. f32) *J.F.W. Herschel delin Cam. Luc. 1824. Vigo in the Valley of Fassa. Monte Vaioletto and Monte Udai.* [1-2 Sep.] GENL N° 179; RECTO Eye 12•5 ± coords of ⊙ x = 6•17 y = 0•87 looking N 7 div W by C NB outline exact detail of ye peaks only exact i.e., general features preserved.; VERSO [key to mountains] a-Monte Vaioletto b-Monte Udai Sasso Roton (Udai) the rounded knob Sasso Camerlaid, the sloping ridge c-Sasso de la Croce the vertical precipice d-house in Pero; WM J. Whatman Turkey Mill 1823. 19.8 x 30.8 cm.

No. 296 (IV. f33) *J.F.W. Herschel delin Cam. Luc. 1824. Valley of the Duron leading out of the Valley of Fassa, Tyrol Looking towards the Cipit.* [4 Sep.] GENL N° 180; RECTO ⊥ on paper. 19.8 x 30.7 cm.

No. 297 (IV. f34) *J.F.W. Herschel delin Cam. Luc. 1824. Valley of Fassa from Campedello Tyrol—Gries, Canazei, Monte Purdoi.* GENL N° 181; RECTO View from osteria door Eye 10•0 (a) steeple E + 1 ½ div S. ⊙ perp on paper. Pyrox very black & rocky. 19.9 x 30.6 cm.

No. 298 (IV. f35) *J.F.W. Herschel delin. 1834 Valley of Fassa from opposite Gries.* GENL N° 182; RECTO ⊙ perp. on paper Eye 15•0 peak b. b. bearing WNW by compass. Level of the ridge on a wide gravelly plain very naked & bare — groups of peasants, etc.; VERSO Singular intermixture of the Pyroxene & Dolomite the black and the white rock; ALBUM PAGE 1824. 19.8 x 30.7 cm.

No. 299 (IV. f36) *J.F.W. Herschel del. Cam. Luc. 1824. Sasso Vernale Valley of Fassa Tyrol.* GENL N° 183; RECTO A bearing SE + 2 div S. Height of eye above paper = 12in•4 ⊙ 12•4 perp; NOTEBOOK (a portrait, much pains bestowed). 19.9 x 30.7 cm.

No. 300 (IV. f37) *J.F.W. Herschel del. Cam. Luc. 1824. Sasso Vernale Valley of Fassa Tyrol from the Gorge of Fredaja.* GENL N° 184; RECTO Height of eye 8″ ⊙ perp on paper; NOTEBOOK near view from its foot showing the stratification of Dolomite; WM J. Whatman Turkey Mill 1823. 21.4 x 32.7 cm.

No. 301 (IV. f38) *J.F.W. Herschel del. Cam. Luc. 1824. Sasso Lungho, with the Villages of Albo & Canazei. Valley of Fassa, Tyrol. from between Albo & Penia.* GENL N° 185; RECTO ⊙ 12•0. 19.9 x 30.6 cm.

No. 302 (IV. f39) *J.F.W. Herschel del. Cam. Luc. 1824. The Schlern Mountain from Seiss in Tyrol. Castle of Haldenstein.* [Sep. 1824] GENL N° 186; RECTO ⊙. 19.9 x 30.8 cm.

No. 303 (IV. f40) *J.F.W. Herschel delin Cam. Luc. 1824. Valley of Seiss, Tyrol.* [September] GENL N° 187; RECTO Eye 13•4 Looking exactly W by compass Church W + ½ div S; WM J. Whatman Turkey Mill 1823. 19.9 x 30.7 cm.

VALLEY OF THE ADIGE & ITALIAN LAKES

No. 304 (IV. f41) *J.F.W. Herschel del. Cam. Luc. 1824. Valley of the Adige from the 61st milestone from Inspruck near Bolzano.* [12 September] GENL N° 176; RECTO Eye 13•3 Looking N 6½ Div W. 20.1 x 30.9 cm.

No. 305 (IV. f42) *J.F.W. Herschel del. Cam. Luc. Sep 11, 1824. Earth Pyramids of Ober Botzen Tyrol, near Ritten.* GENL N° 173; RECTO ⊙; NOTEBOOK 1st view; WM J. Whatman Turkey Mill 1823. 20.0 x 30.9 cm.

No. 306 (IV. f43) *J.F.W. Herschel del. Cam. Luc. 1824.*

Earth Pyramids Ober-Botzen looking N.N.E. [11 Sep.] GENL N° 174; RECTO Eye 14•7 ⊙; NOTEBOOK 2nd view Sep 11, 1824. 19.9 x 30.8 cm.

No. 307 (IV. f44) *J.F.W. Herschel del. Cam. Luc. 1824. Earth Pyramids of Ober-Botzen.* [11 September] GENL N° 175; RECTO Foreground and trees imaginary; NOTEBOOK 3rd view Sep. 11, 1824. 20.0 x 30.9 cm.

No. 308 (IV. f45) *J.F.W. Herschel del. Cam. Luc. 1824. Castle of Solurn or Solothurn. Valley of the Adige.* GENL N° 172; RECTO Eye 11•2 looking E + 3 S. Houses & churches white. Roof black, wood tiles. Station ¼ mile W of church (a) of Solurn. 19.8 x 30.8 cm.

No. 309 (IV. f46) *J.F.W. Herschel del. Cam. Luc. 1824. Lake of Garda (Benacus) looking to SW from Northern end, on the way to Riva Alta.* GENL N° 171; RECTO No. 61; VERSO South End; NOTEBOOK (hasty, & transferred) WM J. Whatman Turkey Mill 1823. 19.9 x 30.8 cm.

No. 310 (IV. f47) *J.F.W. Herschel del. Cam. Luc. 1824. Lake of Garda (Benacus) North End. Looking exactly W. by compass.* GENL N° 170; RECTO The village of Riva Alta behind the promontory on the right. Old No. 60. Eye 11in0. NB On the back of this is a C.L. view See No. 363; VERSO [another drawing: "Vale of Terni before the falls" No. 54]; NOTEBOOK (pains taken) another on the back of it. 19.9 x 30.9 cm.

No. 311 (IV. f48) *J.F.W. Herschel del. Cam. Luc. 1824. Valley of the Adige, near Ala.* GENL N° 169; RECTO Eye 12•0 pl. vert N 10'2 div E. Coord of ⊙ y = 3•05 x = 6•50. Finished 9h 45m A.M. 20.0 x 30.8 cm.

No. 312 (IV. f49) *J.F.W. Herschel delin Cam. Luc. 1824. Valley of the Adige near Peri, Senigo, &tc.* GENL N° 168; WM J. Whatman Turkey Mill 1823. 19.8 x 30.7 cm.

No. 313 (IV. f50) *J.F.W. Herschel del. Cam. Luc. Aug 31, 1821. The Lake of Como.* VERSO No 1. 19.1 x 29.3 cm.

No. 314 (IV. f50) *J.F.W. Herschel del. Cam. Luc. Sep 1, 1821. Lago Maggiore from Thelds Madre.* RECTO [shows actinometer in use]; VERSO Camera Lucida N. 20. Lago Maggiore looking N. 70° West. 18.8 x 28.8 cm.

PASS OF THE SIMPLON

No. 315 (IV. f51) *J.F.W. Herschel del. Cam. Luc. 1821. Ravine in the Simplon opposite Isella.* [field draft of finished version, No. 515]; NOTEBOOK Sep 1, 1821. 29.6 x 20.5 cm.

No. 316 (IV. f51) *J.F.W. Herschel delin Cam. Luc. 1821. Scene in the Simplon Pass near Gondo.* VERSO 22; NOTEBOOK Sepr 1821. 19.4 x 29.3 cm.

No. 317 (IV. f52) *J.F.W. Herschel del. Cam. Luc. Sep 2, 1821. Pass of the Simplon—The Great Gallery.* VERSO Cam Luc. 23. 19.7 x 29.9 cm.

No. 318 (IV. f52) *J.F.W. Herschel del. Cam. Luc. Sep 1821. Valley of the Saltina near Brieg at Entrance of the Simplon.* VERSO No. 24 Ravine near Brygg. 19.7 x 29.7 cm.

ITALIAN & SAVOY ALPS & SOUTH SWITZERLAND

No. 319 (IV. f53) *J.F.W. Herschel del. Cam. Luc. Sep 4, 1821. Clay columns at Stalde in the Visp Thal, Valais.* VERSO 1st series of columns near Stalde. 19.9 x 30.2 cm.

No. 320 (IV. f53) *J.F.W. Herschel del. Cam. Luc. Sep 4, 1821. Clay Columns at Stalde in the Visp Thal, Valais.* [field draft of finished version, No. 516]; VERSO 2nd series of columns near Stalde. 19.2 x 29.4 cm.

No. 321 (IV. f54) *J.F.W. Herschel del. Cam. Luc. Sep 4, 1821. Valley of St. Nicolai on the way from Stalde to Zermatt.* watermark J. Whatman. 19.4 x 29.4 cm.

No. 322 (IV. f54) *J.F.W. Herschel delin Cam. Luc. Sep 5, 1821. Glacier of Zermatt with the summit (1) ascended on Sep 7.* [field draft of finished version, No. 517] VERSO Camera Lucida. Mont Rosa with its glacier &tc the mountains above the Valley of Finle' (Mont Lerblanche?) taken Sep 5, 1821 in ascending from Zermatt to Mont Cenis. 1. The summit of Mont Rosa ascended by us Sep. 7. 2. One of the peaks of Mont Lerblanche. NOTEBOOK Monte Rosa Breithorn. ALBUM PAGE summit (1) was the Breithorn, mistaken for Monte Rosa by the guide, Coretel. 20.1 x 29.6 cm.

No. 323 (IV. f55) *J.F.W. Herschel delin Sep...1821. Summit ascended on Sep 7 from Breil on the Italian side of St. Theadule. Copied from a spoiled Cam. Luc.* RECTO Sun at AM; ALBUM PAGE Breithorn. Mistaken for Monte Rosa. 18.8 x 27.4 cm.

No. 324 (IV. f55) *J.F.W. Herschel del. Cam. Luc. Sep 1821. Tombeck. Back seen from Randa, the site of the destroyed village.* VERSO 28. ALBUM PAGE Sep 8th? 19.7 x 29.5 cm.

No. 325 (IV. f56) *J.F.W. Herschel del. Cam. Luc. Aug 1821. The Fall of Chede.* [14 August] RECTO [rainbow noted]. 29.1 x 19.2 cm.

No. 326 (IV. f56) *J.F.W. Herschel del. Cam. Luc. Sep 13, 1821. The Vale of Martigny.* VERSO Fall of the Pissevache near Martigny. 28.8 x 19.5 cm.

No. 327 (IV. f57) *J.F.W. Herschel del. Cam. Luc. Aug 14, 1821. Valley of the Dioza from behind the Church of Servoz.* VERSO from the point of the Brevant which overlooks the Monument of Eschen. 19.3 x 29.1 cm.

No. 328 (IV. f57) *J.F.W. Herschel del. Cam. Luc. Aug 1821. Defile of the Arveinn "Les borreurs."* VERSO taken Aug 1821 returning from Chamonu. 18.2 x 24.2 cm.

No. 335 (IV. f61) *J.F.W. Herschel del. (copy from a spoiled Cam. Luc. Aug 13, 1821). Contamines. Between Bonneville & Geneva.* VERSO N° 5. 19.3 x 27.9 cm.

No. 336 (IV. f61) *J.F.W. Herschel del. Cam. Luc. Aug 13, 1821. Bonneville near Geneva on road to Chamonix.* VERSO No. 6 The Point du Neufheures in front. Taken from the root of the cliff at the base. 19.2 x 29.0 cm.

No. 337 (IV. f62) *J.F.W. Herschel del. Cam. Luc. Sep 15, 1821. Castle of Chillon, Lake of Geneva from beach of the Lake.* RECTO Sunbeams striking down/Light on upper edges/Strong shade. Catch of sun on trees/Sun on grass/ Catch of light; VERSO N° 33; NOTEBOOK 1st view from the beach of the lake. 19.9 x 30.3 cm.

No. 338 (IV. f62) *J.F.W. Herschel del. Cam. Luc. Sep 15, 1821. Castle of Chillon near view. Dent du Midi &tc.* VERSO Chillon, Villeneuve...upper end of Lake of Geneva; NOTEBOOK from the road 2nd view; WM J. Whatman. 18.3 x 28.3 cm.

No. 339 (IV. f63) *J.F.W. Herschel del. Cam. Luc. 1821. Pass of the Jura at Champagnole Montagne Cornice.* [6-7 August] RECTO [shows actinometer in use]; VERSO pass...where the road passes the top of the Montagne Cornice. 19.9 x 29.9 cm.

No. 340 (IV. f63) *J.F.W. Herschel delin Cam. Luc. 1821. Val de Poligny at entrance of the Jura Pass.* [6 August] VERSO from the 1st turn of the road in the Mountain above the Town; NOTEBOOK between Poli & Champagnoi. [The basis for painting n° 1]. 18.2 x 28.2 cm.

No. 341 (IV. f64) *J.F.W. Herschel del. Cam. Luc. 1821.*

Poligny at the entrance of the Pass of the Jura from France. [6 August] VERSO from the North; WM J. Whatman 1816. 18.6 x 28.0 cm.

PASS OF MT. CENIS

No. 342 (IV. f64) *J.F.W. Herschel del. Cam. Luc. Valley of Chambery at the entrance of the pass of Mont Cenis from France.* [1824?] WM J. Whatman Turkey Mill 1823. 19.1 x 29.1 cm.

No. 343 (IV. f65) *J.F.W. Herschel del. Cam. Luc. 1824. Aiguebelle (from the North).* 19.9 x 30.9 cm.

No. 344 (IV. f66) *J.F.W. Herschel del. Cam. Luc. April 12, 1824. Vale of Montmeillan with the Alluvial mound of the Maltaverne (looking West).* RECTO coordinates of magnetic west p' x = ½ (17•02) = 8•51; VERSO Vale of the Isere from the gorge. 20.0 x 30.8 cm.

No. 345 (IV. f67) *J.F.W. Herschel delin Cam. Luc. April 1824. Valley of the Argue near St• Jean de Maurienne. Crag (a) bearing E.S.E. by Compass.* GENL N° 191; RECTO Coord of a x = 7•95 y = 2•25. 20.2 x 32.7 cm.

No. 346 (IV. f68) *J.F.W. Herschel del. Cam. Luc. April 1824. The fortress of Echellon or Axillon on the route of Mt. Cenis.* GENL N° 192; VERSO No. 5; NOTEBOOK Eseillon; WM J. Whatman Turkey Mill 1823. 20.0 x 31.2 cm.

No. 347 (IV. f69) *J.F.W. Herschel delin Cam. Luc. Aug 22, 1821 (hasty). Contorted strata of Mt. St. Julien near Modane.* VERSO Taken hastily. 20.0 x 29.6 cm.

No. 348 (IV. f69) *J.F.W. Herschel del. Cam. Luc. Aug 22, 1821 (with much care). Mont Cenis—culminating point of the road near the Hospice.* RECTO Haymakers at work; VERSO View from the culminating point in the passage of Mont Cenis by Napolean's road (from the refuge No. vii) taken with much care. 20.2 x 30.0 cm.

No. 349 (IV. f70). [23 Aug. 1821] VERSO Camera lucida No. Vale of Suza, being the entrance into Piedmont in descending from Mont Cenis. Taken Thursday Aug 23. 1. Town of Suze. 2. Avillano ? 3. Tour du convent di— Michel. 19.5 x 30.1 cm.

No. 350 (IV. f70). [Aug. 1821?] ALBUM PAGE Junction of Arve & Rhone below Geneva; WM J. Whatman. 19.3 x 29.1 cm.

NORTH ITALY

No. 351 (IV. f71) *J.F.W. Herschel del. Cam. Luc. 1824. Turin with the chain of the Alps. from the roof of the Observatory.* [18 April] RECTO Coord of Roche Moulon x = 7•065, y = 3•65. Dome des Jesuites x = 7•4, y = 2•65. Clocher des Jesuites x = 7•81, y = 2•95. 20.2 x 31.0 cm.

No. 352 (IV. f72) *J.F.W. Herschel delin Cam. Luc. April 1824. Genoa From a part of the Rampart S.E. of the Town under the Church of Carignano.* [22-26 April] RECTO ⊙ perp. 20.1 x 30.9 cm.

No. 353 (IV. f73) *J.F.W. Herschel delin 1824 Cam. Luc. Padua with the Euganean Hills, from the roof of the Observatory, looking nearly W.S.W.* [21-27 Aug.] RECTO Eye 14•0. 21.6 x 32.4 cm.

No. 354 (IV. f74) *J.F.W. Herschel delin Cam. Luc. 1824. Church of St• Antonio, Padua.* [21-27 August] RECTO Eye 19•0. 19.9 x 30.6 cm.

No. 355 (IV. f75) *J.F.W. Herschel del. Cam. Luc. 1824. Florence from the Church of Monte alla Croce. Looking North West.* [2-12 May] GENL N° 197. 19.9 x 30.8 cm.

No. 356 (IV. f76) *J.F.W. Herschel del. Cam. Luc. 1824. Ponte Della Trinita, Florence from the Ponte...(extreme care taken).* [2-12 May] GENL N° 198; RECTO Eye = 11•5; VERSO 55. NB N° 54 is at the back of N° 60, or N° 60 rather on that of 54, but better. 20.1 x 30.9 cm.

No. 357 (IV. f77) *J.F.W. Herschel del. Cam. Luc. Florence from the Ponte Vecchio.* [2-12 May] GENL N° 199; RECTO ⊙ perp. 20.0 x 31.1 cm.

No. 358 (IV. f78) *J.F.W. Herschel del. Cam. Luc. 1824 Colossal Statue "Father Apennine" by John of Bologna in the Grand-ducal garden of Pratolino near Florence.* [10 May]. 19.9 x 30.8 cm.

No. 359 (IV. f79) *J.F.W. Herschel delin Cam. Luc. May 11, 1824. Bridge and mill of Tori between Florence & Vallombrosa.* WM J. Whatman Turkey Mill 1823. 20.1 x 30.8 cm.

No. 360 (IV. f80) *J.F.W. Herschel delin Cam. Luc. May 11, 1824. Convent of Vallombrosa near Florence.* 19.8 x 30.9 cm.

ROME AND THE PAPAL STATES

No. 361 (IV. f81) *J.F.W. Herschel del. Cam. Luc. May 13, 1824 (looking E.S.E.). The Lake of Perugia (the Ancient Thrasymere) from the 1st Roman Custom House;* NOTEBOOK from 1st Roman Dogana. 19.4 x 31.4 cm.

No. 362 (IV. f82) *J.F.W. Herschel del. Cam. Luc. May 13, 1824. The Lake of Perugia (Thrasymere) from above Torricelli—with Passignano & Mt. Gualandra.* GENL N° 204. 19.9 x 30.9 cm.

No. 363 (IV. f83) *J.F.W. Herschel del. (From a Camera view at the Back of No. 310) taken May...1824. Vale of Terni below the falls below Papignia.* RECTO Height of the eye = 10½ inches. Vale of the Terni from a point on the road from Terni. WM J. Whatman Turkey Mill 1836. 21.5 x 30.9 cm.

No. 364 (IV. f84) *J.F.W. Herschel del. Cam. Luc. May 1824. Caduta delle Marmore, Terni, From the point of view called the "Specola."* [14-15 May] GENL N° 206; WM J. Whatman Turkey Mill 1823. 20.0 x 30.9 cm.

No. 365 (IV. f85) *J.F.W. Herschel del. Cam. Luc. May 1824. Caduta delle Marmore. Terni. from the foot of the falls.* Looking S.S.E. [14-15 May] RECTO ⊙ Eye 10•5 Terni great fall S. 2 div W.; NOTEBOOK Fall of the Velino, Terni, lower view; WM J. Whatman Turkey Mill 1823. 21.1 x 30.8 cm.

No. 366 (IV. f86) *J.F.W. Herschel del. Cam. Luc. May 1824. Terni. The upper fall from the station opposite the Summit.* [14-15 May] NOTEBOOK Fall of the Velino Terni, from near the top of the fall. 30.8 x 20.1 cm.

No. 367 (IV. f87) *J.F.W. Herschel del. Cam. Luc. Aug 8, 1824. Rome from the Pincian Terrace Beyond the Villa Medici.* RECTO Eye 13•0; WM J. Whatman Turkey Mill 1823. 20.1 x 30.9 cm.

No. 368 (IV. f88) *J.F.W. Herschel del. Cam. Luc. May 18, 1824. View of the Capitol, arch of Septimius Severus. Temples of Concord, &tc, taken with Extreme care & precision.* RECTO Campo Vaccino, Rome; NOTEBOOK Forum Romanium looking to the capitol. 20.4 x 30.7 cm.

No. 369 (IV. f89) *J.F.W. Herschel del. Cam. Luc. May 17, 1824. The Coliseum, Rome (with extreme care & precision).* RECTO [compass points indicated]; NOTEBOOK Coliseum of Trajan. External View. 20.1 x 30.8 cm.

No. 370 (IV. f90) *J.F.W. Herschel del. Cam. Luc. May 18, 1824. Interior of the Coliseum, Rome, looking towards the pyramid of Cestius (great care).* GENL N° 212. 20.2 x 30.9 cm.

No. 371 (IV. f91) *J.F.W. Herschel del. Cam. Luc. May 19, 1824. Baths of Caracalla. Interior view.* WM J. Whatman Turkey Mill 1823. 19.7 x 30.7 cm.

No. 372 (IV. f92) *J.F.W. Herschel del. Cam. Luc. Aug 1824 (view from near Horace's Villa). Cascatelli di Tivoli with Tivoli and the Campagna. Hurried & imperfect & a good deal touched since,* RECTO Taken when giddy and fainting with heat & could hardly stand or see; WM J. Whatman Turkey Mill 1823. 21.4 x 31.0 cm.

No. 373 (IV. f93) *J.F.W. Herschel delin Cam. Luc. August 1824. Tivoli. Principal fall and Temple of Vesta.* RECTO Eye = 9•0. 21.7 x 31.0 cm.

NAPLES AND CAMPI PHLEGREAN

No. 374 (IV. f94) *J.F.W. Herschel del. Cam. Luc. 1824. Grotto of Poritipo & Tomb of Virgil. Naples.* [June] RECTO No. 23 24; VERSO Vesuvius from window of the Citta di Napoli Chiaja Sta. Lucia; WM Whatman Turkey Mill 1823. 22.3 x 16.1 cm.

No. 375 (IV. f94) *J.F.W. Herschel del. Cam. Luc. 1824. Vesuvius from the Chiaja Sⁿᵉ Lucia Naples (Extreme care).* [June] GENL N° 219; RECTO Height of eye 15ⁱⁿ •5. No. 24 Pallo N. 291°•4; VERSO grotto of Porilipo; WM J. Whatman Turkey Mill 18____. 16.4 x 22.1 cm.

No. 376 (IV. f95) *J.F.W. Herschel delin Cam. Luc. June 12, 1824. Vesuvius from the Torre dell' Annunziata.* 20.1 x 31.1 cm.

No. 377 (IV. f96) *J.F.W. Herschel delin Cam. Luc. June 9, 1824. Interior of the Crater of Vesuvius.* GENL N° 221. 21.6 x 34.3 cm.

No. 378 (IV. f97) *J F W Herschel del. Cam. Luc. June 12, 1824. View of Statice, Castellammare and the Mountains of St. Angelo, from Pompeii.* GENL N° 222. 19.9 x 33.2 cm.

No. 379 (IV. f98) *J.F.W. Herschel del. Cam. Luc. June 4, 1824. Lake of Agnano near Naples.* GENL N° 216; NOTEBOOK 1ˢᵗ view. 20.1 x 30.9 cm.

No. 380 (IV. f99) *J.F.W. Herschel del. Cam. Luc. June 4, 1824. Lake of Agnano near Naples.* GENL N° 217; NOTEBOOK 2ⁿᵈ view. 20.1 x 30.9 cm.

No. 381 (IV. f100) *J.F.W. Herschel del. Cam. Luc. June 14, 1824. Pozzuoli from the site of Cicero's Villa with the Temple of Serapis, Culigula's Mote, Micenum, &tc.* GENL N° 223; WM J. Whatman Turkey Mill 1823. 21.8 x 33.4 cm.

No. 382 (IV. f101) *J.F.W. Herschel delin Cam. Luc. June 16, 1824. Ischia Procida & Nisida from the Senola di Virgilio (Bad Sun unavoidably situated).* GENL N° 215. 19.9 x 30.8 cm.

No. 383 (IV. f102) *J.F.W. Herschel delin Cam. Luc. June 1824. Palermo from Monte Usciro, looking across the city towards Mte Pellegrino.* NOTEBOOK Palermo, looking Westward across it towards St. Roaslin. 20.0 x 33.1 cm.

SICILY

No. 384 (IV. f103) *J.F.W. Herschel del. Cam. Luc. June 1824. View of the Bay of Palermo from the Monte Pellegrino. See names at the back.* GENL N° 226; VERSO [key to mountains] No 31 Palermo looking across Eastward. 19.9 x 34.0 cm.

No. 385 (IV. f104) *J.F.W. Herschel del. Cam. Luc. July 10, 1824. The Bay of Palermo from a height in the Gardens of the Bagheria Palace.* GENL N° 227; VERSO [key to mountains]. 19.8 x 32.2 cm.

No. 386 (IV. f105) *J.F.W. Herschel del. Cam. Luc. July 10, 1824. The Bay of Termini from a height in the Gardens of the Bagheria Palace.* GENL N° 228; RECTO ⊙ for marks see back; VERSO S 7½ div E. 19.8 x 34.7 cm.

No. 387 (IV. f106) *J.F.W. Herschel del. Cam. Luc. July 10, 1824. Bay of Termini and Capo Zafirano from the Gate of Termini.* GENL N° 227; RECTO ⊙ Eye 15•5 For marks see back Aloë & Cactus hypothetical; VERSO NW by compass. 19.9 x 31.0 cm.

No. 388 (IV. f107) *J.F.W. Herschel delin Cam. Luc. July 9, 1824. Calatovotura, Sicily.* RECTO ⊙ perp. x = 5ⁱⁿ•48 y = 3ⁱⁿ•87. 19.9 x 31.0 cm.

No. 389 (IV. f108) *J.F.W. Herschel delin Cam. Luc. June 24, 1824. Temple of Segestum, Sicily.* GENL N° 231; RECTO 1ˢᵗ column broken, evidently mend[?] on spot; VERSO No 32. 18.8 x 31.6 cm.

No. 390 (IV. f109) *J.F.W. Herschel delin Cam. Luc. June 25, 1824. Ruins of the 1ˢᵗ or Great Temple at Selinunte, Sicily.* GENL N° 232. 18.9 x 33.2 cm.

No. 391 (IV. f110) *J.F.W. Herschel delin Cam. Luc. June 27, 1824. View from below the temple of Juno. Girgenti. Sicily. Temple of Concord in the distance.* GENL N° 233. 19.9 x 30.9 cm.

No. 394 (IV. f113) *J.F.W. Herschel del. Cam. Luc. June 26, 1824. Catoliea, Sicily. Monte Allegro(?).* GENL N° 236. RECTO Decided traces of an Earth Quake in this hill's position out of the Vertical, JFWH/52; WM J. Whatman Turkey Mill 1823. 19.9 x 31.1 cm.

No. 395 (IV. f114) *J.F.W. Herschel del. Cam. Luc. July 3, 1824. Grotta dei Capri, Etna.* GENL N° 237, RECTO [shows actinometer in use]; WM J. Whatman Turkey Mill 1823. 19.8 x 31.0 cm.

No. 396 (IV. f115) *J.F.W. Herschel delin Cam. Luc. July 4, 1824. Etna—the summit called the "Bicorne" from Casa Inglese.* GENL N° 238; RECTO Etna, Crater from Casa Inglese; VERSO 39. 19.9 x 31.1 cm.

No. 397 (IV. f116) *J.F.W. Herschel delin Cam. Luc. July 4, 1824. (Eye-draft). Crater of Etna. Looking down into it & up to the "Bicorne" or highest Summit.* GENL N° 239; RECTO Thick smoke preventing all view of the bottom. Some bottom seen here. N. 282°•5; VERSO Etna. Highest point from crater's edge. 20.0 x 31.1 cm.

No. 398 (IV. f117) *J.F.W. Herschel del. Cam. Luc. July 4, 1824. Crater of Etna looking Northward along the Western rim. The Lipari Islands in the distance.* NOTEBOOK Etna. View Northwards from edge of crater. 19.9 x 33.3 cm.

No. 399 (IV. f118) *J.F.W. Herschel del. Cam. Luc. July 5, 1824. Isole du Ciclopi. From the shore, at the foot of Etna.* GENL N° 241; VERSO Cyclopean islands general view. 42. 19.9 x 33.4 cm.

No. 400 (IV. f119) *J.F.W. Herschel del. Cam. Luc. July 6, 1824. Isole du Ciclopi. Isole du Ciclopi Reale Sicily. La Gran' Forigliona.* GENL N° 242; VERSO 44. 20.0 x 30.7 cm.

No. 401 (IV. f120) *J.F.W. Herschel del. Cam. Luc. July 6, 1824. Isole du Ciclopi. Prima Forigliona (with extreme care).* GENL N° 243; RECTO Height of Eye = 10•3 Fin⁰ 7ʰ 40ᵐ. 19.9 x 30.7 cm.

No. 402 (IV. f121) *J.F.W. Herschel del. Cam. Luc. July 1824. Casteleo d'Asti? near Leonforte Sicily.* GENL N° 244; VERSO 45 Castel d'Asti?? 20.1 x 30.7 cm.

VIEWS IN FRANCE

No. 403 (V. f1) *J.F.W. Herschel delin. Chateau de Clisson near Nantes. (Enlarged from an eye draft).* [1826?]. 21.1 x 31.6 cm.

No. 404 (V. f2) *J.F.W. Herschel del. Cam. Luc. Aug 31, 1850. Chateau de Blois. France 1850.* GENL N° 333; RECTO [details of Baluster & Balustrade]. NRF 24.3 x 37.5 cm.

No. 405 (V. f3) *J.F.W. Herschel del. Cam. Luc. 1850. Remains of the Amphitheatre of Gordian, Bordeaux.* [3 September] GENL N° 334; WM J. Whatman. NRF 25.2 x 38.5 cm.

No. 406 (V. f4) *J.F.W. Herschel delin Cam. Luc. Sep 5, 1850. Chateau de Pau. From the Promenade in the Park.* GENL N° 335. NRF 25.1 x 38.4 cm.

No. 407 (V. f5) *J.F.W. Herschel delin Cam. Luc. Sep 5, 1850. Pau—From the South Side of the river above the Bridge.* GENL N° 336. NRF 25.2 x 38.6 cm.

No. 408 (V. f6) *J.F.W. Herschel del. Cam. Luc. 1850. View from the window of Jeanne d'Albrets Boudoir—Chateau de Pau.* [September 5-8] NRF 25.1 x 38.4 cm.

No. 409 (V. f7) *J.F.W. Herschel del. Cam. Luc. Sep 7, 1850. View from above the Chateau de Montebello near Pau.* GENL N° 338; RECTO Pic du Midi SSW or 4½ div W of S; WM J. Whatman. NRF 24.2 x 37.5 cm.

No. 410 (V. f8) *J.F.W. Herschel del. Cam. Luc. Sep 6, 1850. View of the chain of the Pyrenees (clouded) from the Chapelle de Pieta near Pau.* NOTEBOOK Pyrenees, distant view; WM J. Whatman. NRF 25.2 x 38.4 cm.

No. 411 (V. f9) *J.F.W. Herschel del. Cam. Luc. Sep 7, 1850. Chateau de Montebello and Bernadette's garden. Near Pau (4ʰ 30ᵐ PM).* RECTO ⊙ Eye 14 in. Very green grass Coord of eye x = 6•3 y = 4•57 z = 14 looking N + 10 div W. [image of sun drawn in margin]. 21.6 x 33.5 cm.

No. 412 (V. f10) *J.F.W. Herschel delin. 1850. View on approaching Sevignac from Pau (an Eye draft enlarged).* [9 September] RECTO grassy slopes. grass very green. NOTEBOOK (eye draft assisted). 21.6 x 33.3 cm.

No. 413 (V. f11) *J.F.W. Herschel delin Cam. Luc. Sep 1850. From Sevignac in the Val d'Ossau (the figures by M.L.H.)* [M.L.H. was his 16 year old daughter, Margaret Louisa]. RECTO Looking S 6 div. W [image of sun drawn in margin]. 21.5 x 35.8 cm.

No. 414 (V. f12) *J.F.W. Herschel del. Sep 1850. View in the Val d'Ossau between Sevignac and Laruns (copied from a Cam. Luc. drawing).* 21.2 x 31.7 cm.

No. 415 (V. f13) *J.F.W. Herschel delin. Sep 1850. Le Pic de Gerx Near Laruns (an eye draft enlarged).* NOTEBOOK (eye draft transferred). 22.3 x 33.2 cm.

No. 416 (V. f14) *J.F.W. Herschel del. Cam. Luc. Sep 10, 1850. 6ᵃ AM. Valley of the Eaux Bonnes and distant view of the Place.* RECTO Sep 10, 1860. 21.6 x 33.0 cm.

No. 417 (V. f15) *J.F.W. Herschel del. Cam. Luc. Sep 10, 1850. 7ʰ AM. Laruns, at the head of the Valley of Ossau, Pyrenees.* RECTO Looking N 6 div West. Sun at back a little to right 7 AM. 21.6 x 33.1 cm.

No. 418 (V. f16) *J.F.W. Herschel delin Cam. Luc. Sep 10, 1860 [sic] at Noon. Pic du Mid d'Ossau. Taken from the Bioux d'Artigues above Gabas.* [1850] RECTO Looking South at noon—Sun just over the Pic and its details therefore indistinctly seen; WM J. Whatman. 21.7 x 33.1 cm.

No. 419 (V. f17) *J.F.W. Herschel del. Cam. Luc. Sep 10, 1850. View in the Gorge of Gabas descending from Bioux d'Artigues.* NOTEBOOK Sep 10/60. 21.7 x 33.3 cm.

No. 420 (V. f18) *J.F.W. Herschel del. Sep 10, 1850. View in the Gorge of Gabas above the 1st Bridge. (Enlarged from an eye draft).* 22.2 x 33.1 cm.

No. 421 (V. f19) *J.F.W. Herschel delin. Sep 11, 1850. Great silver fir on the Plateau de Gaurziot 108 f high; girth 17.* RECTO Copied from an eye draft on spot. 31.7 x 20.5 cm.

No. 422 (V. f20) *J.F.W. Herschel delin Cam. Luc. Sep 11, 1850. Valley of the Eaux Chaudes seen from the Plateau de Gaurziot.* RECTO ⊙ Coord of eye x = 6•07 y = 4•15 z = 12•0 Direction S 9½ div W. 21.6 x 33.2 cm.

No. 423 (V. f21) *J.F.W. Herschel del. Cam. Luc. Sep 12, 1850. Les Eaux Chaudes.* 21.7 x 33.1 cm.

No. 424 (V. f22) *J.F.W. Herschel del. Cam. Luc. Sep 12, 1850. View in the Valley of the Eaux Chaudes on the road to Gabas at the 49th kilometre from Pau.* GENL N° 368; WM J. Whatman. 21.7 x 33.3 cm.

No. 425 (V. f23) *J.F.W. Herschel del. Cam. Luc. Sep 12, 1850. View between the Eaux Chaudes & Gabas at the 3d Bridge from the former.* RECTO Let in the light with this gap. Lead in the light along this opening. 21.9 x 33.3 cm.

No. 426 (V. f24) *J.F.W. Herschel del. Cam. Luc. Sep 12, 1850. 2s 25m PM. Gave de Gabas near the Eaux Chaudes. Looking North.* GENL N° 370. 21.6 x 33.1 cm.

No. 427 (V. f25) *J.F.W. Herschel del. Cam. Luc. Sep 12, 1850. Gave de Gabas lower down the Stream near the Eaux Chaudes.* WM J. Whatman 1849. 21.5 x 33.2 cm.

No. 428 (V. f26) *J.F.W. Herschel del. Sep 14, 1860 [sic] View from the Hotel Gallery, Argeler (Very exactly transferred from a Cam. Luc. view on coloured paper).* RECTO Sep 14, 1850; NOTEBOOK transferred from a good Cam. Luc. view on coloured paper Sep. 14/50. 21.6 x 33.3 cm.

No. 429 (V. f27) *J.F.W. Herschel del. Cam. Luc. Sep 14, 1850. 8s AM. Argeler and its Vale with the Pic de Viscon. From the Bridle path to Arens above the hotel.* RECTO [image of sun in border]; NOTEBOOK Sep 14, 1860. 21.8 x 33.2 cm.

No. 430 (V. f28) *J.F.W. Herschel del. Cam. Luc. Sep 14, 1850. Gorge of the Valley of Pierrefitte on the road to Cauterets.* GENL N° 374; WM J. Whatman. 21.4 x 33.1 cm.

No. 431 (V. f29) *J.F.W. Herschel delin Cam. Luc. Sep 15, 1850. Lac de Gaube, above Cauterets, French Pyrenees.* GENL N° 375; RECTO imaginary peaks of the Vigrieniale. 21.6 x 33.1 cm.

No. 432 (V. f30) *J.F.W. Herschel del. Cam. Luc. Sep 15, 1850. Cascade du Pont d'Espangne near Cauterets, French Pyrenees.* NOTEBOOK Sep 15/60. 22.1 x 33.3 cm.

No. 433 (V. f31) *J.F.W. Herschel del. Cam. Luc. Sep 15, 1850. The Pont d'Espagne near Cauterets French Pyrenees. (Dense rain & mist).* NOTEBOOK Rain thick. 21.8 x 33.0 cm.

No. 434 (V. f32) *J.F.W. Herschel del. Sept 15, 1850. Narrow pass in the descent from the Pont d'Espagne to Cauterets. (Eye draft enlarged).* 21.5 x 33.2 cm.

No. 435 (V. f33) *J.F.W. Herschel del. Sep 15, 1850. Cascade de Buisset Valley of Cauterets French Pyrenees. (Eye draft enlarged).* NOTEBOOK Sep 15/60. 22.7 x 33.2 cm.

No. 436 (V. f34) *J.F.W. Herschel del. Cam. Luc. Sep 18, 1850. Le Cirque de Gavarnie.* NOTEBOOK inter nubuim intervalia. 21.5 x 33.3 cm.

No. 437 (V. f35) *J.F.W. Herschel del. Cam. Luc. Sep 18, 1850. The Chaos of Gavarnie, French Pyrenees.* NOTEBOOK Sep 18/50; WM J. Whatman. 21.7 x 33.9 cm.

No. 438 (V. f36) *J.F.W. Herschel del. Sep 18, 1850. Grotte de Gedres. Looking down the stream (Enlarged from eye-draft).* 31.6 x 20.4 cm.

No. 439 (V. f37) *J.F.W. Herschel delin. Sep 18, 1850. Grotte de Gedres near St. Sauveur, French Pyrenees (Enlarged from an Eye draft).* RECTO looking up the stream. 20.3 x 31.5 cm.

No. 440 (V. f38) *J.F.W. Herschel delin. Sep 19, 1850. Valley of Bareges from the castle of Luz French Pyrenees (Enlarged from an Eye draft).* RECTO From an eye draft? 22.7 x 33.2 cm.

No. 441 (V. f39) *J.F.W. Herschel del. Cam. Luc. Sep 19, 1850. Pic de Lithoulse in the Valley of Gavarnie just above Ss Sauveur.* GENL N° 385; RECTO ⊙. 21.7 x 34.7 cm.

No. 442 (V. f40) *J.F.W. Herschel del. Sep 19, 1850. St Sauveur with the Pic de Viscoz (Carefully enlarged from a smaller Cam. Luc. drawing).* GENL N° 386. 21.9 x 33.3 cm.

No. 443 (V. f41) *J.F.W. Herschel del. Cam. Luc. Sep 19, 1860 [sic]. St. Sauveur in the Valley of Gavarnie, French Pyrenees.* NOTEBOOK 2nd view. 21.9 x 33.1 cm.

No. 444 (V. f42) *J.F.W. Herschel del. Cam. Luc. 1850. Cascade de Richard, Val de Lys. Bagneres de Luchon.* 21.6 x 33.1 cm. RECTO

Bonnie cascade in a woodland
With mountains & vallies so wild
Had I been born in such a good land
I'd been proud to have owned me a child.
The thought should be chastened & holy
Where nature her standard uprears
Where man is seen feeble & lowly
And God in his greatness appears.

No. 445 (V. f43) *J.F.W. Herschel del. Cam. Luc. 1850. Cascade d'Enfer. Val de Lys. Bagneres de Luchon.* WM J. Whatman. NRF 38.1 x 25.1 cm. RECTO

How sweet at each turn of the mountain
The shepherd's hut rises to view
Within its grass & its knoll & its fountain!
Oh would I had nothing to do
But to spend my life here in dreaming
Of all that these vallies conceal
And forget this bad world & its scheming
Its struggles, its woe, and its weal
Should my heart e'er be bursting with anguish
And fortune frown dark on my path
For a scene such as this I might languish
And gasp for this sweet mountain air.

No. 446 (V. f44) *J.F.W. Herschel del. Cam. Luc. 1850. Val de Luchon. 1 mile from Bagneres de Luchon (Hautes Pyrenees) toward Val de Lys.* RECTO ⊙ No. 48. 21.7 x 35.7 cm.

No. 447 (V. f45) *J.F.W. Herschel del. Cam. Luc. Sep 19, 1826. Country House on the extinct volcano of St. Loup. Agde near Montpellier.* GENL N° 167. RECTO No. 9. 20.9 x 33.0 cm.

No. 448 (V. f46) *J.F.W. Herschel del. Cam. Luc. Sep 20, 1826. Montpellier with its Aquaduct & Chateau d'Eau.* RECTO ⊙ E + ½ div S Eye 15. 19.8 x 31.3 cm.

No. 449 (V. f47) *J.F.W. Herschel del. Cam. Luc. Sep 30, 1850. Chateau d'Eau. Montpellier.* 21.7 x 36.6 cm.

No. 450 (V. f48) *J.F.W. Herschel delin Cam. Luc. Sep 21, 1850 [sic]. Interior of the Amphitheatre, Nismes.* [Nîmes, France] RECTO ⊙ 5h 40m Eye 13•5 + x N. 288•8 S 109•4 i.e., it is E of Mag. S. about 71°; NOTEBOOK Sep 21, 1826. 21.8 x 34.2 cm.

No. 451 (V. f49) *J.F.W. Herschel delin Cam. Luc. Sep 21, 1826. 3h 45m PM. Exterior view of the Amphitheatre, Nismes.* [Nîmes, France] RECTO Find 3h 45m. Eye 14¾ + x; VERSO 164 Amphitheatre at Nîmes. 21.8 x 32.9 cm.

No. 452 (V. f50) *J.F.W. Herschel del. Cam. Luc. Oct 3, 1850. Amphitheatre of Nismes. Exterior from near the Mairie.* [Nîmes, France] PARTIAL RF 22.5 x 37.5 cm.

No. 453 (V. f51) *J.F.W. Herschel del. Cam. Luc. Oct 2, 1850. S.E. side of the upper corridor.* [Nîmes, France] RECTO No. 45 Modern French pier; NOTEBOOK Nismes Amphitheatre Interior of corridor Oct 2/50 SE side of the upper corridor. PARTIAL RF 35.4 x 25.0 cm.

No. 454 (V. f52) *J.F.W. Herschel del. Cam. Luc. Oct 3, 1850. Pont du Gard near Nismes. View from the S.W.* [Nîmes, France] GENL N° 394; RECTO No. 48; NOTEBOOK 1st view. 21.6 x 33.5 cm.

No. 455 (V. f53) *J.F.W. Herschel del. Cam. Luc. Oct 3, 1850. Pont du Gard near Nismes. From the South.* [Nîmes, France] RECTO No. 47; NOTEBOOK 2nd view. 21.5 x 36.5 cm.

No. 456 (V. f54) *J.F.W. Herschel delin Cam. Luc. Oct 4, 1850. The Tourmagne, Nismes.* [Nîmes, France] 33.2 x 23.2 cm.

No. 457 (V. f55) *J.F.W. Herschel del. Cam. Luc. Oct 1850. Interior of the Amphitheatre, Arles.* [4-6 October] PARTIAL RF 22.4 x 38.2 cm.

No. 458 (V. f56) *J.F.W. Herschel delin Cam. Luc. Oct 1850. Amphitheatre of Arles. From the Street opposite to the principal entrance.* [4-6 October] GENL N° 400. 21.3 x 32.5 cm.

No. 459 (V. f57) *J.F.W. Herschel del. Cam. Luc. Oct 6, 1850. Part of the Exterior Wall & View into the Interior of the Theatre, Arles.* 21.5 x 37.2 cm.

No. 460 (V. f58) *J.F.W. Herschel del. Cam. Luc. Oct 1850. Interior view of the Ancient Theatre, Arles.* [4-6 October] RECTO Chequered neckcloth. Green coat. Black waistcoat. Dress of the fellow who kept slinging stones at me while drawing. 21.4 x 35.7 cm.

No. 461 (V. f59) *J.F.W. Herschel del. Cam. Luc. Oct 1850. Roman Mausoleum. St. Remy near Tarascon.* [7-8 October] 33.2 x 21.6 cm.

No. 462 (V. f60) *J.F.W. Herschel del. Cam. Luc. Oct 1850. Roman Monumental Arch. St. Remy near Tarascon.* [8 October] GENL N° 408; RECTO Inside arch Arabesque flower work not scroll but in tiers. 20.8 x 32.7 cm.

No. 463 (V. f61) *J.F.W. Herschel del. Cam. Luc. Oct 1850. Avignon, from the Esplanade of the Rocher du Dom near the Citadel.* [9-12 October] GENL N° 409. 21.6 x 33.2 cm.

No. 464 (V. f62) *J.F.W. Herschel del. Oct 1860. [sic] Vaucluse, the Castle & rocks near the fountain (enlarged from a Camera View on a smaller scale).* GENL N° 404; RECTO France 1850; NOTEBOOK Vaucluse No. 1. Camera Sk. transferred; ALBUM PAGE from original in 1850. 20.8 x 32.8 cm.

No. 465 (V. f63) *J.F.W. Herschel delin Cam. Luc. Oct 1850. Interior of the Cavern whence issues the Fountain of Vaucluse.* [10 October] GENL N° 405; RECTO No. 50; NOTEBOOK Vaucluse No. 2, Grotto & fountain. 22.8 x 33.2 cm.

No. 466 (V. f64) *J.F.W. Herschel del. Cam. Luc. Oct 1850. Rocks overhanging the fountain of Vaucluse.* [10 October] NOTEBOOK No. 466; NOTEBOOK Vaucluse No. 3. 22.9 x 33.2 cm.

No. 467 (V. f65) *J.F.W. Herschel delin Cam. Luc. Oct 1850. Triumphal Arch of Marius. Orange (Camera unsteady).* [11 October] 22.3 x 33.1 cm.

No. 468 (V. f66) *J.F.W. Herschel del. Cam. Luc. Oct 1850. Interior of the Roman Theatre at Orange.* GENL N° 408. [11 October] 21.5 x 33.2 cm.

VOLCANIC DISTRICT OF AUVERGNE & VIVARAIS

No. 469 (V. f67) *J.F.W. Herschel del. Cam. Luc. Sep 23, 1826. Basaltic Rock near Maygre. Rochemaure. Montelimar (Vivaris).* RECTO Find 11h 45m Eye 12½ + x a. S + 1 div. W. by compass; VERSO 152. 21.9 x 34.2 cm.

LOOSE INSERT @ No. 469 (V. f67): A comparison to the rocks of Rochemaure. VERSO 469 Z. 75. 9.5 x 15 cm.

No. 470 (V. f68) *J.F.W. Herschel del. Cam. Luc. Sep 23, 1826. Basaltic Colannade of Chenavari near Montelimar.* RECTO Eye 13¾ + x. Facade fronts to NNE ± (magnetic). 14. W by compass exact. 20.0 x 31.9 cm.

No. 471 (V. f69) *J.F.W. Herschel del. Cam. Luc. 1850. Pont Labaume and Chateau Ventadour.* RECTO 394. No. 62. 20.7 x 32.7 cm.

No. 472 (V. f70) *J.F.W. Herschel del. Cam. Luc. Oct 16, 1850. Basaltic Colonnade with the Chateau de Ventadour. Pont la Baume.* GENL N° 412. RECTO 397. No. 65. 21.6 x 33.0 cm.

No. 473 (V. f71) *J.F.W. Herschel del. Cam. Luc. Oct 1850. Pont Labaume and its Basaltic Colannade from the old road to Montperat.* GENL N° 403; NOTEBOOK Oct 16/50. 20.7 x 32.7 cm.

No. 474 (V. f72) *J.F.W. Herschel del. Cam. Luc. Oct 1850. Suspension Bridge. Montperat.* GENL N° 414; RECTO No. 67. 21.5 x 33.2 cm.

No. 475 (V. f73) *J.F.W. Herschel del. Cam. Luc. Oct 1850. Basaltic Colonnade, 3 kilometres from Janjeau.* GENL N° 405; RECTO 396 No. 64. 21.6 x 33.2 cm.

No. 476 (V. f74) *J.F.W. Herschel delin. Oct. 1850. The extinct Volcanic Crater of Janjeau (Enlarged from an Eye draft).* GENL N° 406. 21.6 x 33.4 cm.

No. 477 (V. f75) *J.F.W. Herschel del. Cam. Luc. Sep 25, 1826. Vals. between Aubenas & Entraigues.* GENL N° 154; RECTO Eye 12•2 + x. a. 20.9 x 33.0 cm.

No. 478 (V. f76) *J.F.W. Herschel del. Cam. Luc. Sep 26, 1826. Cascade & Basaltic Colonnade near the Bridge of Rijandel Valley & Entraigues.* GENL N° 163; RECTO No. 24; WM J. Whatman Turkey Mill. 22.1 x 32.5 cm.

No. 479 (V. f77) *J.F.W. Herschel del. Cam. Luc. Sep 26, 1826. Basalt of the Pont de Rijandel. Valley of Entraigues.* GENL N° 168; RECTO Eye 12 + x. a. N + 6 div. E. B. 3h 40m. F. 4h 50m; VERSO 20 NOTEBOOK Basaltic columns; WM J. Whatman Turkey Mill 1824. 21.3 x 34.4 cm.

No. 480 (V. f78) *J.F.W. Herschel del. Cam. Luc. Sep 27, 1826. Town of Entraigues shewing the situation of the "Fromage" on the Granite Rock.* WM J. Whatman. 21.4 x 34.9 cm.

No. 481 (V. f79) *J.F.W. Herschel del. Sep 27, 1826. 9h 45m AM. Le Fromage. A Basaltic remnant on the Granite of Entraigues.* GENL N° 156; RECTO 9h 45m finished. Eye 10 + x; VERSO 21; WM J. Whatman. 21.5 x 35.0 cm.

No. 482 (V. f80) *J.F.W. Herschel del. Cam. Luc. Sep 26, 1826. 9h 15m AM. Basaltic Grotto near Entraigues—near view.* GENL N° 158; RECTO Eye 13 + x. 21.0 x 32.9 cm.

No. 483 (V. f81) *J.F.W. Herschel del. Cam. Luc. Sep 26, 1826. Basaltic grotto near Entraigues—a more distant view.* RECTO f^d 9^h 15^m Eye 13½ + x. No. 47. Turf. Grotto near L'Entraigues composed of Basalt immediately on its entry into the valley of the Volent from the Crater of Ceyzal; WM J. Whatman 1825. 20.9 x 32.9 cm.

No. 484 (V. f82) *J.F.W. Herschel del. Cam. Luc. Sep 27, 1826. "Le Rideau" a basaltic formation in the Valley of the Bize Entraigues.* GENL N° 159; RECTO Eye 15 + Fin^d 1^h 10^m No. 22; WM J. Whatman. 21.3 x 34.9 cm.

No. 485 (V. f83) *J.F.W. Herschel del. Cam. Luc. Sep 26, 1826. Crater of the Volcano of Ayzac near Entraigues. From above the Church of Ayzac.* GENL N° 160; RECTO Eye 12.0 + x. Eye line. Fin^d 12^h 32^m No. 18 Exterior view in front of crater; WM J. Whatman 1825. 20.7 x 34.3 cm.

No. 486 (V. f84) *J.F.W. Herschel del. Cam. Luc. Sep 25, 1826. View from the interior of the Crater of Ayzac, near Entraigues, Looking N.N.E.* GENL N° 161; RECTO Eye 12.0 + x. 4^h 40^m + Corr; VERSO 16. 21.8 x 34.3 cm.

No. 487 (V. f85) *J.F.W. Herschel del. Sep 1826. The "Coupe d'Ayzac" as seen from the Valley of Entraigues (from a very rough Eye draft).* NOTEBOOK Cone of Ayzac; WM Whatman. 20.1 x 32.1 cm.

No. 488 (V. f86) *J.F.W. Herschel del. Cam. Luc. 1850. The Valley of Thueys, looking E. by N. from the Chestnut grove on the Basaltic plateau.* 22.6 x 35.4 cm.

No. 489 (V. f87) *J.F.W. Herschel del. Cam. Luc. 1850. Valley of Thueys. Basaltic cliff & old bridge. Looking down from the Viaduct.* 21.4 x 35.2 cm.

No. 490 (V. f88) *J.F.W. Herschel del. Cam. Luc. 1850. Basaltic Cliffs on Northern & Granite Rocks on Southern side of the valley of Thueys, looking SW by S from the Basaltic Plateau.* NOTEBOOK Thueys, 2nd view. 21.6 x 35.2 cm.

No. 491 (V. f89) *J.F.W. Herschel del. Cam. Luc. 1850. Ravine of Thueys with Basaltic Cliff on left & Granite rock on right. Looking up (NE by E) to the Viaduct.* GENL N° 417. 21.5 x 33.6 cm.

No. 492 (V. f90) *J.F.W. Herschel del. Cam. Luc. 1850. View from the old bridge over the Ardeche? below Thueys. Looking S. by W. up the stream.* GENL N° 418. 21.7 x 33.2 cm.

No. 493 (V. f91) *J.F.W. Herschel del. Cam. Luc. 1850. The old bridge below Thueys looking up the stream.* 34.1 x 23.6 cm.

No. 494 (V. f92) *J.F.W. Herschel del. Cam. Luc. 1850. Aiguille & Church of St. Michel at Le Puy — from the descent from the Rocher du Corneille.* 20.6 x 32.4 cm.

No. 495 (V. f93) *J.F.W. Herschel del. Cam. Luc. Oct 19, 1850. Le Puy. From across the bridge. The Church of St. Michel bearing ENE. The Rocher du Corneille N.E. by E. (by compass) & the Cathedral.* 21.5 x 33.2 cm.

AUVERGNE, VIVARAIS & CANTAL

No. 496 (V. f94) *J.F.W. Herschel del. Cam. Luc. Oct 1850. Chateau de Polignac near Le Puy.* 21.5 x 33.2 cm.

No. 497 (V. f95) *J.F.W. Herschel del. Cam. Luc. Oct 1850. Basaltic Rock, Castle, and Valley of Ceyssai near Le Puy. Looking nearly SW.* 21.3 x 33.3 cm.

LOOSE INSERT @ No. 497 (V. f95); MS map of Auvergne. Geographical Miles 60 to the degree; WM Rye Mill 1848. 55.5 x 45 cm.

No. 498 (V. f96) *J.F.W. Herschel del. Cam. Luc. Oct 1850. Les orgues d'Expailly near Le Puy. The falling portion of the Colonnade.* 21.5 x 33.2 cm.

No. 499 (V. f97) *J.F.W. Herschel del. Cam. Luc. Sep 6, 1826. Puy de Dome and the Chaine des Puys or Extinct Volcanos from the Puy Chopine.* WM J Whatman. 22.7 x 35.5 cm.

No. 500 (V. f98) *J.F.W. Herschel del. Cam. Luc. Sep 7, 1826. Chaine des Puys (near Clermont) from the Puy Pariou.* GENL N° 145; RECTO Eye 13•8; WM J. Whatman Turkey Mill 1824. 21.0 x 35.8 cm.

No. 501 (V. f99) *J.F.W. Herschel del. Cam. Luc. Sep 8, 1826. Chaine de Puys (Clermont) from the Puy de la Nagere.* GENL N° 146; RECTO Summit of Puy de Dome N point 6•0 to W; WM J. Whatman Turkey Mill 1824. 21.0 x 32.9 cm.

No. 502 (V. f100) *J.F.W. Herschel del. Cam. Luc. Sep 9, 1826. The Puys of Clermont (Auvergne) as seen from the Summit of the Puy de Dome.* GENL N° 147; RECTO • Eye 1375. 21.5 x 34.1 cm.

No. 503 (V. f101) *J.F.W. Herschel delin Cam. Luc. Sep 10, 1826. Coude and the Tower of Montpeiroux•* RECTO Eye 13•5 + x; NOTEBOOK Gisement of Arragonite; WM J. Whatman Turkey Mill. 20.8 x 32.7 cm.

No. 504 (V. f102) *J.F.W. Herschel del. Cam. Luc. Sep 11, 1826. View of the Bone Breccia beds of the Mont Boulade.* RECTO ⊙. Mont Boulade Giscment of Fossil Bones. Eye 13•0 + x. 20.9 x 32.8 cm.

No. 505 (V. f103) *J.F.W. Herschel del. Cam. Luc. Sep 12, 1826. Massiac in Cantal. Shewing the Basaltic Plateau crowning all the heights.* RECTO Eye 15•0 + x. Sep 12 2^h 10^m; WM J. Whatman 1825. 20.9 x 32.6 cm.

No. 506 (V. f104) *J.F.W. Herschel del. Cam. Luc. Sep 15, 1826. The Bridge of Montferrand in Cantal.* RECTO 8^h 50^m Sep 14. Center of bridge S ½ div E by Com. Eye 13•0 + x. 21.1 x 33.0 cm.

No. 507 (V. f105) *J.F.W. Herschel delin Cam. Luc. Sep 23, 1821. The Lake of Brienz from Iseltwald.* [field draft of finished version No. 519] RECTO No. 39. 20.2 x 30.5 cm.

No. 508 (V. f105) *J.F.W. Herschel del. Sep 23, 1821. The Lake of Brienz [sic] from the Giesbach (exactly transferred from a Cam. Luc. drawing).* 21.1 x 30.2 cm.

No. 509 (V. f106) *J.F.W. Herschel del. Cam. Luc. Sep 23, 1821. Fall of the Giesbach, Brientz.* VERSO [another sketch: Lake _____ from _____ Sep. 15] No. 32. 30.8 x 20.6 cm.

NORTH SWITZERLAND

No. 510 (V. f106) *J.F.W. Herschel del. Cam. Luc. Sep 23, 1821. Fall of the Staubbach, Valley of Lauterbrunn.* 20.3 x 30.3 cm.

No. 511 (V. f107) *J.F.W. Herschel del. Cam. Luc. Sep 21, 1821. Valley of Lauterbrunn. Descending from Wengern Alk.* RECTO JFWH del No. 106 No. 36; VERSO [geometrical sketch]; NOTEBOOK from the Leper Scheideck. 19.6 x 29.4 cm.

No. 512 (V. f107) *J.F.W. Herschel del. Cam. Luc. Sep 22, 1821. Traitisel-lavines & Schmadribach. Via Lauterbrunn.* 19.1 x 29.0 cm.

No. 513 (V. f108) *J.F.W. Herschel del. Cam. Luc. Sep 20, 1821. Valley of Grindelwald with the Wetterhorn.* 17.7 x 26.6 cm.

No. 514 (V. f108) *J.F.W. Herschel del. Cam. Luc. Sep 20, 1821. Valley of Grindelwald from near where the lower glacier is seen.* RECTO [arrow]'May 1823' No. 351; VERSO No. 36; NOTEBOOK Valley & lesser glacier of Grindelwald; WM J. Whatman 1820. 20.2 x 30.5 cm.

No. 515 (V. f109) *JFWH. [enlarged copy of field draft No. 315].* GENL N° 429; VERSO Ravine in the Pass of the Simplon near the Gallery of Isella; NOTEBOOK enlarged copy made for Mrs. Babbage. 29.3 x 19.2 cm.

No. 516 (V. f110) *Copied from the original Camera Lucida drawing of Sep 4, 1821 by JFWH. Earth Columns at Stalde in the Visp-Thal. Switzerland.* NOTEBOOK Clay columns at Stalde, enlarged copy made for Mrs. Babbage, [enlarged copy of field draft No. 320]. 19.3 x 29.4 cm.

No. 517 (V. f111). NOTEBOOK Glacier of Zermatt. Enlarged copy of...made for Mrs. Babbage. [enlarged copy of field draft No. 322]. 21.0 x 30.7 cm.

No. 518 (V. f112). [1821] GENL N° 432; NOTEBOOK Aiguille de Dieux, Mont Blanc. Enlarged copy of...made for Mrs. Babbage. 19.7 x 29.5 cm.

No. 519 (V. f113) *Lake of Brienz from Iseltwald.* GENL N° 433; NOTEBOOK Enlarged copy made for Mrs. Babbage; [enlarged copy of field draft No. 507]. 20.8 x 30.8 cm.

SWITZERLAND. EYE DRAFTS. MISCELLANEOUS.

LOOSE INSERT @ No. 267 (IV. f4) No. 521 *Traced from eye draft. The Ghemmi, Sep 11, 1821.* NOTEBOOK 521 no vol. n = 121 pass of the Ghemmi (eye-draft) Sep 11, 1821. 36.3 x 22.2 cm.

ISLE OF WIGHT & NETLEY

No. 538 (III. f73) *J.F.W. Herschel del. Cliffs on the Main Beach. Isle of Wight. Near Babbinet Devon.* [1828 or 1831?] [original of painting #6]; VERSO [slight sketch of figure]. NRF 19.0 x 25.1 cm.

No. 539 (III. f73) *J.F.W. Herschel delin. 18.. Culver Cliffs & Dunmore Point from Lithcombe Chine. Isle of Wight.* [July 1831?] VERSO No. 103. NRF 17.9 x 25.1 cm.

No. 540 (III. f74) *J.F.W. Herschel delin. Cliffs immediately West of Shanklin Chine. Isle of Wight.* [July 1831?] VERSO 85. 22.5 x 31.2 cm.

No. 541 (III. f75) *J.F.W. Herschel delin. Landslip of the Undercliff. Isle of Wight near Bonchurch.* [July 1831?] VERSO [rough ms, including musical score, mathematics notes & diagram]. NRF 22.4 x 29.2 cm.

No. 542 (III. f76) *J.F.W. Herschel delin Cam. Luc. Sand Rock Hotel and Undercliff. Isle of Wight.* [July 1831?] RECTO Foreground 6 donkeys feeding, 27 hogs, 398 ducks, geese, and poultry, with 3 naughty boys petting them and one licking his sister with an old hat doubled up into the semblance of a partitious whip. This rock imaginary as to place but a portrait unto form. Its place is quite in character with the fall of the masses. Sandrock Hotel and part of the undercliff, Isle of Wight. 19.8 x 32.1 cm.

No. 543 (III. f77) *J.F.W. Herschel delin Cam. Luc. July...1831. Alum Bay, Isle of Wight.* [8 July] GENL N° 106; RECTO Eye x = 6•5•0 y = 3•0 z = 10•4 Farthest of the needles bears W + 1^{div} South (or in common with 92• ½ West). Coloured cliffs off Alum Bay. The Needles. WM J. Whatman Turkey Mill. 19.9 x 33.3 cm.

No. 544 (III. f78) *J.F.W. Herschel delin Cam. Luc.*

July...1831. Scratchell's Bay near Freshwater. Isle of Wight. [7 July] RECTO Eye = 9½ + x. 20.2 x 33.0 cm.

No. 545 (III. f79) *J.F.W. Herschel delin. Netley Abbey near Southampton. Interior, East Window.* [July 1832?] GENL N° 340. 21.6 x 32.6 cm.

No. 546 (III. f80) *J.F.W.H. delin. Netley Abbey. Interior. Cross Aisle.* [July 1832?] GENL N° 339; NOTEBOOK (?N); WM J. Whatman 1849. 21.9 x 32.4 cm.

No. 547 (III. f81) *J.F.W. Herschel delin Cam. Luc. Netley Abbey, Southampton. East Window & South Transept.* [July 1832?] GENL N° 100. 19.7 x 31.8 cm.

No. 548 (III. f82) *J.F.W. Herschel delin Cam. Luc. July...1832. Netley Abbey. Southampton. Nave & West Window.* GENL N° 101; RECTO eye = 11 inches. Netley Abbey, Hants. Principal vertical W. 2½ div. S. per compass. 19.9 x 31.8 cm.

IRELAND. GIANTS CAUSEWAY.

No. 549 (III. f83) *J.F.W. Herschel delin Cam. Luc. View of Fairhead, Antrim, Ireland, from the deck of the "City of Londonderry" steamer.* [13 September 1827]. 20.0 x 30.2 cm.

No. 550 (III. f84) *J.F.W. Herschel del. Cam. Luc. Bengore Head. Giant's Causeway. Antrim, Ireland.* [14 September 1827] GENL N° 112; RECTO Querry the course of the red rock beds in the basalt where not marked "Red." Bengore Head. Drawn in a heavy rain the paper streaming with water & under every unfavourable circumstance for the use of the camera, but the general outline may be relied on — only querry the course of the red layers marked a a a being put in afterwards in conformity with parts marked Red and red rock; WM J. Whatman Turkey Mill. 20.7 x 31.0 cm.

No. 551 (III. f85) *J.F.W. Herschel delin Cam. Luc. Port N'abo and Rooranvalley Head. Giant's Causeway. Antrim Ireland.* [14 September 1827] GENL N° 113; RECTO (r r r) the organ pipes very regular beneath view of the Chumley (Chimney) Head (r) and Rooranvalley Head (rr) with Port N'abo from the Giant's Causeway looking Eastward; WM J. Whatman Turkey Mill. 19.7 x 30.7 cm.

No. 552 (III. f86) *J.F.W. Herschel delin Cam. Luc. Plaskin Head and Ben-an-Newsan. Giant's Causeway Antrim Ireland.* [14 September 1827] GENL N° 114; RECTO Place of the sun at 2^h 50^m pm. 20.2 x 31.4 cm.

No. 553 (III. f87) *J.F.W. Herschel del. (copy from Cam. Luc.). Process of measuring the Base of the Ordnance Survey. Loch Foyle.* [September 1827] NOTEBOOK Loch Ban Measurement of the base of the Irish trigonometrical survey at Londonderry. Copied from the engraving taken from my original camera lucida sketch made on the spot. 15.9 x 24.0 cm.

WARWICKSHIRE, WORCESTERSHIRE, & THE WYE

No. 554 (III. f87) *J.F.W. Herschel delin 1829. Leamington, Warwick.* [March] NOTEBOOK Leamington, Warwickshire, from Hotel window; VERSO [rough sketch of optical principle of the camera lucida]. 17.0 x 23.8 cm.

No. 555 (III. f88) *J.F.W. Herschel del. Cam. Luc. March 24, 1829. Warwick Castle, Bridge and Churches.* GENL N° 94; RECTO Dist. of eye = 18 inches Gray's Tower top = ⊙. 20.0 x 32.3.

No. 556 (III. f89) *J.F.W. Herschel delin Cam. Luc. March 1829. Ruins of Kenilworth Castle, near Warwick.* RECTO ⊙ N. 2½ div E by comp. Dist of eye 16 inches. 19.4 x 31.8 cm.

No. 557 (III. f90) *J.F.W. Herschel delin Cam. Luc. 1829. Worcester Cathedral.* RECTO Eye = l + 1; WM J. Whatman Turkey Mill. 19.9 x 32.1 cm.

No. 558 (III. f91) *J.F.W. Herschel delin Cam. Luc. 1829. Malvern Hills from a field near Worchester.* WM J. Whatman Turkey Mill. 19.8 x 32.1 cm.

No. 559 (III. f92) *J.F.W. Herschel delin Cam. Luc. 1829. Goderick Castle, Monmouth.* RECTO ⊙; WM J. Whatman. 19.7 x 32.2 cm.

No. 560 (III. f93) *J.F.W. Herschel del. Cam. Luc. 1829. Tintern Abbey on the Wye. Interior, West Window.* GENL N° 90. 19.7 x 32.2 cm.

No. 561 (III. f94) *J.F.W. Herschel del. Cam. Luc. 1829. Tintern Abbey on the Wye. Interior, East Window.* [16 April] GENL N° 91; RECTO ⊙. 19.4 x 32.2 cm.

No. 562 (III. f95) *J.F.W. Herschel delin 1829. River Wye near Tintern.* [16 Apr.] GENL N° 89; RECTO Eye Draft. "Us, here we are;" VERSO 89. NRF 18.7 x 24.7 cm.

No. 563 (III. f95) Hants. *View of the Village of Selborne from the Manor. May 27th, 1827 J.F.W. Herschel.* GENL N° 324; RECTO eye draft; NOTEBOOK Selbourne, Hants, with "White's House." To replace a missing one of Mr. Willis's House. Out of place but . NRF 17.7 x 25.4 cm.

NORTH WALES

No. 564 (III. f96) *J.F.W. Herschel del. Cam. Luc. Sep 29, 1827. The Menai Suspension Bridge. from the Bangor side.* RECTO E = 18ⁱⁿ. Bridge chains and Piers white much brighter than the wood behind. Sky dark & cloudy. Mountains beyond if any not seen; NOTEBOOK distant view. 20.1 x 31.0 cm.

No. 565 (III. f97) *J.F.W. Herschel del. Cam. Luc. Sep 29, 1827. Menai Suspension Bridge. Near view from the Bangor side.* RECTO 7• 55' = /ab ac = 17• 26' pq = 43• 22'. ⊙ Eye 9¼ + x; NOTEBOOK nearer Bangor side. 19.7 x 30.7 cm.

No. 566 (III. f98) *J.F.W. Herschel delin Cam. Luc. Sep 29, 1827. Menai Suspension Bridge from the Beach on the Anglesea side.* RECTO Eye 9 inches + x. ⊙ Menai Bridge Anglesea side of the Strait from the North or from the Beaumaris side of the bridge road; NOTEBOOK Menai Bridge from below. Anglesea side; WM J. Whatman Turkey Mill. 19.7 x 30.9 cm.

SUSSEX, KENT, BAYHAM, BODIHAM, MOUNTFIELD

No. 567 (III. f99) *J.F.W. Herschel del. Cam. Luc. Sep 1, 1846. Bayham Abbey near Lamberhurst, Sussex.* GENL N° 325. 21.6 x 33.7 cm.

No. 568 (III. f100) *J.F.W. Herschel delin Cam. Luc. Sept 1, 1846. Bayham Abbey near Lamberhurst, Sussex.* GENL N° 324; VERSO No. 325. NRF 24.5 x 37.6 cm.

No. 569 (III. f101) *J.F.W. Herschel delin Cam. Luc. Aug 29,1849. Bayham Abbey near Lamberhurst, Sussex.* GENL N° 327. 23.2 x 34.2 cm.

No. 570 (III. f102) *J.F.W. Herschel del. Cam. Luc. Aug 29, 1849. Bayham, Lord Camden's house near the Abbey.* GENL N° 328. 22.5 x 34.1 cm.

No. 571 (III. f103) *J.F.W. Herschel delin Cam. Luc. July 1, 1856. Bayham Abbey, near Lamberhurst, Sussex.* NRF 24.3 x 37.4 cm.

No. 572 (III. f104) *J.F.W. Herschel del. Cam. Luc. June 18, 1859. Bayham Abbey near Lamberhurst, Sussex;* WM J. Whatman Turkey Mill 1853. 21.4 x 32.6 cm.

No. 573 (III. f105) *J.F.W. Herschel del. Cam. Luc. June 18, 1859. Bayham Abbey near Lamberhurst, Sussex.* 21.2 x 32.4 cm.

No. 574 (III. f106) *J.F.W. Herschel del. Cam. Luc. May 21, 1860. Bodiham Castle. Sandhurst, Sussex.* GENL N° 343; WM J. Whatman Turkey Mill 1853. 20.8 x 32.4 cm.

No. 575 (III. f107) *J.F.W. Herschel del. Cam. Luc. Sept 4, 1860. Bodiham Castle, Sandhurst, Sussex.* GENL N° 342. 20.7 x 32.4 cm.

No. 576 (III. f108) *J.F.W. Herschel del. Cam. Luc. July 29, 1850. Great Pinaster. Mountfield, Sussex. Girth 2 feet high = 13ᶠ 6ⁱⁿ.* 34.1 x 22.5 cm.

No. 577 (III. f109) *J.F.W. Herschel del. Cam. Luc. July 29, 1850. Group of Scotch firs at Mountfield, Sussex.* GENL N° 330. 20.7 x 32.4 cm.

No. 578 (III. f110) *J.F.W. Herschel delin. (copy from a smaller) Brasted Church near Sevenoaks, Kent.* [prior to August 1833] RECTO from behind Mʳ Jones Parsonage House. 20.1 x 29.7 cm.

No. 579 (III. f111) *J.F.W. Herschel del. Cam. Luc. 1859. A group of yuccas flowering in our garden at Collingwood.* 20.9 x 32.4 cm.

No. 588 (V. f114) *J.F.W. Herschel delin. Seagrove—the seat of Sir Wm. Watson. Dawlish, Devon.* [prior to 1825] VERSO 84. 22.3 x 30.4 cm.

No. 589 (V. f115) *J.F.W. Herschel delin. Cliffs on beach to the Westward of Dawlish, Devon. Looking Eastwards.* [prior to 1825] VERSO 83. 21.8 x 29.9 cm.

No. 590 (V. f116) *J.F.W. Herschel delin. The Parson Rock & others on the Beach. Dawlish, Devon. From the summerhouse window at Seagrove.* [prior to 1825] VERSO from summerhouse window at Sir Wm. Watsons; WM J. Whatman 1811. 22.0 x 29.4 cm.

No. 591 (V. f117) *J.F.W. Herschel delin. The Clerk Rock on the coast of Dawlish, Devon, from a point westward of "the Parson" Rock.* [1816?] VERSO 83. 22.3 x 30.0 cm.

No. 592 (V. f118) *J.F.W. Herschel del. 1816. Rocks on the beach west of Dawlish, Devon. "The Clerk" and others.* VERSO JFWH 1816; WM J. Whatman 1814. 18.3 x 25.2 cm.

No. 593 (V. f118) *J.F.W. Herschel delin. 1816. Rocks on the beach and cliffs. Dawlish, Devon.* NOTEBOOK other rocks on the beach; VERSO monogram 'JFWH' 1816. 18.2 x 25.6 cm.

No. 594 (V. f119) *J.F.W. Herschel delin. 1816. A cave in the cliff on the beach. Dawlish, Devon.* NOTEBOOK first cave on the beach; VERSO monogram 'JFWH' 1816 Aug. 18.6 x 25.7 cm.

No. 595 (V. f119) *J.F.W. Herschel delin. 1816. Another cave in the cliff on the beach. Dawlish, Devon.* NOTEBOOK second cave on the beach. 18.2 x 24.4 cm.

No. 596 (V. f120) *J.F.W. Herschel delin. 1816. Rocks and cliffs on the beach. Dawlish, Devon.* VERSO [grid layout]; NOTEBOOK looking across towards Starcross. NRF 15.7 x 22.6 cm.

No. 597 (V. f120) *J.F.W. Herschel del. 1816. Rock on the beach Dawlish.* VERSO 77 [another sketch VERSO]. NRF 22.1 x 15.7 cm.

No. 600 (III. no f, after f119) *J.F.W. Herschel delin (Eye-draft). Ripon, Yorkshire.* RECTO Minster more in distance & town. NRF 18.3 x 25.4 cm.

No. 601 (III. no f, after f119) *J.F.W. Herschel delin (Eye-draft). Chesterfield Church, Derbyshire.* [ink drawing] VERSO N• 85. 28.4 x 21.7 cm.

LOOSE INSERT No. 741 (III. no f) *J.F.W. Herschel delin Cam. Luc. Oct 19, 1864. Collingwood. View of the trees & pond from the upper walk beyond the Hermitage.* NOTEBOOK The pond from near the hermitage in the open walk. 21.6 x 33.2 cm.

LOOSE INSERT (v. III, with #741): 1 oz gum to 1 lb. water. A. ½ oz. Gum Arabic and 8 oz. vial of water. Experiment to try the preservation of pencil drawings. NB, is perfectly indelible but gives a glossy surface.

No. 750 (III. f112) *J.F.W. Herschel del. Cam. Luc. Aug 4, 1865. Windsor Castle from Upton Court.* NOTEBOOK Mr. Nelsons Aug 3, 1865; VERSO Aug 2, 1865. NRF 25.1 x 37.9 cm.

No. 751 (III. f113) *J.F.W. Herschel del. Cam. Luc. Aug 5, 1865. Windsor Castle from Upton Court, between the Great Elms.* RECTO ~~height 135 feet~~. Height 103ᶠ 6ⁱⁿ. Girth at 4 f = 18ᶠ 4ⁱⁿ. VERSO Aug 2, 1865; NOTEBOOK Aug. 4, 1865. 22.2 x 35.1 cm.

No. 752 (III. f114) *J.F.W. Herschel delin Cam. Luc. Aug 3, 1865. Mr. Nelson's Upton Court. North front.* NOTEBOOK Mr. Nelson's Upton Court S & E fronts Aug 5, 1865; VERSO Aug. 2, 1865. NRF 24.8 x 38.2 cm.

No. 753 (III. f115) *J.F.W. Herschel del. Cam. Luc. Aug 6, 1865. Upton Court. East Front. From across the pond.* NOTEBOOK D• South front. Aug. 7, 1865; VERSO Upton Court Aug 6 & 7 1865. 21.7 x 34.1 cm.

No. 754 (III. f116) *J.F.W. Herschel del. Cam. Luc. Aug 9/65. Donnington Castle near Newberry.* NOTEBOOK The Gateway. 24.6 x 37.9 cm.

No. 755 (III. f117) *J.F.W. Herschel del. Cam. Luc. Aug 9, 1865. Donnington farm (Mr. Bebb's formerly) from behind the castle.* NOTEBOOK Donnington Castle from behind. Looks on Donnington Park; VERSO Donnington Castle & Mr. Bebb's house? 21.9 x 34.6 cm.

No. 756 (III. f118) *J.F.W. Herschel del. Cam. Luc. Aug 14, 1865. Salisbury Cathedral from the NE.* ALBUM PAGE drawn when he was aged 73. NRF 24.8 x 38.2 cm.

No. 757 (III. f119) *J.F.W. Herschel del. Cam. Luc. Aug 12, 1865. Stone Henge.* ALBUM PAGE drawn when he was 73. 25.1 x 38.3 cm.

PAINTING NO. 1. *JFWH. Pass of Campagnole, Jura.* [copied from No. 340] [6 August 1821] RECTO No. 2 copied in colour, bad sketch; VERSO Pass of Champagnole JFWH. 21.2 x 29.6 cm.

PAINTING NO. 2. [cottage with figures] VERSO probably JFWH [additional pencil sketch VERSO]. 21.3 x 29.7 cm.

PAINTING NO. 3. VERSO Ilfracombe, probably JFWH. 19.9 x 29.8 cm.

PAINTING NO. 4. [mother, child, and house] VERSO probably JFWH. 21.3 x 29.7 cm.

PAINTING NO. 5. *426. Copied in colour. Bad.* [Dawlish, Devon] [1816?] VERSO copy of 426 [not #426 in this listing]. JFWH. 21.2 x 29.6 cm.

PAINTING NO. 6. [Copied from No. 538, Cliffs on the Main Beach, Isle of Wight]. RECTO 103 copied from pencil drwg; VERSO JFWH Aug 1820. 21.2 x 29.7 cm.

PAINTING NO. 7. [landscape with island] VERSO probably JFWH. 21.2 x 29.8 cm.

PAINTING NO. 8 *761. JFWH. del. et Pinx. July 8th 1809. JFW Herschel.* NOTEBOOK White Lily, Slough 1820...23??? 31.1 x 22.4 cm.

INDEX

FIGURE 42. Attributed to Henry Moses, *Woman sketching with a camera lucida*. Pencil and ink sketch, ca. 1823. 7.6 x 10.8 cm. By courtesy of the Board of Trustees of the Victoria & Albert Museum.

TRACINGS OF LIGHT: SIR JOHN HERSCHEL & THE CAMERA LUCIDA

Production: Curatorial Assistance
Design: Karen Bowers
Text: ITC Garamond
Printing: Gardner Lithograph
Binding: Roswell Bookbinding
Stock: Mowhawk Superfine cover. This paper exceeds archival requirements and standards of permanence listed under ANSI No. Z39.48-1984.

This publication is accompanied by a traveling exhibition of J.F.W. Herschel's camera lucida drawings circulated by Curatorial Assistance, Los Angeles.